Aperture® 3

PORTABLE GENIUS
2nd EDITION

by Josh Anon and Ellen Anon

WILEY

John Wiley & Sons, Inc.

Aperture® 3 Portable Genius, 2nd Edition

Published by
John Wiley & Sons, Inc.
10475 Crosspoint Blvd.
Indianapolis, IN 46256
www.wiley.com

ISBN: 978-1-118-27429-3

Manufactured in the United States of America

10 9 8 7 6 5 4 3 2 1

For general information on our other products and services or to obtain technical support, please contact our Customer Care Department within the U.S. at (877) 762-2974, outside the U.S. at (317) 572-3993 or fax (317) 572-4002.

Wiley publishes in a variety of print and electronic formats and by print-on-demand. Some material included with standard print versions of this book may not be included in e-books or in print-on-demand. If this book refers to media such as a CD or DVD that is not included in the version you purchased, you may download this material at http://booksupport.wiley.com. For more information about Wiley products, visit www.wiley.com.

Library of Congress Control Number: 2012948911

WILEY

Credits

Senior Acquisitions Editor
Stephanie McComb

Project Editor
Kristin Vorce

Technical Editor
Paul Shivonen-Binder

Senior Copy Editor
Kim Heusel

Editorial Director
Robyn Siesky

Business Manager
Amy Knies

Senior Marketing Manager
Sandy Smith

Vice President and Executive Group
Publisher
Richard Swadley

Vice President and Executive Publisher
Barry Pruett

Senior Project Coordinator
Kristie Rees

Graphics and Production Specialists
Andrea Hornberger

Quality Control Technician
Jessica Kramer

Proofreading and Indexing
BIM Indexing & Proofreading Services

About the Authors

Josh Anon has been a nature photographer for most of his life, with his interest in photography starting when he received his first Kodak 110 camera at the ripe old age of 4. Camera in hand, he received a BS in computer science from Northwestern University.

After graduating, Josh started working at Pixar Animation Studios in Emeryville, California. There he worked on *The Incredibles*, *Up*, *Toy Story 3*, and more, primarily as a camera and staging artist. Currently he is a senior product manager at Lytro.

Josh travels the globe searching for the next great picture, be it 100 feet deep on the Great Barrier Reef, on a cold and windy beach in the South Atlantic, or inside the Arctic Circle. His award-winning images, represented by the prestigious Jaynes Gallery and available at www.joshanon.com, have appeared in a variety of galleries, calendars, and other publications including the San Diego Natural History Museum, *Nature's Best Photography*, NBC Nightly News, *The Kiteboarder*, and more. Josh teaches photography, both privately and for the Digital Photo Academy, and he and his mother, Ellen, have also coauthored *Photoshop CS5 for Nature Photographers* (Sybex, 2010), *See It: Photographic Composition Using Visual Intensity* (Focal Press, 2012), *iPhoto iOS: Tap the Power* (available on the Apple iTunes bookstore, 2012), and more.

Josh continues to develop software in his free time, currently focusing on FlipBook HD, which is movie-making software for the iPad. When not shooting, making cartoons, or coding, Josh can be found kiteboarding.

Ellen Anon got her start in photography around age 5, but for years it remained a hobby as she took a very long fork in the road, earning a PhD in clinical psychology. In 1997, a broken foot forced her to take a break from work as a psychologist and she used the time to study photography. She debated briefly between building a traditional darkroom in her home and creating a digital darkroom. Because she's not fond of being closed up in small dark spaces with strong smells of funky chemicals, she opted for the latter. Ever since, photography has been a two-part process for her. Capturing the images in the field is the first step, and optimizing them in the digital darkroom is the second. Being creative with it is the icing on the cake!

Ellen is now a full-time freelance photographer, speaker, and writer. Her goal with her photographs is to go beyond the ordinary in ways that she hopes stimulates others to pause and appreciate some of the beauty and wonder of our earth. Ellen's images are included in collections in several continents. She is also represented by the Jaynes Gallery and her photos have been showcased in galleries and featured in numerous publications. In addition, she has been Highly Honored in *Nature's Best Photography* Windland Smith Rice International Awards and Highly Commended in the BBC Wildlife Photographer of the Year competition.

Ellen has coauthored nine books including the popular *Photoshop CS5 for Nature Photographers* series and other books mentioned previously. In addition, she has contributed chapters to other books and has created video training materials on photography-related subjects for several companies. Ellen leads photographic and digital darkroom-oriented workshops and is a popular featured speaker at various events. She had been an active member of the North American Nature Photography Association (NANPA) and is an instructor for its high school scholarship program. She is an Apple Certified Trainer for Aperture and is honored to be a member of Nik Software's Team Nik and SanDisk's Extreme Team.

Acknowledgments

For the hints of wisdom that sometimes tag along with the wrinkles of time — Ellen

First and foremost, we both owe our family, especially Jack and Seth, a big thank you for their continued support and encouragement. Neither of us would have made it where we are without it.

Someone once said it takes a village to raise a child. We don't know whether that's true, but it sure feels like it takes a village to create a book like this. Specifically, we want to thank Stephanie McComb, our Acquisitions Editor, and Kristin Vorce, our outstanding Project Editor. It's been a pleasure working with them on this project.

We both want to thank our friends at Apple involved with Aperture, especially Kirk Paulsen and Martin Gisborne as well as all the engineers, for creating such an amazing program that's the core of our workflows.

Josh wants to thank his friends and coworkers at Pixar, including Trish Carney, Jeremy Lasky, Patrick Lin, Eben Ostby, and Adam Habib. You guys always provide great inspiration and are just awesome people. To his friends Michelle Safer and Jeffrey Cousens: Thank you for always being there to provide moral support. Last but certainly not least, he owes his continued gratitude to his high school English teacher Claudia Skerlong for teaching him to write well; although he heard she once said something about the odds of her achieving sainthood for the efforts she put into teaching Josh compared to the odds of his writing a seventh book.

Ellen wants to thank her friends and colleagues who continue to inspire and encourage her, particularly Art Becker and George Lepp, as well as all the readers of our books, who make it possible for us to continue writing. She also wants to thank Dr. Gary Brotherson and Dr. J.P. Dailey for their flexibility and perseverance in ensuring that she can continue to see through the viewfinder in search of the next dramatic image.

Contents

Acknowledgments v

Introduction xiv

chapter 1

How Do I Get Started with Aperture? 2

Welcome to Aperture

This version of Aperture can also open libraries created with iPhoto. With one photo library shared by both apps, you can now move seamlessly between iPhoto and Aperture at any time. Learn more.

Continue

Understanding Why Aperture Is a Key
Part of Your Workflow 4

 Seeing the difference between
 Aperture and iPhoto 4

 Choosing Aperture over Lightroom 5

Working with Aperture's File Structure 6

 Understanding the Aperture
 library and where your files live 7

 Understanding referenced and
 managed files 8

Understanding how images are
organized within Aperture 9

 Original images 9

 Versions 9

 Projects 11

 Albums 11

 Folders 11

 Stacks 12

A Brief Tour of Aperture's Interface 13

 Understanding the Inspector,
 Browser, and Viewer 13

 Inspector 14

 Browser 17

 Viewer 20

Managing files with Projects
and Albums 21

Using special built-in views 23

 All Projects 23

 Faces and Places 24

 Photo Stream 24

 Aperture Trash 25

Using gestures 25

Basic Customization Options 26

 Setting library location and other
 General preferences 26

 Changing appearance preferences 27

Changing default import behavior 28

Modifying preview preferences 29

Understanding Unified iPhoto and
Aperture Libraries 54

Dragging and Dropping Files into
Aperture 58

Using Photo Stream 59

chapter 2

How Do I Import Images? 30

Importing from a Memory Card,
Camera, or Hard Drive 32

 Touring the Import panel 32

 Using the different views in the
Import panel 34

Choosing Import Settings 37

 Configuring a destination project
for your images 38

 Using referenced or managed files 40

 Renaming files on import 42

 Fixing time zone settings on your
images 44

 An introduction to presets 45

 Setting up and applying a
Metadata Preset on import 45

 Setting up and applying an
Effect Preset on import 48

 Configuring what types of files
to import 50

 Working with RAW+JPEG pairs 51

 Running actions automatically
after importing 53

 Setting up an automatic backup
on import 53

chapter 3

What Methods Can I Use
to See My Images? 60

Customizing the Interface 62

 Rearranging and grouping
library items 62

 Using Viewer modes 64

 Using the Viewer with multiple
monitors 65

 Using multiple Browsers 66

 Showing hot and cold areas
of an image 67

Taking a Closer Look 68

 Zooming and scrolling in Viewer 68

 Using and customizing the Loupe 70

Viewing in Full-Screen Mode 72

 Using Browser and Viewer in
full-screen mode 73

 Working with the filmstrip
and toolbar 74

 Working with heads-up displays 76

Additional Viewer Options 77

Using Primary Only 77

Using Quick Preview 78

Viewing the original image 79

Configuring and Using Metadata Overlays 80

Switching between RAW+JPEG Originals 82

Working with Referenced Images 83

Identifying and managing referenced images 83

Reconnecting a missing original 84

Relocating referenced originals 85

Converting referenced originals to managed originals 87

Deleting referenced files 87

Working with Stacks in Browser 88

Creating and Working with a Light Table 90

chapter 4

How Can I Use Metadata to
Organize and Find My Images? 94

Using Ratings to Sort Images 96

Setting ratings 96

Working with rejected images 98

Using Flags and Labels to Further Organize Images 99

Setting flags and labels 99

Customizing label names 101

Using the Info Inspector 102

Switching and customizing metadata views 104

Setting metadata 107

Managing and applying presets 107

Adjusting Date and Time after Import 109

Working with Keywords 110

The Keywords control bar 112

Editing button sets and keywords 113

Keywords library 113

Customizing button sets 115

The Keywords heads-up display 116

Adding Custom Metadata 117

Applying Batch Metadata Changes 117

Using the Batch Change tool 118

Using the Lift and Stamp tool 119

Searching for Images 120

Searching within Browser 120

Creating Smart Albums 122

Searching with stacks 124

Writing IPTC Information to an Original 125

chapter 5

How Do I Use Faces and Places
to Categorize My Images? 126

Using Faces 128

Enabling Faces 128

Using the Faces interface 129

Assigning names using Faces 130

Assigning names using the
Name button 133

Correcting a name 134

Finding people using Faces 135

Using Places 137

Enabling Places 137

Assigning locations to photos 137

Dragging images onto the
map using Places 139

Using the Info Inspector map
to assign a location 141

Using the search option in
Places to assign a location 142

Creating and assigning custom
locations 143

Assigning locations using
iPhone GPS information 144

Assigning locations using
GPS receivers 146

Assigning location information
using Projects view 147

Moving a pin 148

Removing location information
from an image 148

Finding images using Places 149

What Tools Can I Use to Make My Images Better? 154

Getting Started with Adjustments 156

Reprocessing originals for
Aperture 3.3 or later 156

Setting preferences for making
adjustments 158

Making Adjustments 162

Commonalities of all the adjustment
bricks 162

Working with the histogram 163

Straightening an image 164

Cropping images 166

Using Auto Enhance 167

Using the adjustment bricks 169

Setting white balance 169

Using the Exposure controls 172

Taking advantage of the
Enhance tools 176

Using the Highlights & Shadows
adjustments 181

Using Levels 182

Taking advantage of the Color
controls 184

Sharpening the image 186

Adjusting the Raw Fine Tuning 187

Taking advantage of Curves 190

Converting an image to
black and white 194

Converting an image to a color
monochrome or sepia 195

Adding or removing a vignette 196

Removing chromatic aberration 197

Removing noise 198

Using iPhoto Effects 199

Brushing adjustments in or out 200

Using Quick Brushes 202

Using the Retouch Brushes 202

Using the remaining Quick Brushes 204

Creating and Using Effects 211

Using an External Editor 214

Using Third-Party Editing Plug-Ins 215

Using Aperture's Print Dialog 224

Configuring a standard print 225

Layout and Margins 226

Rendering 227

Image Adjustments 229

Image Options 230

Metadata & Page Options 230

Creating a contact sheet 231

Using built-in custom presets and
creating your own 232

Clicking the Print button and
its settings 234

Ordering Prints 235

Creating a Book 236

Creating a new book album
and picking themes 236

Navigating the Book Layout Editor 238

Placing images and text 239

Adjusting metadata boxes 241

Configuring item options 242

Working with Browser's
extra book features 243

Using maps 244

Switching page styles 247

Adding and removing pages 248

Customizing page layout 248

Editing master pages 250

Printing or ordering your book 251

chapter 7

What Options Do I Have to Create
a Physical Copy of My Photos? 218

Color Management 220

Calibrating your monitor 221

Calibrating your printer 222

Soft proofing 222

chapter 8

How Can I Share My Images Digitally? 254

Exporting Originals and Versions of Images 256
 Exporting originals 256
 Folder and filename options 257
 Metadata options 259
 Exporting versions 260
 Managing Image Export Presets 261
 Adding watermarks 263
E-mailing Images 264
Setting Your Desktop Image 265
Creating Slide Shows 265
 Creating a new slide show 265
 Creating a custom slide show preset 266
 Using the Slideshow Editor 267
 Arranging a slide show 269
 Adjusting the show's settings 269
 Adjusting individual slide settings 270
 Adding video clips 273
 Adding music 273
 Playing and exporting your shows 274

Creating Web Pages 275
 Comparing web journals, web pages, and Smart Web Pages 275
 Creating and configuring a new web page 277
 Creating and configuring a new web journal 280
Facebook 282
 Setting up Facebook access within Aperture 282
 Publishing images from Aperture to Facebook 283
 Managing your Facebook account 284
Flickr 285
 Setting up Flickr access within Aperture 285
 Publishing images to Flickr 286
Using Other Export Plug-ins 287

chapter 9

How Can I Use Aperture with My HDSLR's Video Files? 290

How Does Aperture Handle Video Files? 292
Importing Video Files 292
Viewing Video Files 293

Editing a Clip 294
 Setting the clip's poster frame 294
 Trimming the clip 295
Exporting a Video Clip 296
Working with Audio Files 296
 Importing audio files 296
 Playing audio 296
 Attaching and detaching audio files 297
 Attaching audio files 297
 Detaching audio files 298

Working with Multiple Libraries 306
 Switching libraries 306
 Moving images between libraries 307
 Exporting a library 308
 Importing a library 309
 Working with multiple computers 310
Controlling Tethered Shooting 311
 Configuring a tethering session 312
 Running a tethering session 312
Customizing Keyboard Shortcuts 313
Using Aperture with Automator 315
Using Vaults and Backup 319
 Using vaults to back up your images 320
 Creating a vault 321
 Updating a vault 321
 Restoring from a vault 322
 Deleting a vault 322
 Alternate backup strategies 323
 Time Machine 323
 Other physical storage 324
 Online backup 324
Using Aperture's Database Repair Tools 326

chapter 10

How Can Aperture Make My Workflow Smoother?

300

Understanding Badge Meanings 302
Managing Photo Previews 304
 Controlling preview preferences 304
 Generating previews 305
 Previews and stacks 306

Introduction

In many ways, Aperture needs no introduction. It's professional photo management done by Apple, the same folks who brought you iPhoto, iPhone, iPad, and more. We could lavish it with praise for the next few hundred pages and describe to you how happy we are with the photographic workflows we've developed with Aperture, but while that praise would be completely true (perhaps garnished with a touch of hyperbole to add some humor), that wouldn't leave much room to explain how Aperture can help your workflow. Instead, we'll simply say that Aperture has helped us optimize our digital workflows more than any other piece of software (and between the two of us, we've tried them all) so that we can quickly process thousands of images and spend more time shooting and less time at our computers. The latest revisions to Aperture continue to make it more powerful and user friendly.

When you first look at it, though, it's tough to understand how this neutral-gray window can do so much, and more importantly, what all these weird words like *stacks* and *projects* mean. Don't worry: We're here to help.

The next few hundred pages will take you through Aperture, from understanding the basic terms in Chapter 1 to using skin tone mode to remove a color cast in Chapter 6 to creating books that include a map showing where you took your photos in Chapter 7 to advanced backup topics in Chapter 10. As you read, we encourage you to import some images and videos into your Aperture library and to try clicking the buttons we describe for yourself.

Don't feel obligated to read this book from start to finish, however. While we've tried to build the text so that the chapters follow roughly a digital workflow order and build on each other, feel free to skip around, especially if you've used Aperture before.

Finally, while it's easy to sometimes feel overwhelmed by all the features in a program like Aperture, don't be. There's no test at the end of this book, and you don't have to use every possible feature to its fullest to integrate Aperture into your workflow. That's part of what's so great about Aperture — it's flexible enough to fit into your workflow instead of forcing you to fit into its workflow.

How Do I Get Started with Aperture?

Aperture is like iPhoto on steroids in some ways; but in other ways, it's a completely different beast. Unlike iPhoto, it's designed to be an incredibly flexible image, video, and audio file asset management tool that you can integrate into your existing workflow. However, this flexibility means that Aperture has more jargon, settings, and buttons than iPhoto. This chapter helps demystify Aperture's jargon and shows you key fundamentals you need to know when using Aperture.

Understanding Why Aperture Is a Key Part of Your Workflow......... 4

Working with Aperture's File Structure 6

A Brief Tour of Aperture's Interface 13

Basic Customization Options 26

Understanding Why Aperture Is a Key Part of Your Workflow

Most photographers agree that the time you spend behind the lens shooting is the best part of being a photographer, and all the other stuff (processing an image, categorizing it, trying to sell it, or using it to promote business) is really just annoying. While digital photography enables you to be more creative as a photographer, from being able to see right away whether you got the shot to being able to experiment as much as you want with the only cost being hard drive space, the "other stuff" arguably gets more frustrating because now you have to manage digital files instead of physical film and learn to use multiple programs to develop and output your images. That's where Aperture comes into play. Aperture is a central point for all of your image management from the moment you download an image from camera to computer until you search for an image and click Print to make a physical copy for a client. Aperture makes it relatively easy and fast to organize and manage your digital files, and that lets you spend more time having fun shooting. However, Aperture isn't the only digital asset management tool out there. Let's look at what Aperture gives you over iPhoto and Lightroom.

Seeing the difference between Aperture and iPhoto

If you've been using iPhoto to manage your images, then you know that our explanation of why Aperture is a key part of our workflow could apply to iPhoto, too. While iPhoto is great for managing images of your family and friends taken with your point and shoot, it's really limited when you put it under a microscope. For example, while you can make basic retouching adjustments in iPhoto like a levels adjustment, Aperture lets you fine-tune those adjustments to develop your image exactly the way you want it to look, perhaps adjusting the levels in just one color channel or using the quarter tone controls (which we cover in Chapter 6) to adjust the levels in a specific part of your image. If you really like the effect your adjustment creates, you can save it as a preset to easily apply to other images, even on import. Aperture 3 has the ability to brush those adjustments selectively onto just part of your image, meaning you can make one levels adjustment in the sky and another on the ground, something iPhoto just can't do. Oh, and if you prefer using curves to levels, Aperture 3 has a curves adjustment, too.

However, more advanced image-adjustment controls aren't the only difference between iPhoto and Aperture. Aperture provides tools to manage a far larger library than iPhoto can manage. For example, Aperture lets you make complicated searches for images, such as the search in Figure 1.1 that finds all your top-rated images taken in 2010 in San Francisco that have the keyword *water*. If you want to know specifics about Aperture's tools to help categorize and search for images, check

out Chapters 5 and 6. Aperture is also a lot more flexible with managing your photos, and unlike in iPhoto, images in Aperture can easily be stored on multiple hard drives. Aperture 3 also adds great new tools to merge and split off collections of images, making it easy to share image collections between two machines.

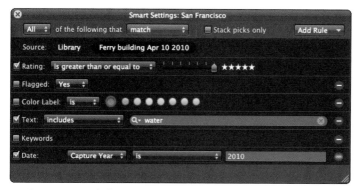

1.1 An image search that's easy to do in Aperture but just not practical in iPhoto.

Lastly, while there are similar features in iPhoto and Aperture, like Faces, Places, books, and slide shows, they are just more powerful in Aperture. Aperture's Book tool, which is covered in Chapter 7, has advanced layout options that let you completely customize the image and text boxes on your page, or even use a photo to create a two-page background spread. Aperture's slide shows, explored in Chapter 8, let you go beyond iPhoto's click-and-play slide shows, creating custom titles, transitions, and music. You can even include HD video within an Aperture slide show.

Fortunately, starting with Aperture 3.3, iPhoto and Aperture have a unified library and adjustment format. This means you can seamlessly move between the two programs using the same library data. As an example, you could use Aperture to split your library over multiple drives and to adjust your images, and then you could switch to iPhoto, load up that same library displaying your adjusted images, and then order a card or calendar, something you can't do in Aperture.

In summary, while iPhoto is great for the casual consumer, just as you move from a point-and-shoot camera to a dSLR to upgrade your photography, moving to Aperture from iPhoto lets you upgrade your image-management tools.

Choosing Aperture over Lightroom

For many photographers, Adobe Photoshop is the number one program for image work, and we certainly agree that it's a great image-manipulation program (although Aperture's adjustment tools combined with third-party Aperture plug-ins have made it so that we do more than 90

percent of our manipulation work in Aperture instead of Photoshop). You might be asking yourself why you shouldn't just use Adobe products, such as Adobe Lightroom.

While in some ways the Lightroom-versus-Aperture debate is a bit like a religious Mac-versus-PC debate, there are specific reasons that we find Aperture to be a much better choice than Lightroom for our workflows. The main reason is that Lightroom has different modules that you must switch between for different tasks, whereas Aperture does not. Practically speaking, adjustments affect editing decisions, and it's faster to make those decisions in Aperture than in Lightroom. For example, you may frequently look at an image and say, "This is good, but if I straighten it, will it be great?" In Aperture, you can use one keyboard shortcut and then drag the mouse to straighten the image. In Lightroom, you need to switch from the Organize to the Develop module, adjust the image, and then switch back to the main module to continue making editing decisions. Less time having to switch modes to make a decision means more time shooting and having fun!

We prefer Aperture for specific, technical reasons as well. One is that Aperture has a more powerful hierarchy (we dig into the specific parts of its structure shortly) that you can customize, such as moving albums wherever you want them to be, whereas Lightroom has a relatively flat hierarchy with limited customization options. In Aperture 3, like in Lightroom, you are able to brush adjustments onto an image, but Aperture provides far more control over how those adjustments are applied, such as only affecting the highlights or shadows. Furthermore, only a few adjustments in Lightroom can be brushed onto an image, whereas most adjustments in Aperture can be selectively applied. Aperture's curves control is far more powerful than Lightroom's parametric curves, too. Some tools, such as book authoring, have been in Aperture since the first version and have undergone a lot of refinement, whereas in Lightroom they are just appearing and are not as mature. Then there are also features that Lightroom just doesn't have, such as Faces.

We should mention that while we far prefer Aperture to Lightroom, Lightroom is not a bad program, and if you have a PC, it's a very good choice. However, if you have a Mac, we enthusiastically recommend that you use Aperture.

Working with Aperture's File Structure

If you've used a program like Bridge before (one that is essentially an image viewer and metadata editor for the files on your drive), then you're accustomed to the folder hierarchy on your hard drive being exactly what you see in Bridge, and when you move images around within Bridge or make new folders, it also creates new folders and moves files around on your hard drive for you. Programs such as Aperture (and Lightroom) take a different approach. Your images live in a

particular location on your hard drive (more on this in a minute) and appear within a different structure within Aperture. When you move images around within Aperture, between albums for example, they don't move around on your hard drive (although there are special commands to let you move the files around), and when you create a new folder within Aperture, that folder doesn't actually exist on your hard drive. Let's take a minute to explore how Aperture stores files and the different terms for the various collections of images.

Note

We frequently use the word *image* to talk about any file in Aperture, including movie and audio files, as Aperture treats them all in essentially the same way, especially as far as the file structure is concerned.

Understanding the Aperture library and where your files live

One of the fundamental concepts in Aperture is a library. A library refers to a collection of images. On your hard drive, a library, like the one in Figure 1.2, stores and tracks information about an image, ranging from the various-sized thumbnails that Aperture uses to display the image to the image's metadata, information about the faces in your images, and information about what adjustments you've made to an image. If you choose, Aperture will also store your image files themselves within a library (more on this in a minute), but your image files can also live outside the library instead. An Aperture library appears as a bundle within the Finder (a bundle is a special type of folder that appears as if it were a single file) and discourages you from digging inside your library. If you dig inside your library, you might accidentally do something, such as move a key file, which causes a problem in Aperture.

Unlike in iPhoto, where most users tend to just have one photo library, you will most likely have multiple libraries with Aperture. For example, you could have a library on an external drive containing every image that you've ever taken and a second library on your laptop's internal hard drive that has a library with images from the previous shoot or two.

By default, Aperture creates a library in your Pictures folder. Chapter 10 explains how to work with multiple libraries.

Genius

When Aperture is closed, double-click on a library in the Finder to launch Aperture with the contents of that library.

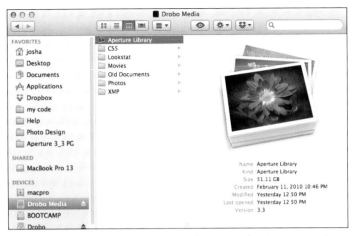

1.2 An Aperture library as seen in the Finder. Notice that it appears as just a single file, even though it contains other files within.

Understanding referenced and managed files

Referenced and managed files refer to where your image files are stored. Put simply, referenced files are stored in whatever folder on your hard drive you select, and Aperture stores a reference to their location within the library. If you move the files around on your hard drive, you have to tell Aperture to update its reference (we cover working with referenced files in depth in Chapter 3). Managed files, on the other hand, are stored within the Aperture library. You don't need to worry about where they are on your hard drive because they'll always just be inside your library, and if you want to access the image files you must do so via Aperture rather than the Finder.

Choosing to use referenced or managed files is largely a personal choice, and within Aperture they are treated exactly the same. The main benefit to managed files is that you don't have to worry about into what folder on your drive you're importing your images because they're all just going into your Aperture library. You might find it preferable to use managed files because they help prevent you from losing track of your images.

However, the main benefit to referenced files is that you can store your images wherever you want, even on a separate hard drive. Aperture stores previews of your images inside the library that you can view in Aperture, even if the full image files can't be found. This means that you can keep your full Aperture library on your MacBook Pro's hard drive so that you can always have your images with you, but you can store all the large image files on a large, external drive.

Referenced files that you see in Aperture but whose image files can't be found are called *offline images*. Aperture indicates an offline image with the badge overlay indicated in Figure 1.3.

A second benefit to referenced files is that if you want to use another program to work with your images, such as Adobe Photoshop, without going through Aperture, you can because your image files are not locked away inside of the library bundle. Just be careful about reorganizing your image files outside of Aperture. If you move the file on your hard drive, you need to tell Aperture where the file's new location is so that it doesn't think the image is offline. Chapter 3 covers working with referenced files in depth.

1.3 When this badge overlay appears over a thumbnail in Aperture, it indicates an offline image.

Last, if you use an online backup service like CrashPlan or Mozy, we recommend using referenced files so that if Apple updates the internal library format and changes where the managed images are stored, these backup services won't have to upload a new copy of every image to the cloud.

Understanding how images are organized within Aperture

Aperture has special terms to explicitly describe which image you're working with: the *original* file on disk or a *version* within Aperture. Furthermore, a key concept to understand about Aperture is that files within Aperture have their own hierarchy that isn't guaranteed to be anything like the file hierarchy on your hard drive. When you move an image around within Aperture, it doesn't also move it between folders on your hard drive. As such, Aperture has a special vocabulary to describe how originals and versions are organized into projects, albums, folders, and stacks.

Original images

An original is the initial file you import into Aperture, whether it's a RAW, JPEG, TIFF, DNG, and so on. Aperture never modifies the original file; you can always return to your original image no matter how many adjustments you make within Aperture.

Versions

A version is a representation of an original file that you work with within Aperture. It refers to the original file but is not the original file. No matter how many changes you make to a version, you aren't changing the original. This is called nondestructive editing.

Something special about Aperture is that you can make multiple versions of an image with different adjustments applied to each, as shown in Figure 1.4. And unlike iPhoto, which makes a full copy of the original file each time and uses a lot of hard drive space, Aperture only stores the changes you make to each image, saving hard drive space. (This alone is a great reason to use Aperture for all of your adjustments, even if you use iPhoto for everything else.) Then, when you ask to see a particular version, Aperture loads the original behind the scenes and applies the changes you made to create this version.

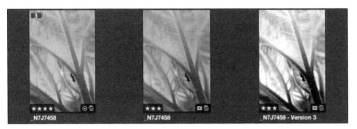

1.4 All three versions of this image share the same original file, and each new version only takes a few kilobytes more hard drive space to create.

Working with versions can get a little confusing. Although all of Aperture's built-in adjustments are nondestructive and are stored as information on top of an original file, Aperture also supports third-party adjustment editors such as plug-ins to create High Dynamic Range (HDR) images, as well as external editors like Photoshop. In order for these third-party programs to see the adjustments you make to an image, Aperture makes a TIFF or PSD file from your version for the other tool to work with. This means that if you make a bunch of adjustments to an image within Aperture and want to open it in Photoshop, rather than trying to describe to Photoshop how Aperture converted the RAW file and then also convey to Photoshop the changes you made on top of the converted file, Aperture just collects everything, makes a new TIFF file, and then tells Photoshop to open that TIFF file.

Genius Even if you're using referenced files, this new file that Aperture makes from your version will be stored within your Aperture library. You can relocate the Aperture-created original wherever you want after it's created, as discussed in Chapter 3.

This new version has an original file on the hard drive, but it's not the original file that you imported from your camera, and this version with its new original consumes far more hard drive space than a normal version because it isn't just a small bit of data describing what changes you made.

If you see the badge overlay indicated in Figure 1.5 within Aperture, it means that this version also has an Aperture-created original aside from the original file you imported.

Projects

Within an Aperture library, you group your original files and versions into projects. A project might represent an entire shoot, multiple shoots of the same subject, a part of a shoot, or just a completely random collection of images. Each time you import an image, you must determine into what project to place it. If you delete a project, you are removing the original files contained within it from your library. There is no limit on how many projects you can create. If you open your Aperture library in iPhoto, a project appears as an event, and vice versa.

1.5 This badge overlay on a thumbnail or image means that this version has an Aperture-created original.

Albums

Albums are a collection of image versions that you create manually. Versions may exist in more than one album (for example, you might put an image in both a *Brooks Wedding Dinner* album and a *Show to Bride* album). Albums can either exist within a project to provide a finer-grained grouping of images or at a library level if they contain images from multiple projects. For example, we typically create a project for a shoot such as *Japan – February 2012* and then create albums within the project to represent specific parts of the shoot such as *Tsurui Day 3 AM*. Later, we create a library-level album, such as *Images to Copyright,* containing images from every project that we need to submit for copyright registration. No matter how many albums within a library you put an image into, Aperture does not create a new copy of the original file on disk. Furthermore, deleting an image from an album does not remove it from your library or hard drive.

There are special types of albums, called Smart Albums, whose contents are created dynamically. For example, Aperture has built-in Smart Albums at the library level (called Library Albums) for 5-star images (the highest rating you can give), videos, images created in the last week, and more. Each time you add or adjust an image and make it meet one of these criteria, such as rating an image with 5 stars, Aperture automatically adds it to the appropriate Smart Album. Smart Albums are covered in depth in Chapter 4.

Folders

A folder is a container for projects, albums, and other folders. As you create more and more projects, you may find it helpful to use folders to group related projects together so that you're not

always scrolling through a long list of projects. For example, we have a folder in our library called Antelope Valley (shown in Figure 1.6) that contains projects for each time we've shot at that location.

Stacks

While not strictly part of Aperture's hierarchy, Aperture calls a small collection of images that are related in some way a *stack*. The difference between a stack and a project or album is that a stack of images tends to essentially be one image, but just slightly different versions of that image, whereas a project or album might contain many stacks of images.

For example, Aperture can automatically group bursts of images taken close together into a stack. If you shoot a sporting event and import the images into one album, you would have many stacks representing each burst of action. Additionally, if you want to create multiple versions of a single image with different adjustments, you could group these different versions into a stack for organization. Each time you open your image in an external editor such as Photoshop, Aperture automatically stacks the previous version and this new externally edited version together. Stacks are covered in more detail in Chapter 3.

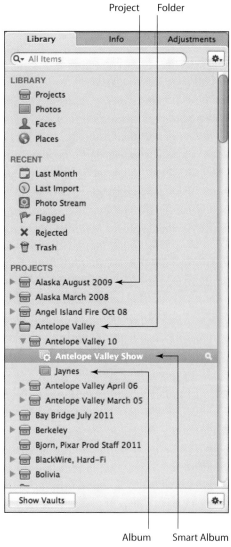

1.6 Here's what part of our Aperture library looks like. Notice how projects, albums, and folders all have different icons, how folders help us organize our library, and how we have albums at both the library and project levels.

A Brief Tour of Aperture's Interface

Now that you've learned some of Aperture's basic jargon, let's look at Aperture itself. The first time you launch Aperture, you see the Welcome screen in Figure 1.7. Click Continue to close this window to begin using Aperture. The main parts of the interface you see right away are the Inspector, Browser, and Viewer, and this section explores these pieces in depth and explains how to work with the Library Inspector, which you use to manage Aperture's file hierarchy.

1.7 Aperture's Welcome screen.

Understanding the Inspector, Browser, and Viewer

The three key parts of Aperture's interface are the Inspector, the Browser, and the Viewer. These three areas are shown in Figure 1.8.

Viewer

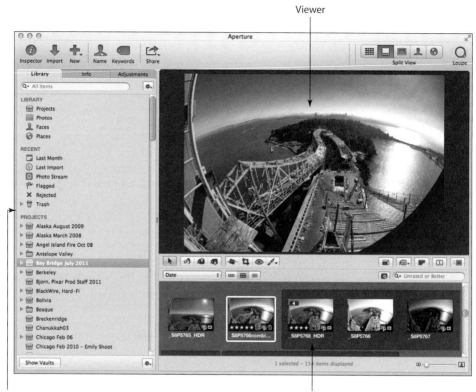

Inspector Browser

1.8 Three areas of the Aperture interface that will serve you well.

Inspector

The Inspector has three tabs within it to let you inspect different items. The initial tab is the Library tab. The Library Inspector has four groups, as shown in Figure 1.9. At the top is a library-wide group that lets you see all your projects, all your images, every face in your library, and more (we discuss this section shortly). Below that is the Recent group that has images you've worked with recently as well as flagged images and rejected images. This group also has the iCloud Photo Stream collection (covered in Chapter 2) as well as Aperture's Trash. Next is the Projects group. This has all of your projects (or iPhoto events), folders of projects, and items within projects. Last is the Albums group, which contains library-wide albums as well as built-in Library Albums — Smart Albums that search your entire library for certain groups of images.

To create an empty project, choose File ⇨ New ⇨ Project. To create an empty album within a Project, select that project and choose File ⇨ New ⇨ Album. To create an empty, library-level album, do one of three things:

- Deselect everything in the Library Inspector before running this command.

- Select an item, such as Photo Stream, not within the Projects group and choose File ⇨ New ⇨ Album.

- Click and drag a project-level album out of the project and into the Albums group.

To create a new folder, choose File ⇨ New ⇨ Folder.

At the very top of the Library Inspector is a search field that filters the contents of the Library Inspector. This search field does not search inside the metadata of your images. It simply searches your project, album, and folder names for a match. Next to the search field is an Action pop-up menu. This menu contains the following four commands:

1.9 The Library, Recent, Projects, and Albums groups within the Library Inspector.

- **Add to Favorites/Remove from Favorites.** Over time, you will end up with many items in your Library Inspector. To filter the list so that you only see your favorite items, select Favorite Items from the search field's pop-up menu. To mark an item as a favorite, select it in the Library Inspector and choose Add to Favorites from the Action pop-up menu.

- **Keep Albums & Projects Arranged By.** This submenu affects how items at the same level (such as all the top-level items, all the items directly under a project, and all the items directly within the same folder) are sorted within the Library Inspector. Choose

Name from this submenu to sort all the items in the Library Inspector alphabetically. Choose Kind to group the items by kind (for example, all projects will be grouped together, all folders will be grouped together, and so on). Choose Manual so that you can drag and drop items to rearrange them however you want. Even if you choose Name or Kind, you can manually rearrange an item at any point and Aperture will automatically switch to Manual sorting.

- **Export Project/Folder/Album as New Library.** We cover this topic more in Chapter 10, but the quick explanation is that any item in Aperture can be exported as a new library to make it easy to share groups of images.

- **Maintain Previews for Project.** By default, Aperture maintains large previews of your images for use in other applications such as iWork. However, these previews can take a lot of hard drive space, and it's often useful to not maintain them for an entire project. We cover previews and this command more in Chapter 10.

At the very bottom of the Library Inspector is a button marked Show Vaults and another Action pop-up menu with vault-related commands. Vaults are special Aperture-created backups of your library. We cover Vaults and other backup options in Chapter 10.

By clicking the Info tab at the top of the Inspector, you switch from the Library Inspector to the Info Inspector. As you might expect, this inspector allows you to view and edit information about your image, information that's also referred to as *metadata*. This inspector is covered in depth in Chapter 4. The last tab, Adjustments, lets you switch to the Adjustments Inspector, which contains tools to adjust your image. The Adjustments Inspector is covered in Chapter 6.

If you're working on a small screen, it's often useful to hide the Inspector and to only show it when needed. To hide the Inspector, choose Window ⇨ Hide Inspector; to reveal it, choose Window ⇨ Show Inspector. The keyboard shortcut for hiding and showing the Inspector is I (with no modifiers). There are menu commands for quickly switching to the Library, Info, and Adjustments Inspectors under View ⇨ Inspector, but more useful are the keyboard shortcuts to switch to those views: Control+P for the Library Inspector (think P for Project), Control+D for the Info Inspector, and Control+A for the Adjustments Inspector. W (with no modifiers) is also a keyboard shortcut for View ⇨ Inspector ⇨ Next Tab, which lets you quickly cycle among Inspector tabs.

Note

If you're working with a tablet display like a Wacom Cintiq, you might find it useful to move the Inspector to the right side of the screen. Choose View ⇨ Inspector ⇨ Swap Position.

Browser

The Library Inspector lets you switch between collections of images within your library, and the Browser lets you see the contents of those collections. The three views within Browser are Filmstrip, Grid, and List, which you can switch by clicking the view buttons marked in Figure 1.10. Filmstrip (the default) and Grid are similar in that they both show primarily thumbnails of your image (we cover customizing what other data you see in Chapter 3), but Filmstrip only has one row of images that scrolls from side-to-side. Grid view arranges your images into a grid that you scroll up and down. List view turns Browser into a table where each column has a different piece of metadata, such as the image's date, aperture, and shutter speed. Another way of switching views is to choose View ➪ Browser ➪ Filmstrip (Control+F), Grid (Control+G), or List (Control+L). In Grid and List views, there is a thumbnail size slider that lets you make the displayed thumbnails larger or smaller. In Filmstrip view, use the Split view control, as described shortly, to resize the thumbnails.

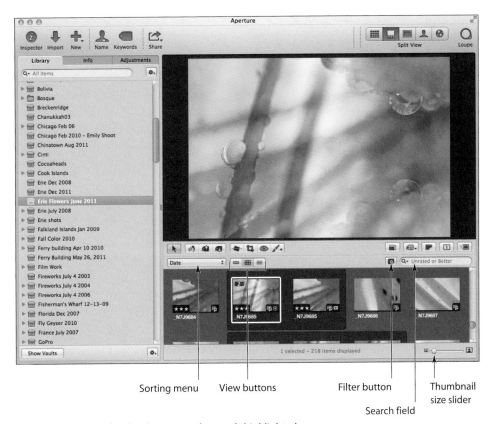

Sorting menu View buttons Filter button Thumbnail size slider

Search field

1.10 Browser with a few key buttons and controls highlighted.

Browser also has a sorting pop-up menu that lets you determine how your images are sorted, be it by date, rating, or more. Switch between Ascending and Descending in the Sorting pop-up menu to change the sort direction. When in List view, you can also click the column header to sort by that criteria, and click the header again to change the sort direction. If you prefer, it's also possible to manually arrange the images by clicking and dragging an image (or group of images) wherever you want it to be. If for some reason the sorting and filtering controls aren't visible, choose View ⇨ Browser ⇨ Show Sort and Filter Controls (⌘+Shift+F). Similarly, if you want to hide those controls, choose View ⇨ Browser ⇨ Hide Sort and Filter Controls.

Caution If you start to work with your images in the Browser while Aperture is still importing your images, it tends to revert to Manual sorting. We highly recommend making sure you're sorting by Date when editing your photos so that it's easier to see sequences of images.

At the top right of Browser is a search field. As you might expect, if you start typing in it, Browser filters its contents to only show images whose name or other metadata match the text you're typing. If you click on the search field's pop-up menu, you will see commands to quickly filter Browser based on image ratings and labels. By clicking the Filter button to the left of the search field, you open the Filter dialog, as shown in Figure 1.11, which lets you refine your filter even further. This is covered more in Chapter 4, but this control is where you can make advanced queries like "filter Browser so that it only shows images taken last Tuesday containing Eric's face."

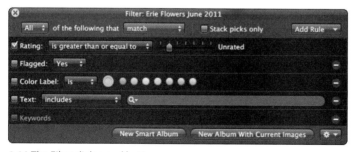

1.11 The Filter dialog and button.

Sometimes, when looking for an image, you'll find it useful to make Browser larger. There are two ways to do so. If you're working in Split view, which has both Browser and Viewer on-screen at the same time, click the dark line between Browser and Viewer and drag it up and down to adjust

Browser's size. Note that if you're using the Filmstrip view, Aperture just makes the thumbnails larger when you adjust the split. Switch to Grid view to see more images in Browser. Unfortunately, Aperture only lets you drag Browser so that it takes up about 60 percent of the screen. To hide Viewer and make Browser take the entire screen, click the Browser button in the toolbar indicated in Figure 1.12 (if for some reason the toolbar is hidden, click the pill-shaped button at the top right to reveal it). To return to the previous view, click the Split view button in the toolbar. Note that when you're in Browser mode, you can only switch between Grid and List views, not Filmstrip. If you're comfortable using keyboard shortcuts, press V to cycle among Viewer and Browser, Viewer only, and Browser only.

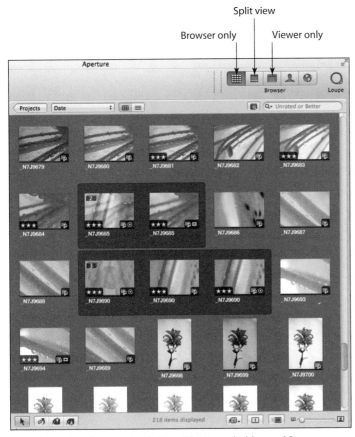

1.12 This is what Aperture looks like with Viewer hidden and Browser maximized. Note the Browser and Split view buttons in the toolbar that let you toggle layouts.

Genius

In Browser, you can use keyboard shortcuts to quickly scroll through your images. Press L to scroll forward, J to scroll backward, and K to stop scrolling. Press L and J multiple times to scroll faster in their respective directions. Make sure to click inside of Browser so that it has focus before using these hotkeys.

If you prefer to see your thumbnails in a vertical Filmstrip rather than a horizontal one, it's possible to rotate Browser by choosing View ➪ Browser ➪ Rotate Position (Shift+W). Like Inspector, it's also possible to swap which side of the screen Browser's on (as shown in Figure 1.13) by choosing View ➪ Browser ➪ Swap Position (Option+W).

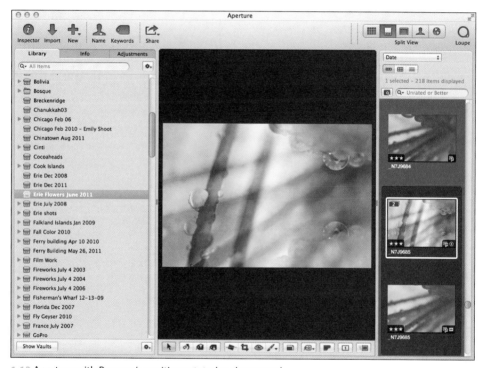

1.13 Aperture with Browser's position rotated and swapped.

Viewer

Viewer, the last key part of Aperture's interface, is where you see the full contents of your image (or selected images). When you select an image in Browser, Aperture loads the full contents of that version, displaying a "Loading" indicator while doing so, and displays it in Viewer. Many tools in Viewer help you examine your image in detail, from zooming in to 1,000 percent to quickly

switching between seeing the original image and the current version with your adjustments. Viewer is covered in depth in Chapter 3.

Aperture also has an excellent full-screen mode for Browser and Viewer that removes any distraction and lets you focus on your images. We explore this mode in depth in Chapter 3.

Managing files with Projects and Albums

As mentioned earlier, Projects are where your images and originals truly live. Making a new project is quite easy. To move a group of images into a new project, do the following:

1. **Select the images in Browser that you want to use for the new project.**

2. **Choose File ⇨ New ⇨ Project (⌘+N).** Aperture displays the New Project dialog, as shown in Figure 1.14.

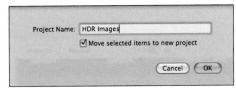

3. **Type the project name.**

4. **Select the Move selected items to new project check box if you want to move your selected images into the new project.**

1.14 The New Project dialog.

5. **Click OK.**

Another very common task in Aperture is to make a new, empty album at the project or library level and then move images into it. For example, we might make a *Submit to Agency* album and then drag whatever images we want to submit to our stock agent into that album. Another common task is to prepopulate a new album at the project level with the images you've selected in Browser, such as if you select all the images of a certain subject and want to make a new album just for that subject. These tasks are straightforward and similar to making a new project.

1. **Choose one of the following options to begin creating an album:**

 - **To make an empty album, select the project in the Library Inspector where you want the album to live.**

 - **To make a new album from a group of images, select the images in Browser that you want to put into the album.** Aperture creates the new album at the same level as the currently selected item.

 - **To make a library-level album, click on the Projects collection under the Library group instead of selecting a specific project in Library Inspector.**

2. **Choose File ⇨ New ⇨ Album.**
 Aperture displays the New Album
 dialog, as shown in Figure 1.15.

3. **Type the album's name.**

1.15 The New Album dialog.

4. **If you are creating a new album from
 a group of images, select the Add
 selected items to new album check box if you want to add the selected items to the
 album.** If you are creating an empty album at the project level in the Library Inspector or
 at the library level in Albums, leave this check box unselected.

5. **Click OK.**

6. **If the album doesn't appear in the right place, drag and drop it to the right location
 in the Library Inspector.** To drag it to the library level, drag it out of the project and to
 the Albums group and then drop it. To drag it into another project, drag the album until
 a black box appears around the right project. Note that this does not move the original
 files into this new project.

Things get confusing when you start to move images between albums and different projects. To
move images (and videos and other items in your projects and albums) around, select them in
Browser and drag and drop them to the desired destination. Holding down the Option key while
dragging affects what Aperture does with the files in some cases. Table 1.1 explains the situations
you can encounter.

Table 1.1 Effects of Dragging Images between Projects and Albums

Source	Destination	Effect	Effect with Option Key Held
Project	Different Project	Original and all versions are moved to the new project	Original and all versions are copied to the new project
Project	Album in Same Project	Image is copied into the album	Same
Project	Album in Different Project	Image is copied into the new album, but the original lives in the original project	Same
Album	Album in Same Project	Image is copied into the new album	Same
Album	Album in Different Project	Image is copied into the new album, but the original lives in the original project	Same
Album	Different Project	Original and all versions are moved to the new project	Original and all versions are copied to the new project

To quickly reveal which project an image is in from any album, select the image and choose File ⇨ Show in Project.

To remove an image from an album, select it and choose Photos ⇨ Remove from Album (or press Delete). However, removing an image from an album does not move the original to Aperture's Trash. To delete a specific version of an image, whether you're in a project or an album (and by delete we really mean move to Aperture's Trash), select it and choose File ⇨ Delete Version. If the version has an Aperture-created original file, it is deleted, too. If there is only one version of an image, then Aperture deletes the image's original file when you empty Aperture's Trash. However, if there are multiple versions of an image and you want to remove all of them, select the image and choose File ⇨ Delete Original Image and All Versions.

Also note that it's possible to delete an album, project, or folder by selecting it in the Library Inspector and choosing File ⇨ Delete Album, Project, or Folder, respectively. Deleting an album does not delete the contents of an album, but deleting a project (or folder that contains a project) does remove its contents, too.

Using special built-in views

We mentioned earlier that there is a special group at the top of the Library Inspector that lets you access library-wide collections. Specifically, they are Projects, Photos, Faces, Places, Last Month, Last Import, Photo Stream, Flagged, Rejected, and Trash. We discuss these views next with the exception of Photos, Last Month, and Last Import, as these views are straightforward (clicking the Photos item displays every image in your library). Rejected/Flagged items are also not discussed here but are detailed in Chapter 4.

All Projects

Clicking the Projects item opens the All Projects view, as shown in Figure 1.16. This view is similar to the Events view in iPhoto, especially if you click the Group by Year button. Move your mouse over a project's thumbnail to scroll through all the images within a project. If there's a particular image you want to set as the project thumbnail, press the spacebar when the image is displayed.

Genius

A more direct way to set an image as a project's key photo is to Control+click on it in either the Browser or Viewer and choose Set Key Photo.

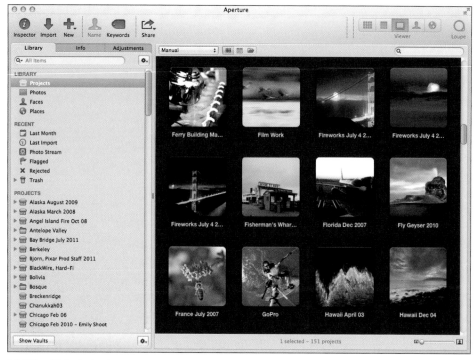

1.16 The All Projects view.

Genius

To merge two projects together, drag and drop one onto the other in the All Projects view.

Click the Info button (which becomes visible when you move your mouse over a project's thumbnail) to display the Project Info panel, where you can add a project description and assign its general location on a map. Double-click on a project's thumbnail to open the project in Browser view.

Faces and Places

Clicking the Faces item provides quick access to the Faces corkboard, with every face Aperture finds in your library. Clicking the Places item takes you to the Places map, with pins for every location you've assigned to a photo. These features are covered in depth in Chapter 5.

Photo Stream

Photo Stream is an iCloud service that automatically syncs up to 1,000 of your most recent images to iCloud. Those images can include pictures you take with your iPhone, images you import to

your iPad with the Camera Connection Kit, and images you import into Aperture. Chapter 2 covers Photo Stream in more detail.

Aperture Trash

When you delete an item in Aperture, whether it's an entire project or a specific image, it's placed into the Aperture Trash, as shown in Figure 1.17. You can view the contents of Aperture's Trash at any time by clicking the Trash item in the Library Inspector and either retrieve something from it or empty it. Click the disclosure triangle next to the Trash group to see the items in the Trash separated out by original location. To empty Aperture's Trash, choose Aperture ⇨ Empty Aperture Trash. Note that if you're using referenced files, you need to select the Move referenced files to System Trash check box because otherwise, Aperture deletes the images from Aperture but leaves the original files in their current location on your hard drive.

1.17 Note how you view Aperture's Trash just like you would any other album.

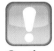

Caution Emptying Aperture Trash does not delete the image from your hard drive. To completely remove it, you must also empty the Trash in Finder. If you want to recover the file, open the Trash in Finder, and within the Aperture folder, there will be a folder for the image's project that contains the original file.

To restore an item from the Trash, either drag it back to the desired location or Control+click on it and choose Put Back.

Using gestures

If you're using Aperture on a portable with a Multi-Touch trackpad or on a computer with a Magic trackpad, a number of gestures will speed up your workflow. We mention any gestures at appropriate places throughout this book, but there are a few general gestures to be aware of. Whenever you see thumbnails of images, such as in Browser or on the corkboard in Faces, use a pinch gesture

to scale the thumbnails. Swipe when in Browser to go to the next or previous image, and if you make a rotation gesture in Browser, Aperture rotates the image beneath the cursor. Viewer zooms in and out of the full image when you pinch. In Viewer and in slide shows, swipe to go to the next or previous image. In the Book Layout Editor, swipe to go to the next or previous page.

Basic Customization Options

To open the Preferences panel within Aperture, choose Aperture ⌤ Preferences. Specific preferences are discussed throughout the rest of the book when they apply, but there are a few key options we want to point out for your initial Aperture setup.

Setting library location and other General preferences

The most basic setting under the General pane, shown in Figure 1.18, is which current Aperture library you're working with. In addition to the ways mentioned earlier to switch libraries (using the commands in File ⌤ Switch to Library), you can also switch libraries by clicking Change and browsing for the new library. Clicking Reveal opens a new Finder window with your current Aperture library selected.

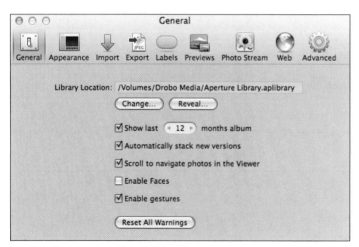

1.18 The General pane of the Preferences panel.

Select or deselect the Show Last *X* months album check box (where *X* is the number of months of images you want to see) to enable or disable the Last Month group under Recent. We find it useful to leave this check box selected so that if we're in a hurry when downloading a card and then forget where we imported an image, we can quickly locate it.

We recommend selecting the Scroll to navigate photos in the Viewer check box so that using your mouse's scroll wheel in Viewer (as long as you're not zoomed in) enables you to go to the previous or next image.

The next option in the General pane is Enable Faces. We highly recommend deselecting this check box, unless you primarily photograph people and use Faces all the time. The reason we recommend disabling Faces is that it slows Aperture down, especially when importing images.

If you have a portable with a Multi-Touch trackpad or a Magic trackpad and want to use gestures within Aperture, make sure to select the Enable gestures check box.

The last key option in the General pane is the Reset All Warnings button. Sometimes, a dialog has an Ask again next time check box or something similar. If you deselect that check box but decide that you really do want to be prompted again, clicking Reset All Warnings makes all the dialogs appear again.

Changing appearance preferences

The second Preferences pane is the Appearance pane, as shown in Figure 1.19. We recommend leaving the brightness levels at their default values, although you might prefer to set your Full Screen Viewer brightness to 18% (which is neutral gray) because the color surrounding an image can influence your perception of an image.

On the bottom half of the pane on the View Slideshows on pop-up menu, we recommend choosing Secondary Display instead of Main Display. That way, if you're presenting a slide show from your laptop while connected to a projector, the show appears on your projector's display.

We highly recommend selecting the Show "Loading…" indicator while full size photos load check box so that you know when the full version of your image is loaded into the viewer. We also recommend selecting the Badge referenced items check box so that you know which of your images are referenced and which are managed. This badge helps avoid accidentally making an image referenced or managed without meaning to and losing the original file. The other options are largely a matter of personal taste.

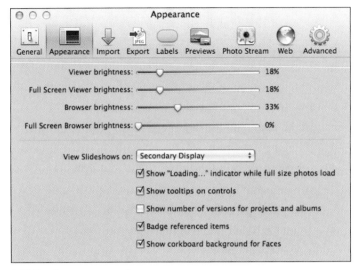

1.19 The Appearance preferences pane.

Changing default import behavior

The Import pane, shown in Figure 1.20, lets you modify the default import behavior. Importing is covered in detail in Chapter 2, but the key option here is what you want to happen when a camera is connected. This pop-up menu allows you to pick between having a specific application open or doing nothing at all. Although you can set this preference within Aperture, it affects your entire system. We typically leave this set to Aperture, but if you sync an iPhone with your computer, we recommend choosing No application so that Aperture doesn't open every time you plug in your iPhone.

1.20 The Import preferences pane.

Starting with Aperture 3.3, you also have the option to have Aperture generate new previews from the RAW files or use the camera-created previews embedded into your RAW files. Using the camera-created previews is much faster, and especially if you're working on a battery-powered portable, selecting that option saves processor work and hence battery life. But the camera-created preview might look different (how different can vary) from the RAW file when it loads, and if you want the most accurate previews possible, instead select the Standard Previews option so that Aperture generates new previews after importing a RAW file.

Modifying preview preferences

Aperture automatically generates JPEG versions of all your images with all your adjustments applied so that other applications, like iWork or Apple TV, can access your adjusted images. However, these previews can take a *lot* of hard drive space if you're not careful. These are covered in depth in Chapter 10, but for now we recommend that you either disable them entirely by deselecting the New projects automatically generate previews check box or at least limiting the size to your screen resolution and selecting a medium quality, as shown in Figure 1.21.

1.21 The Previews pane.

How Do I Import Images?

After you capture your images, the next step is downloading them onto your computer. The Import interface in Aperture 3 enables you to do far more than just copy the photos from a memory card to your computer's hard drive. It gives you a head start on organizing and optimizing your images as well. You determine where the images should be stored, whether to simultaneously create a backup copy of them, rename them or modify a time stamp, apply keywords or other metadata, and apply any Effect Presets. You can even view each image nearly full-screen to determine whether to import it.

Importing from a Memory Card, Camera, or Hard Drive **32**

Choosing Import Settings . **37**

Understanding Unified iPhoto and Aperture Libraries **54**

Dragging and Dropping Files into Aperture . **58**

Using Photo Stream . **59**

Importing from a Memory Card, Camera, or Hard Drive

We know that when you finish shooting you want to get your images into Aperture as quickly as possible so you can see the results and start editing. Aperture offers lots of ways to import files, all designed to give you as much control of the process as possible while simultaneously making it as efficient and painless as possible. Most of the time, the files you want to import will be on a memory card. You can also import images that are already stored on your computer but that are not yet in Aperture, or that are on an external hard drive that's connected to your computer. You can even use Aperture to import video and audio clips in addition to your image files and keep them organized so they're easily accessible. Then you can play the video and audio clips in the Browser and use them in Aperture-generated slide shows. By using Photo Stream, you can also wirelessly import images from your iPad or iPhone. (Photo Stream is covered in a separate section later in this chapter because doing so bypasses the Import panel.)

Note Currently, you can't use Aperture to make adjustments to audio or video files beyond basic trimming.

If your files are on a memory card, you have the option to use a card reader attached to your computer or to directly attach your camera to the computer using the USB cable that comes with most cameras. Using card readers enables faster image downloading in many cases and means that you don't need to rely on the camera's battery. Some computers offer built-in card readers that are convenient and fast.

Touring the Import panel

After you attach your memory card, camera, or hard drive to the computer, you're ready to use the Import panel. We recommend that you set up Aperture Preferences to automatically open Aperture when a camera is connected by following these steps:

1. **Choose Aperture ⇨ Preferences to open the Preferences dialog.**

2. **Click the Import button.** The import-related preferences appear, as shown in Figure 2.1.

3. **In the When a camera is connected, open pop-up menu, select Aperture.** Aperture's import interface now opens automatically whenever you connect a memory card or camera.

4. **Select the Camera Previews option to use the previews that are embedded in most RAW files.** We recommend selecting this so that you can see and work with your images as quickly as possible. However, after Aperture loads the full RAW files, the colors and sharpness of the images may change. If you prefer to see accurate previews initially even though it may take longer for Aperture to import your images, choose Standard Previews.

2.1 Set Aperture Preferences to automatically open the Import panel whenever a camera or memory card is connected to the computer.

To access the Import panel manually, click the Import button at the top left of the main Aperture window, as shown in Figure 2.2.

The Import panel contains a lot of powerful options in a concise and well-laid-out interface that's divided into several major sections. You specify where to look for the images in the upper-left section of the interface, and the Viewer displays the images found on the card or the content of the hard drive that you selected. If you don't select a card, camera, or external drive, then the Browser appears beneath the Viewer and displays a directory to the files on your computer and any drives that are connected to the computer.

The Import Settings pop-up menu contains presets and options that determine how the files are imported, where they're stored, how they're named, and more. Those are covered in detail later in this chapter. To the right of the Import panel and beneath the Import Settings pop-up is the Aperture library area where you specify where to store the images when they're imported. At the bottom right, the number of files to import is indicated followed by buttons to initiate the import or to cancel out of the Import interface.

Aperture library options

Access Import panel button Import from options Viewer Import Settings pop-up menu

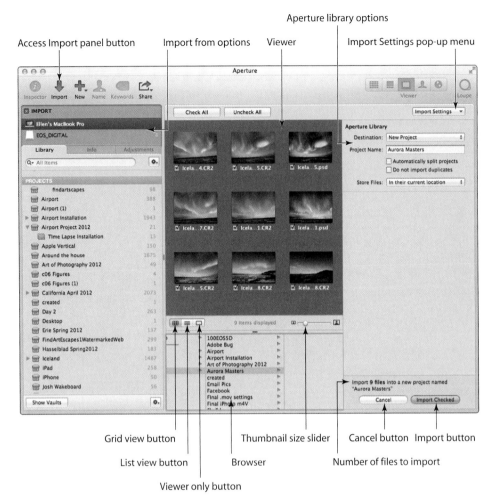

Grid view button Thumbnail size slider Cancel button Import button

List view button Browser Number of files to import

Viewer only button

2.2 The Import interface is divided into well-organized sections.

Using the different views in the Import panel

When you first open the Import panel, it displays thumbnails of your images. This is the Grid view. You can control the size of the thumbnails by using the slider beneath the Viewer panel.

There are three icons beneath the Viewer that you use to control how the images are displayed. Choose the Grid view (refer to Figure 2.2) to see the images displayed as a series of thumbnails, choose the List view, shown in Figure 2.3, to view basic information about each file as well as a tiny thumbnail, or choose the Viewer only mode, shown in Figure 2.4, to display a single image at a time so that you can inspect it more closely.

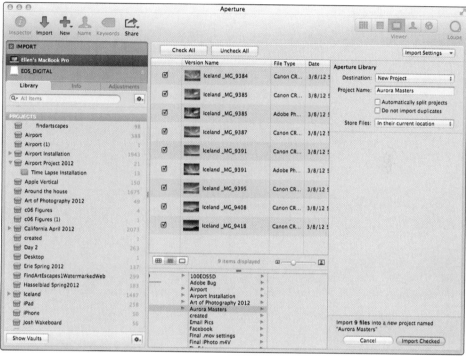

2.3 The List view displays information about each file.

Note If you're in Grid view, double-clicking any image changes the Import panel to the Viewer mode. Double-clicking the image in the Viewer again returns it to the Grid view.

2.4 The Viewer only mode displays a single image at a time.

Each image has a check box that is selected by default to indicate that image should be imported.
Selecting or deselecting the check box toggles the check mark on and off. You can quickly select
or deselect all images by clicking the Check All or Uncheck All buttons at the top of the Import
panel. While in Grid view or List view, to select or deselect a group of images, follow these steps:

1. **If the images are contiguous, select the first image, press and hold the Shift key, and click the last image in the group.**

2. **If the images are not contiguous, select the first image, then ⌘+click each subsequent image you want to select.**

3. **With the images selected, click the check box of one of the images.** All check boxes of the selected images will change accordingly, as shown in Figure 2.5.

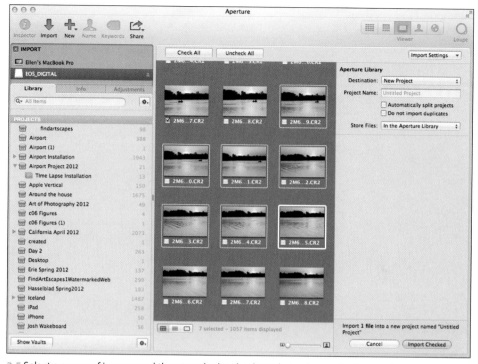

2.5 Select a group of images and then toggle the check marks to choose the images to import.

Choosing Import Settings

In addition to selecting which images to import, you have a number of other choices to make about the import process, such as specifying a project for your images, choosing referenced versus managed files, renaming your images, changing the time stamp, applying Effect Presets, specifying what type files to import, deciding how to handle RAW+JPEG pairs, running actions immediately after import, and automatically backing up the import. These choices help you to keep your images organized and increase the efficiency of your workflow as you customize the settings for your individual needs.

Configuring a destination project for your images

You need to decide whether you want to import the images into an existing project or to create a new project for them. If you set the default import location in the Import Preferences to New Project, then by default the Destination pop-up chooses New Project even if you already have a project selected in the Library Inspector. However, if you specify Selected Item in the Import preferences, then by default the Destination pop-up in the Import panel reflects whatever project you've selected in the Library Inspector. If you have not yet selected a specific project or album, then the Destination pop-up automatically chooses New Project.

You can override the default setting in the Destination pop-up by selecting a specific project or album to import the images there, or by selecting New Project, as shown in Figure 2.6.

If you use a memory card to hold images that you take over an extended period, whether several hours, days, or weeks, the Automatically split project option is enabled in the Import interface.

Aperture can automatically split the import into several projects, one for each span of time. You can determine the timeframe by

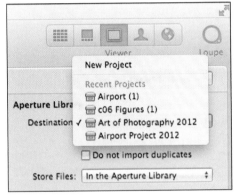

2.6 Choose whether to import your images into an existing project or to create a new project.

choosing Preferences ⟶ Import ⟶ Autosplit into Projects and choosing One project per day, One project per week, Two-hour gaps, or Eight-hour gaps, as shown in Figure 2.7.

As shown in Figure 2.8, the Viewer panel of the Import interface changes to show which images are in each project. The additional projects can be manually renamed in the Library Inspector after import.

Genius

If you opt to use an existing project for the import, you can create a new album within that project to further organize your images while in the Import panel by pressing ⌘+L. This opens a new dialog in which you name the new album by typing in the Album Name field. The images are imported within the selected project, but they are also visible within the new album, and that's very handy. To import your images into a new album within a new project, you must first create the new project in the Library by choosing New ⟶ Project and naming it before using the Import interface.

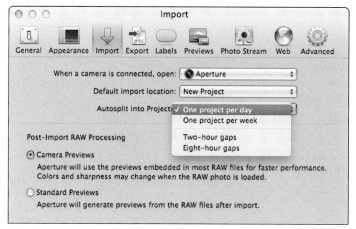

2.7 Set Preferences to split the import into new projects according to the timeframe in which they were captured.

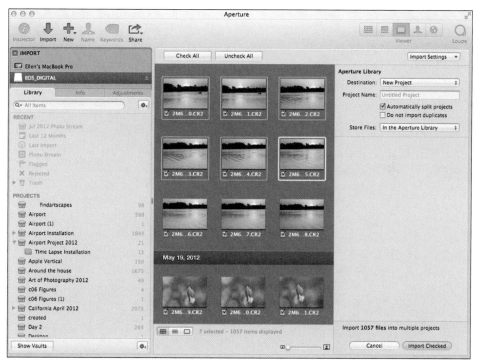

2.8 Aperture can automatically divide your images into additional projects based on when they were shot.

When you import into an existing project, select the Do not import duplicates check box to avoid importing multiple copies of the same file.

Using referenced or managed files

The next choice in the Aperture library section of the Import interface is one of the most impor-tant. You tell Aperture whether you want to use referenced or managed files. Before you choose the setting in the Store Files pop-up menu, you need to be certain that you understand the differ-ences between referenced and managed files. Although the differences between referenced and managed files are covered in Chapter 1, the topic is important enough, and at times confusing enough, that it bears a little repetition.

When you choose to store your files in the Aperture library, you are specifying that you want Aperture to *manage* your files. This means that Aperture stores the managed files within the Aperture library. In addition, any versions of the image that you create are also stored in the library, which makes it easy to keep track of both your originals and the versions. You choose the location of the library, which can be on your hard drive or on an external drive or even on a backup device such as a Pegasus or Drobo.

Note A Pegasus or a Drobo is a type of external drive system containing two or more drives that creates automatic backups of each drive to protect against data loss in the event that a single drive fails. For more information, go to www.promise.com or www.datarobotics.com.

If you opt to use referenced files, your original files are not stored within the Aperture library. Instead, they can be wherever you specify, such as the hard drive, an external drive, or even cloud storage such as Dropbox (www.dropbox.com). Aperture imports thumbnails of the images and cre-ates previews (according to your Preference settings) for the images and stores those within the Aperture library. In addition, any versions of the image that you create within Aperture are also stored in the Aperture library, including versions made using an external editor or plug-in. However, the originals remain in the separate location that you choose. As mentioned in Chapter 1, the pri-mary difference is that you are in charge of organizing and keeping track of the originals. If you move them — for example, you decide to move the folder from your computer's hard drive to an external drive — Aperture won't know where to look for them, and you'll have to spend time help-ing Aperture find them using the Locate Referenced Files command, which is covered in Chapter 3.

Note

Because Aperture creates thumbnails (and previews if you've set Preferences to automatically create them, as mentioned in Chapter 1), you can view referenced files, create slide shows, and use the images in other iWork and iLife programs and not have the drive containing the originals attached to the computer (after you finish importing them, of course). However, to apply adjustments, e-mail, or export the images, the drive needs to be connected.

Note

If you opt to have Aperture not generate previews automatically, you can create previews later manually by choosing Photos ⇨ Generate Previews.

Most people find it a little easier to use managed files, unless their workflow requires referenced files. Both approaches work well, but referenced files require a bit more caution. In addition, sometimes it can be frustrating when you see a referenced file in the library but you can't export it or adjust it because the original isn't available.

Caution

In an emergency, you can directly access your managed original files without using Aperture. Control+click on the Aperture library in the Finder and choose Show Package Contents. Then click the Masters folder and all the subfolders. Eventually you will find all the original files. *However, we don't recommend doing this except under dire circumstances because it's extremely easy to accidentally corrupt the library by moving or deleting a file.*

After you decide whether to use managed or referenced files, you specify that on the Aperture Store Files pop-up menu, as shown in Figure 2.9.

To use managed files, choose In the Aperture Library. This moves the files into Aperture so that it keeps track of all original files as well as any versions of them.

Aperture Library

Destination: Art of Photography 2012

☐ Automatically split projects
☐ Do not import duplicates

Store Files ✓ In the Aperture Library
In their current location

Pictures

Choose...

2.9 Use the Store Files pop-up menu to choose managed files or to specify where to store referenced files.

To use referenced files, choose one of the following:

- **In their current location.** This leaves the files where they are and points Aperture to them.

- **Pictures.** This places the files in a subfolder there; use the radio button beneath the pop-up to either move the files or to create a copy of them. Then choose a name for the sub-folder. We recommend choosing Project Name so it's easy to recognize which files belong to which projects.

- **Choose.** This places the files elsewhere on your hard drive or on an external drive. Specify whether to copy or move the files by selecting the radio button and then choose the name for the subfolder.

Renaming files on import

Most digital cameras assign filenames to your images that are a combination of letters and num-bers that don't offer any clues about the images, so it can be very helpful to rename your images as you import them. That way, when you see the filenames you have an idea which images they are. This is particularly true when working with referenced files.

To rename files as you import them, follow these steps:

1. **Click the Import Settings button in the upper right of the Import inter-face and choose Rename Files.** A Rename Files brick appears on the right side of the Import interface, as shown in Figure 2.10.

2. **On the Version Name pop-up menu, select one of the preset naming options that Aperture offers.** If you choose Custom Name with an option, such as Custom Name with Index, a Name Text field appears in which you add the text for Aperture to use. (In our example we selected a custom preset, Custom Name with a Master, that we created.)

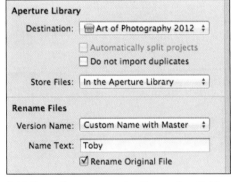

2.10 If you choose a preset with a custom field, add the text in the Name Text field.

3. **Select the Rename Original File check box if you want to rename the original files and not just the versions within Aperture.** This is optional. If you select this option and then export an original file, the exported file shows the name you gave it rather than the name assigned to it in-camera.

To create a custom preset name to use for renaming your files, follow these steps:

1. **On the Version Name pop-up menu, choose Edit from the preset options.** The File Naming dialog, shown in Figure 2.11, appears in which you create a custom preset.

2. **To add a new naming preset, click the Add button (+) on the bottom left, and type a name for the preset over the highlighted name in the list of presets.**

3. **Drag buttons into the Format field to customize the format.** To remove a button from the format field, click and drag over it to select it, and press Delete on your keyboard. If you choose a custom button, a new field appears that you can leave blank or fill with text. If you add text, then that text automatically appears when you choose the preset in the Import options. If you leave it blank, you can add the text during the Import process.

4. **Click OK.**

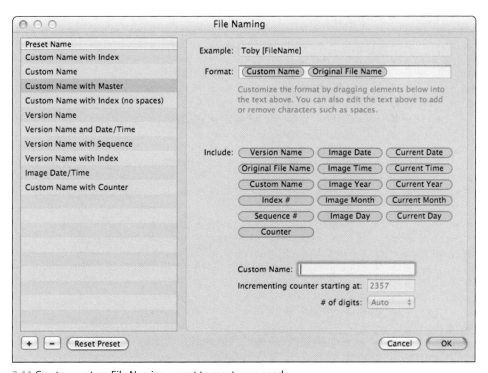

2.11 Create a custom File Naming preset to meet your needs.

We commonly rename our files with a Custom Name plus Original File Name. The Original File Name, which is the name assigned in-camera, provides a unique indexing number for the file as well as an easy way to identify the original filename in case you need to find it on a backup drive. The custom option enables you to add a meaningful name related to location or subject matter.

Note The same file naming presets are available when exporting images. So if you create a custom preset for use while importing, it appears in the file naming presets for use when exporting files as well.

Fixing time zone settings on your images

Most digital cameras record the time that you captured the file. The problem is that some photographers, including us, rarely take the time to change the time setting in the camera when they travel and photograph in different time zones. Admittedly, the time stamp is more important for some types of photographers than others. For photojournalists, it may be imperative; whereas for family photos, it may be purely optional.

However, you never know when having the information will be useful, and Aperture makes it so easy to correct the time stamp that there's no reason not to fix it.

To ensure that the correct time is associated with the image, assuming that the in-camera clock was accurately set for your home time zone, follow these steps:

1. **Click the Import Settings button in the upper right of the Import interface and choose Time Zone.** Two pop-up menus appear, as shown in Figure 2.12.

2. **Specify the time zone the image is currently in, which is normally your home time zone, using the Camera Time pop-up menu.**

3. **On the Actual Time Zone pop-up menu, choose the time zone to associate with the images.** It's that simple.

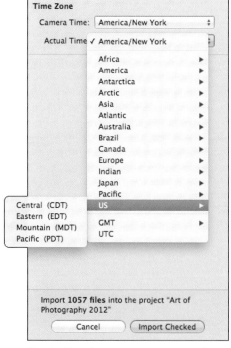

2.12 Use the Time Zone settings to correct the time associated with the image.

An introduction to presets

You can use presets in many places in Aperture, including the Import panel, Adjustments Inspector, Info Inspector, and File Naming dialog. In each case, presets enable you to apply a predetermined combination of settings with a single click. That saves time.

The Apple engineers have created some default presets that they think will be useful to many photographers, but you can create your own as well, and we show you how to customize them. By taking advantage of presets, you spend less time on the computer.

The first place you encounter presets is in the Import interface. You can apply Metadata Presets and/or Effect Presets while you import your images, which means your images are already partially optimized and contain metadata when you initially begin working with them, and that's efficient!

Setting up and applying a Metadata Preset on import

To apply metadata while importing, follow these steps:

1. **Choose Import Settings and select Metadata Presets.** This opens the Metadata brick in the right panel of the Import dialog, as shown in Figure 2.13.

2. **Choose None to apply no metadata.**

3. **Choose Basic Info to apply a default set of metadata options and then complete each field as you want.**

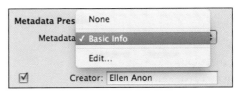

2.13 Use the Metadata Import Settings brick to choose a preset or to modify an existing one.

4. **Choose Edit to customize the fields in the Basic Info preset or to create an entirely new preset.** Although you can use the Basic Info preset at the default settings, it is even more useful if you take the time to customize it. That way you can prefill some of the fields that remain constant, such as your contact information, as well as choose which fields to display.

Choosing Edit opens the Metadata heads-up display (or HUD), as shown in Figure 2.14. On the left side is the list of current presets, and on the right are all the possible fields that you can include in the preset. Any field that you select is included in the preset and unselected fields are not visible in the preset. If you add text to any of the text fields, then the text becomes part of the preset. We fill in our personal information and any other fields that remain constant such as copyright so we don't have to retype them each time we import images. We select other fields, such as Keywords,

so that the fields appear within the preset, but we leave them blank so we can add text during import. Note that you can add fields that enable you to rate, label, or flag images as they're imported.

Of course, it's up to you to decide which fields to include, but we recommend completing at least some of the IPTC contact information as well as the Copyright field in the IPTC Status section. It's important to include a way to reach you and information about the copyright with the file itself. Otherwise, it's all too easy for an image to be used without your permission and/or become "orphaned," meaning no one knows whose picture it is.

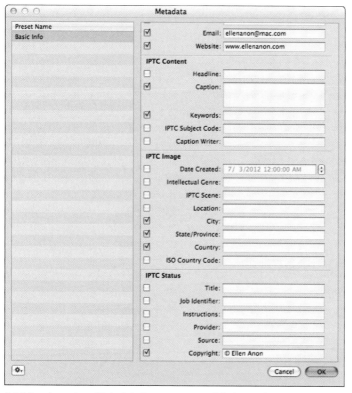

2.14 Create custom Metadata Presets to use while importing images.

To type the copyright symbol, press ⌘+G.

Note

To create an entirely new preset, take these steps:

1. **Click the Action pop-up menu (gear icon) at the lower left of the Metadata HUD and choose New Preset.** A new preset appears called Untitled.

2. **Type a name for the preset.**

3. **Select the fields to include and fill in any fields that remain constant.** We created one called Contact and Copyright that contains just the copyright information and our contact information.

As shown in Figure 2.15, you can also duplicate or delete presets as well as import or export presets, which means you can create a preset on one computer and then export it for use on another.

To use a preset on another computer, take these steps:

1. **In the computer containing the preset you want to use, access the Metadata Preset dialog from the Metadata HUD as just described, and choose Export.** A new dialog appears in which you choose a name for the preset (although most likely you won't want to change the name) and specify where to export the preset. We find it easiest to export to an external drive or thumb drive.

2.15 You can manage your Metadata Presets via the Action pop-up menu and even export them for use on other computers.

2. **Connect the drive to the other computer.**

3. **Open Aperture and access the Metadata HUD.**

4. **Click the Action pop-up menu and choose Import.** A new dialog appears containing a directory of your computer.

5. **Select the drive containing the exported preset.**

6. **Click OK.** Your preset is added to the list of presets. When you return to the Import dialog, your new preset or customized version of the Basic Info preset are available in the Metadata pop-up window.

Under the Metadata pop-up in the Import interface are radio buttons to Append or Replace the metadata. When you select Append, the metadata is added to the existing metadata in the image whereas Replace removes any metadata that already exists and replaces it with the information in the preset. Most of the time we opt to append the metadata.

You then need to add text to any blank fields. We often type the image location information as well as a few keywords that apply to all the images. You may want to add caption information, special instructions, or any other information you need, but not having to retype your contact and copyright information for each import session is very convenient. What's even better is the knowledge that every image in your library has the basic metadata applied as it's imported.

Setting up and applying an Effect Preset on import

RAW files often seem to be a little flat and may seem slightly less saturated, which can be a bit disconcerting when you first view your images and may make you hesitant to share your images with others until you've fully optimized them.

At other times you may realize that your white balance is off in a series of images, or perhaps you want to view them as black and whites. Aperture 3.3's Import Panel offers access to the default Adjustments Inspector Effect Presets as well as your custom Effect Presets by choosing Import Settings ⇨ Effect Presets. Figure 2.16 shows the Effect Presets that are available from the pop-up menu.

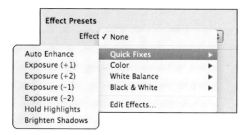

2.16 All the Effect Presets are available from within the Import panel although only one can be applied during the import process.

Only a single Effect Preset can be applied to each image during the import process, so one of the Quick Fix presets such as Auto Enhance, which has been significantly improved in Aperture 3.3, may provide a good starting place for optimizing your images. Auto Enhance applies a combination of different adjustments to optimize each image, but it's smart enough to recognize if a particular image doesn't need one of the adjustments, and then it doesn't apply that adjustment to the image even if you're importing numerous images. Of course, you can apply additional Effect Presets after the images are imported by using the Adjustments Inspector.

You may prefer to create customized Effect Presets containing several of the adjustments you routinely use and have Aperture apply that preset during import. That way your images will look better when you're editing them and you'll have less work to do to optimize them. Keep in mind that

you can create a variety of Effect Presets, each containing different combinations of numerous adjustments.

To modify an existing Effect Preset containing more than a single adjustment, do the following:

1. **Click the Edit Presets option in the Preset pop-up menu in the Effects Presets brick in the Import window.** Doing so opens the Effect Presets Manager, as shown in Figure 2.17.

2. **Select a preset.** The adjustments it contains are listed in the panel on the right side of the dialog.

3. **Click the minus radio button by each adjustment to remove one or more of the adjustments within the preset.**

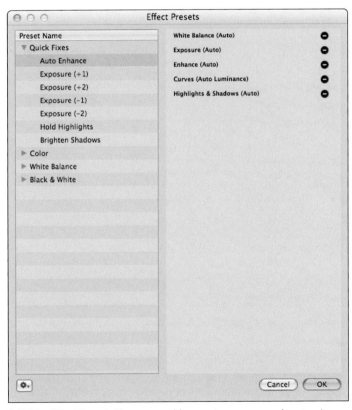

2.17 The Effect Presets Manager enables you to manage and customize your Effect Presets.

To create your own custom Effect Preset from scratch, follow these steps:

1. **Create an Effect Preset by clicking on an image that's already imported into Aperture.** Choose an image that has only the adjustments applied that you want to use for your preset, or even better, an image with no adjustments applied at all.

2. **Apply the adjustments you want as part of the preset.** For example, we often apply a combination of a Curve adjustment to add a small amount of midtone contrast, along with some Definition and some Edge Sharpening. It's a good idea to be fairly conservative as you set the sliders, although all adjustments that are applied via a preset can be tweaked by adjusting the sliders later in the Adjustments Inspector.

3. **Go to the Effects pop-up menu that's in the Adjustments Inspector, as shown in Figure 2.18, and choose Save as Effect.** The Effect Presets Manager appears.

4. **Assign a descriptive name in the Effect Presets dialog so that later you remember exactly what the preset does.** Your customized presets will appear in the list of Effect Presets in the Import panel as well as the Adustment panel in addition to the default presets.

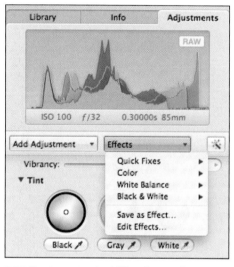

By taking advantage of the Metadata and Effect Presets in the Import panel, you'll have considerably less work to do later.

2.18 Create customized Effect Presets from scratch within the Adjustments Inspector in Aperture and apply them in the Import panel.

Configuring what types of files to import

Because many digital cameras now include options to capture video and audio files as well as photos, Aperture 3.3 gives you the option to exclude certain types of files or to only include specific types of files while importing from your memory card. That way only the types of files that you're interested in appear in the Import Viewer, making it easier to quickly choose the files that you want to import. You don't have to wait while files that you're not interested in are imported, or spend time individually deselecting files in the Import panel.

To limit the types of files that Aperture imports, choose Import Settings ➪ File Types. In the File Types brick that appears, as shown in Figure 2.19, select any file types you want to exclude, or select the option to only include files that were flagged or locked in the camera.

File Types
- ☐ Exclude photos
- ☐ Exclude videos
- ☐ Exclude audio files
- ☐ Exclude audio attachments
- ☐ Only include files flagged/locked in camera

2.19 Use the File Types options to control which type files are imported from your memory card.

Working with RAW+JPEG pairs

Some cameras offer the option to shoot in RAW+JPEG pairs so that each image is recorded as both a JPEG file and a RAW file. Aperture now offers more flexibility in how to deal with these image pairs.

Shooting in RAW+JPEG can be helpful in several types of circumstances. For example, if you've purchased a newly released camera and Apple has not yet updated Aperture to support that camera's RAW file, you can still view and work with the files by using a RAW+JPEG workflow. Or perhaps you've applied a Picture Style in-camera to your JPEG files and want to view your images using those settings. You might also opt to shoot using both file types if you need to work extremely quickly initially to output files and want the convenience of using JPEG files, but you want the flexibility and power of RAW files to use later.

Begin by choosing Import Settings ➪ RAW+JPEG. A new RAW+JPEG Pairs brick appears in the Import dialog. As shown in Figure 2.20, there are a variety of options for instructing Aperture how you want to import the image pairs.

The first three options allow you to import both file types of each pair, while the other options import only one type of file.

- ⦿ **Both (Use JPEG as Original).** Both files are imported, but you actually see the JPEG file in the Viewer. Adjustments are applied to the JPEG version but are maintained if you switch to the RAW file.

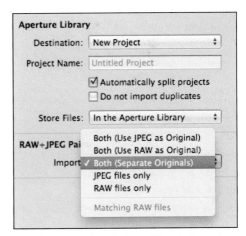

Aperture Library

Destination: New Project
Project Name: Untitled Project
 ☑ Automatically split projects
 ☐ Do not import duplicates

Store Files: In the Aperture Library

RAW+JPEG Pai
Import ✓ Both (Use JPEG as Original)
Both (Use RAW as Original)
Both (Separate Originals)
JPEG files only
RAW files only
Matching RAW files

2.20 Aperture offers choices of how to import RAW+JPEG pairs as well as options to import just one type of file.

- **Both (Use RAW as Original).** Both file types are imported, but you actually see the RAW version in the Viewer, and any adjustments are applied to the RAW file. However, the adjustments are maintained if you switch to the JPEG version.

- **Both (Separate Originals).** This option imports both the JPEG and the RAW files and treats each one as an original file. The advantage of this method is that you can easily remove either type of file later to save space. The disadvantage is that adjustments applied to one member of the image pair are not automatically applied to the other. Instead, you need to use the Lift and Stamp tools that are covered in Chapter 6.

- **JPEG files only or RAW files only.** This is self-explanatory. If you choose one of these options and want to keep the mate, you need to store those files manually and remember where you put them.

- **Matching RAW files.** This is a good option if you initially import just the JPEG files and do your editing based on them, and later you want to import the RAW files associated with just the JPEGs that you've kept.

Matching RAW files is a fantastic feature because it enables you to automatically import just the RAW files that match the JPEGs that are in the project; the other RAW files are ignored without your having to manually select the files individually or reedit the project. In addition, you can specify whether you want to import all matching files that Aperture finds, just those files that are unrated or better (so Aperture doesn't reimport images you've rejected but not yet deleted), or only the mates to the images that are visible in the project using the current filter. So if what you really want are the RAW files associated with just your five-star images, for example, those are the only RAW files that Aperture imports.

Note

When you use either of the first two options, you can access the other files after you import them by selecting the file and choosing Photos ➪ Set RAW as Original or Set JPEG as Original. Any adjustments you apply to one file type are applied to the other file type.

Caution

Unfortunately, there isn't a way to delete just the JPEGs or just the RAW files from the pairs when they are imported as Both (Use JPEG as Original) or Both (Use RAW as Original). When you delete one, you delete the other, which means that if you're looking to conserve storage space at a later time, you can't delete just one type of file for image pairs. If you import as Both (Separate Originals) then you can use the filter to show a specific file type and then delete just those files.

When importing Matching RAW files you must select the project that contains the JPEG images rather than a specific album.

Caution

Running actions automatically after importing

In addition to being able to apply Effect and Metadata Presets while importing, you can instruct Aperture to run custom AppleScripts immediately after importing your images. Although many users will never need this feature, for others it can be a huge advantage, particularly for those with customized workflows using repetitive tasks. You can create custom actions using AppleScript so that your images can be uploaded to FTP servers automatically on import, sent to the web, inserted into a Keynote presentation, and so on. AppleScript can be used to automate just about any actions that you do repeatedly.

To apply an action, choose Import Settings ⇨ Actions. Then, as shown in the Actions brick in Figure 2.21, choose the AppleScript to use.

Actions

AppleScript: No Script Selected

Clear Choose...

2.21 Use Actions to apply custom AppleScripts to your images immediately after import to save time.

Setting up an automatic backup on import

One of the disadvantages of digital images is that the media used to store them can fail. In fact, every hard drive will fail at some point, including the one in your computer. The hope is that day is far away, long after you no longer need that particular hard drive. But the harsh reality is that a hard drive failure can occur at any time. To protect against losing your images, you need to store them on at least two separate drives. We talk more about creating backups for your Aperture library in Chapter 10. However, you can create a backup of the files that you're importing during the import process. That way when you reformat the memory card to reuse it, you still have your files stored in two places. We strongly recommend that you take advantage of this feature.

To automatically back up your files on import, take these steps:

1. **Connect a backup drive to the computer and choose Import Settings ⇨ Backup Location.** The drive appears in the Backup To pop-up menu, as shown in Figure 2.22.

Backup Location

Backup To: G-DRIVE MINI TRIPLE

Subfolder: Project Name

2.22 It's smart to create a backup copy of your files on an external drive as you import them into Aperture.

2. **Select the backup drive.**

3. **Use the Subfolder pop-up menu to create a folder for the backups on that drive.** We recommend using the Project Name for the subfolder to make it easier to identify, but you can choose any of the presets, or click the Edit option to create a custom name for the folder. Aperture not only imports the files into the Aperture library, but simultaneously creates an external backup. That's efficient!

When you finish choosing your import settings, click Import Checked. The Import interface disappears, and you see your images in the Viewer and/or Browser, ready for you to begin editing.

Understanding Unified iPhoto and Aperture Libraries

Prior to Aperture 3.3, if you were an iPhoto user and wanted to move up to Aperture, it was challenging because the two programs maintained separate image libraries. Similarly, it was awkward for an Aperture user to take advantage of some of iPhoto's features such as cards and calendars. The new unified iPhoto and Aperture libraries make it easy to move back and forth between the two programs.

After you install the Aperture 3.3 upgrade, the first time you open Aperture you'll see the message in Figure 2.23 and Aperture will modify your library. As you'd expect, if you have a huge library this can take some time. Similarly, when you open iPhoto 9.3 the first time, your iPhoto library is upgraded.

Caution You must upgrade to OS 10.7.4 or later and iPhoto 11.9.3 or later to be able to take advantage of unified libraries.

To open an Aperture library in iPhoto, take these steps:

1. **Open iPhoto.**

2. **Choose File ⇨ Switch to Library.**

3. **Navigate to the Aperture library you want to open and click Choose.**

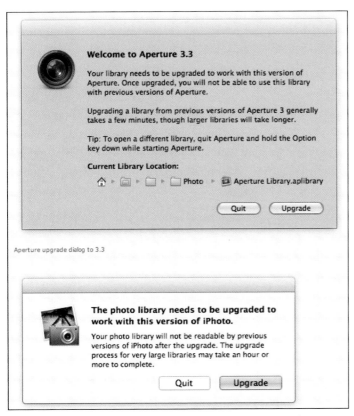

2.23 The first time you open Aperture 3.3 (or iPhoto 9.3) you see these messages.

4. **A message appears (see Figure 2.24) asking if you want to switch libraries; click Relaunch to do so.**

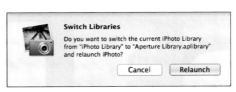

2.24 Click Relaunch to switch to your Aperture library.

To open an iPhoto library in Aperture, do the following:

1. **Open Aperture.**

2. **Choose File ⇨ Switch to Library ⇨ Other/New.**

3. **Navigate to the desired library and click Choose.** (Unlike iPhoto, Aperture does not need to relaunch.)

55

Note

Your unified library cannot be open in Aperture and iPhoto simultaneously.

Overall, a unified library is a huge convenience. The organization of your Aperture and iPhoto images is maintained as are all the adjustments you've made and any keywords, ratings, and so on.

Albums and Smart Albums are maintained when you move between the two applications, as are any Faces and Places features that you've used, and any images that you've shared via Flickr or Facebook. If you create a slide show in one program, you can view it in the other. Of course, any changes you make to an image in one program are visible if you open the image in the other program.

There are, however, a few differences to be aware of between the two programs:

- iPhoto uses Events, whereas Aperture calls them Projects (see Figure 2.25).

- Aperture enables you to choose whether to create previews and at what size, whereas iPhoto always creates full-size previews. When you open the library in iPhoto, previews generated in Aperture remain unless you edit the image in iPhoto, in which case iPhoto generates a new full-size preview.

- Smart Albums created in one program are fully functional in the other program, but to change the "smart" criteria, you must use the application you used to create the album.

- Photos that you've hidden using iPhoto's hide command are not visible in Aperture until you return to iPhoto and unhide them. Similarly, photos that you've rated as Rejected in Aperture are not visible within iPhoto unless you first change the rating in Aperture.

- If you have stacked images in Aperture, only the stack "pick" is visible in iPhoto although the full stack continues to be available in Aperture.

- PDF files, audio files, and audio attachments are visible within Aperture but not within iPhoto.

- If you've specified various criteria within Aperture's Browser to determine what's visible, iPhoto doesn't recognize the criteria and instead displays all the images.

- In Aperture you can opt whether to use Faces for each library, but iPhoto always uses Faces.

- Output that you create in iPhoto such as books, cards, and calendars are visible in Aperture in the Source list, but cannot be edited. Similarly, books, web pages, and web journals you create in Aperture are not visible in iPhoto.

- Slide shows you create in Aperture can be viewed but not edited in iPhoto. Slide shows created in iPhoto can be played as well as edited within Aperture and still played back within iPhoto, but once edited in Aperture they are no longer editable within iPhoto.

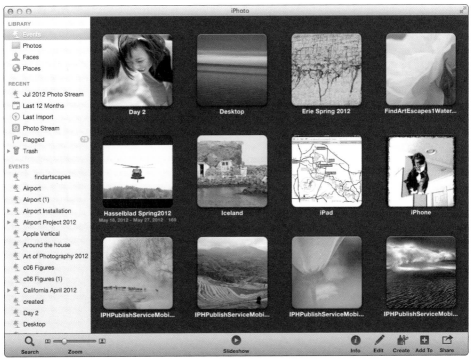

2.25 If you open your Aperture library in iPhoto, Projects are called Events and use iPhoto icons.

If you've been an iPhoto user and are just starting to use Aperture, you can switch to Aperture to make a few adjustments to your images that are unavailable within iPhoto — such as the selective brush tools (see Chapter 6) — and then return to iPhoto. That way you can transition gradually. (Remember that if you use an adjustment in Aperture that's not available within iPhoto, the effect of the adjustment is visible within iPhoto, but obviously you can't tweak that particular adjustment unless you return to Aperture.)

For iPhoto users who have several image libraries, another advantage of the unified libraries is that you can merge the iPhoto libraries using Aperture. To merge iPhoto libraries, open each of the libraries in iPhoto 9.3 at least once (so that the library is updated), and then do the following:

1. **Open Aperture 3.3 or later.**

2. **Choose File ⇨ Switch to Library ⇨ Other/New and navigate to the iPhoto library you want to use as the main iPhoto library.**

3. **Choose File ⇨ Import ⇨ Library and select the iPhoto library you want to merge into the main iPhoto library.**

4. **Repeat Steps 2 and 3 as many times as needed to merge all your iPhoto libraries into a single iPhoto unified library.**

Note The libraries you merged still exist independently. Once you are certain that all the content has been correctly imported into the unified library, you may want to delete the older libraries to conserve memory.

Dragging and Dropping Files into Aperture

There are times when you may be looking through your Finder or your desktop or other place on your computer and come across one or more files you want to import into Aperture. Although you can choose File ⇨ Import ⇨ Files or use the Import interface, it may be more efficient to select the images and drag them directly onto the Viewer, Browser, or a specific item in the Library. Aperture imports image, audio, and/or video files this way. This can be particularly helpful with files that didn't originate within your camera. It's also helpful if you use third-party software that functions as a free-standing program rather than a plug-in within Aperture, or if you accidentally choose Save As rather than Save when working on a file in your external editor. Dragging and dropping is a quick and easy way to get the files into Aperture.

Using Photo Stream

Photo Stream is part of iCloud. An easy way to visualize it is to imagine it as a digital shoe box in the sky. It can hold up to 1,000 photos from the last 30 days. Depending on your Photo Stream settings in Aperture's Preferences, images that are initially on your mobile device, such as your iPhone or iPod, may be uploaded to Photo Stream and then automatically imported into Aperture when you are connected by Wi-Fi. Similarly, photos that you import into Aperture may be uploaded to Photo Stream and shared with your mobile devices.

To enable Photo Stream, choose Aperture Preferences ➪ Photo Stream and select the Enable Photo Stream check box (see Figure 2.26). Then if you want Aperture to automatically import images from your iOS devices, select the Automatic Import check box. Photos will be imported into Projects, Photos, Faces, and Places.

To automatically share images that you import into Aperture with your iOS devices via Photo Stream, select the Automatic Upload check box. We recommend that you keep this option unselected and select it only at specific times when you want to share images. Otherwise it's easy to accidentally upload the maximum number of images and unintentionally fill your mobile device's memory. If you do not select this option, you can still upload images from Aperture to Photo Stream to share with your devices by selecting the image and then choosing Share ➪ Photo Stream.

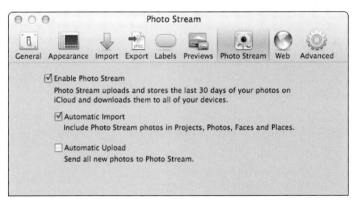

2.26 Enable Photo Stream to have Aperture automatically import images from your mobile devices and/or to send images from Aperture to your devices.

What Methods Can I Use to See My Images?

As you work with Aperture, there are times that you want to focus on a single image at a time, while at other times you need to compare two or more images or even to peruse all the images in an album or project. Sometimes you need to take a closer look at an image, and at other times you want to see certain information about images. In this chapter, you learn how to customize the way you see your images.

Customizing the Interface... 62

Taking a Closer Look... 68

Viewing in Full-Screen Mode 72

Additional Viewer Options .. 77

Configuring and Using Metadata Overlays 80

Switching between RAW+JPEG Originals............................ 82

Working with Referenced Images................................... 83

Working with Stacks in Browser 88

Creating and Working with a Light Table........................... 90

Customizing the Interface

Aperture's engineers realize that you may prefer to organize the interface differently in order to work more efficiently, so there are many ways to customize the interface. This section covers rearranging library items, using different Viewer modes, using the Viewer with multiple monitors, using multiple Browsers, and showing hot and cold areas (clipping) in images.

Rearranging and grouping library items

Chapter 1 covers several ways to filter what you see in the Library Inspector, but the more you shoot and use Aperture, the more cluttered the Library Inspector becomes. There are several ways you can organize and rearrange your albums and projects so that you can easily find them. By default, Aperture organizes the items by name. If you'd rather it organize items by kind or manually, go to the Action pop-up menu at the top right of the Library Inspector shown in Figure 3.1 and choose Keep Projects & Albums Arranged By ⇨ Kind (or Manual).

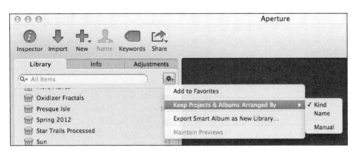

3.1 Choose how to organize your projects and albums.

If you opt to manually order the projects and albums, the next step is to select the projects, albums, and/or folders to move, and then click and drag them to the desired location.

Another way to organize albums and projects is to add folders to the structure. Using Folders is similar to taking a pile of papers that is sitting on your desk and putting it in a folder — the papers are still in the same order they were while sitting out on your desk, but your desktop looks cleaner and more organized. To use folders to help organize your projects, as shown in Figure 3.2, do the following:

Note
To create one or more folders within a project, first select a Project, and then click the New button and choose Folder. Then you can use the folders to organize any Albums, Books, Web Pages, Web Journals, or Slide Shows within it.

1. **Click on the word Library in the Library Inspector to remove any selections, and then click the New button and choose Folder to create a new folder at the same level as projects.** A new untitled folder appears at the bottom of the list of projects. (If you have a project selected, the new folder is added within that project.)

2. **Name the folder.** If you've opted to organize the library by Name, the folder moves to the correct alphabetical location. If you've organized the library by Kind, the new folder is added alphabetically to the other folders, following projects.

3. **Drag the folder wherever you want it.**

4. **Drag projects and albums into the folder.**

5. **Toggle the disclosure arrow by the folder to display or hide the projects and albums.**

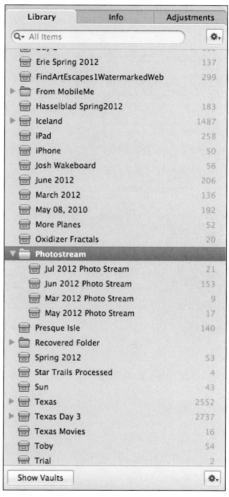

3.2 Move some projects and albums into folders to simplify the Library Inspector. We've created a folder for our Photo Stream projects.

Using Viewer modes

You might think there's only one way for Aperture to display your images in the Viewer, but in fact, Aperture offers a number of choices when you choose View ⟹ Main Viewer, as shown in Figure 3.3.

3.3 Choices for the Main Viewer.

Choose one of the Main Viewer options as follows:

- **Show Multiple.** This is the default setting, and it allows the Viewer to display one to 12 images at a time.

- **Show One.** This option allows the Viewer to display only one image, no matter how many images are selected in the Browser.

- **Three Up.** This option displays the image you select as well as the one immediately before it and after it in the Browser.

- **Compare.** This option helps you select the best image from a group of similar images.

- **Stack.** This option helps you select the best image within a stack. We cover that in more detail later in this chapter.

To use the Compare mode, follow these steps:

1. **Select two images and choose View ⟹ Main Viewer ⟹ Compare.** Both images appear in the Viewer; the one on the left has a green border in both the Viewer and the Browser and the one on the right has a white border, as shown in Figure 3.4. The image that has the green border is the "keeper so far" and the one with the white border is the one you're comparing to it.

2. **To compare the next image to the keeper, press the right arrow on your keyboard.**

3. **If you decide you want the image with the white border to be the new keeper, press Return.** That image moves to the left in the Viewer and now has a green border, and the next image in the Browser automatically appears with a white border.

4. **When you're happy with the image you've chosen, ⌘+click the image you don't want.** Then add stars, a label, or a flag to the remaining image, as covered in Chapter 4, to identify your favorite image from the group.

3.4 Use the Compare mode to help choose your favorite image from a series.

Using the Viewer with multiple monitors

If you're fortunate enough to have multiple monitors, Aperture is designed to take advantage of them. As you might expect, you have choices as to what's displayed on the second monitor. Access these choices by choosing View ⇨ Secondary Viewer, as shown in Figure 3.5.

Choose one of the Secondary Viewer options
as follows:

- **Mirror.** This allows each monitor to dis-
 play the same thing. You might use this
 option if you're doing a live demonstra-
 tion and have a large monitor set up for
 your audience.

- **Alternate.** This displays the currently
 selected image only in the secondary
 Viewer. That way you can have multiple
 images visible in the main Viewer and a
 single image on the other monitor.

- **Span.** This extends a single Aperture
 window across both monitors. We rarely
 find this helpful.

- **Black.** This leaves the other monitor
 black so that it's not distracting.

- **Off.** This enables you to see the con-
 tents of your desktop displayed on the
 secondary monitor while Aperture is vis-
 ible on the primary monitor.

3.5 Choices for what to display on a secondary
monitor.

Using multiple Browsers

Sometimes you want to select images from multiple projects or albums; for example, if you're
creating a slide show or a book or entering a contest and you know the task would be easier if you
could view two projects or albums at a time. To open two Browsers, select the first project or
album as usual. Then hold the Option key and click on another project or album. This divides the
Browser into two panes, as shown in Figure 3.6. You can then select images from each Browser to
copy or transfer to another item in the Library.

3.6 Divide the Browser into two panes to access images from two projects or albums.

Click the Close (X) button on the top left of the Browser pane tab to close one of the Browsers.

Showing hot and cold areas of an image

Some of your images may have highlights that are quite bright (hot) and/or shadows that are quite dark (cold) in which no details are visible. We refer to these areas as *clipped*. This can happen while you're taking the shot in-camera, particularly in contrasty conditions, or while you're optimizing your images. Aperture can display these areas with a color overlay so that it's easy to see where the image is losing detail. That way you can set the adjustments to restore as much detail as possible

To set Aperture to display the hot and cold areas, choose View ⇨ Highlight Hot & Cold Areas, or press Option+Shift+H. Aperture displays clipped shadows with a blue overlay and clipped highlights with a red overlay, as shown in Figure 3.7.

3.7 Aperture can place a red or blue overlay on any highlight or shadow areas that are losing detail due to clipping.

Note Clipping can occur in one or more of the Red, Green, and Blue channels. If it occurs in all three channels, then the pixels appear pure white or pure black. But if only one or two channels are clipped, the area may appear as a very saturated color without detail, as in the image shown previously in Figure 3.7.

By default, Aperture places the overlay on pixels in which at least one channel is completely clipped. To change the sensitivity of the threshold so that the overlay shows areas that are quite dark, but not completely clipped, or that are extremely light but not completely clipped, follow these steps:

1. **Choose Aperture ⇨ Preferences to open the Preferences dialog.**
2. **Click the Advanced icon.**
3. **Adjust the Hot Area threshold slider and the Cold Area threshold slider as desired.**

To change the clipping overlay to monochrome, which can be easier to see on images with areas of saturated reds and blues, choose Monochrome in the Clipping overlay pop-up menu in the same Advanced Preferences dialog. That way the overlay appears as a shade of gray.

Taking a Closer Look

At times when adjusting your images, just seeing the image filling your monitor isn't enough; you need to look closely at parts of the image at increased magnification. For example, when you apply sharpening, check for chromatic aberration, remove a dust spot, and so forth, viewing the image at 100 percent magnification or even more is important so that you work as accurately as possible. That way you can check details to make certain you're not accidentally adding (or leaving) artifacts. In this section, we show you how to use the Zoom tool and the Loupe tool to readily see the details in your pictures.

Zooming and scrolling in Viewer

The Zoom tool increases the magnification of the entire image in the Viewer. There are several ways to access the Zoom tool.

- **Click the Zoom Viewer button, shown in Figure 3.8, to magnify the image to 100 percent focused on the center of the image.**
- **Choose View ⇨ Zoom to Actual Size to accomplish the same thing.**

- **To zoom in centered on a specific part of the image, place your cursor on that area, and then press Z.** Aperture increases the magnification to 100 percent and the area under the cursor is visible. We find this the most efficient way to zoom.

- **Press ⌘+± to zoom in/out incrementally centered on the part of your image under the cursor.**

Zoom Viewer button

3.8 Use the Zoom Viewer button to increase or decrease the magnification of the image in the Viewer.

After zooming in using any of the preceding methods, you see the Zoom Scroll tool appear displaying the current magnification in the image, as shown in Figure 3.9. As you hover your cursor over it, it increases in size and displays a tiny thumbnail of the image with a small white rectangle. Click and drag the rectangle to navigate through the image so that different areas are displayed at the increased magnification.

3.9 Use the white rectangle in the Zoom Scroll tool to navigate through the magnified image view.

To zoom out to see the entire image, press Z again or choose View ⇨ Zoom to Actual Size and click to toggle it off. To decrease the magnification incrementally, press ⌘+−.

Note

Although you can press the spacebar and hold it while dragging in the Viewer to navigate through the image, in most cases we find it far easier to use the Zoom Scroll tool.

Genius

To increase or decrease the magnification of the image to any amount from 25 percent to 1000 percent, click and drag the cursor over the field displaying the current magnification on the Zoom Scroll tool or click and hold the arrow to the right or left of the numerical display. The magnification changes accordingly.

Using and customizing the Loupe

If you'd rather see a small part of your image in detail and still see the overall image, as shown in Figure 3.10, you can use the Loupe tool. You can also use the Loupe tool to view the thumbnails in the Browser at increased magnification.

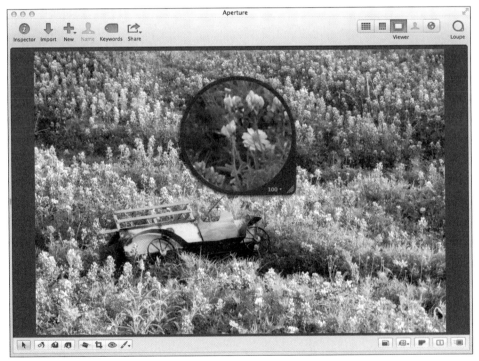

3.10 Use the Loupe tool to view a small section of the image at increased magnification while still seeing the entire image.

To access the Loupe tool, do one of the following:

- **Click the Loupe tool button at the top right of the interface.**

- **Choose View ➪ Show Loupe.**

- **Press Shift+`.**

To use the Loupe tool, click in the dark area near the bottom right and drag it over the part of the image you want to see magnified.

Click the downward arrow next to the magnification percent in the lower-right area of the Loupe to access the dialog shown in Figure 3.11, in which you can customize the Loupe tool as follows:

- **Choose Focus on Cursor to change the behavior of the Loupe tool so that you can leave the Loupe tool in one place and have it display whatever is under your cursor.** Some people prefer to use it this way so that the Loupe doesn't block part of the image.

- **Choose a magnification from 50 percent to 1600 percent.**

- **At magnifications greater than 200 percent, choose Pixel Grid to display a grid within the Loupe tool.**

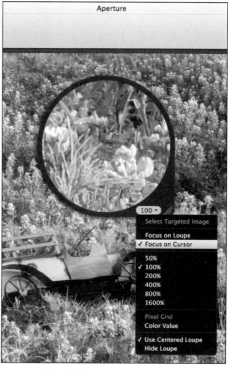

3.11 Use this dialog to customize the Loupe tool.

- **Choose Color Value to add a readout to the Loupe of the Red, Green, and Blue channel values as well as the luminosity value of the point under the Loupe.**

- **Choose Use Centered Loupe to toggle off the Use Centered Loupe option and return to the older style Loupe that was introduced in the original version of Aperture.** The Loupe will change shapes slightly, and whatever is shown under the small circle will appear magnified in the larger part of the Loupe. Some people may find this convenient, but we prefer to keep Use Centered Loupe selected and use the newer Loupe. To return to the newer style Loupe, Control+click on the Loupe and choose Loupe Options ➪ Use Centered Loupe.

Viewing in Full-Screen Mode

Although the default workspace is very usable, some people prefer an interface with the least amount of distractions possible. Full-screen mode hides your desktop completely, and you control what parts of the Aperture interface are visible.

To access full-screen mode, press F or click the Full Screen button in the toolbar, as shown in Figure 3.12. The display changes to full-screen mode, as shown in Figure 3.13. To exit full-screen mode, press F again, Esc, or click the Exit Full Screen button in the Full Screen toolbar.

3.12 Click this button to enter and exit full-screen mode.

In this section, we show you how to work with the Viewer and Browser in full-screen mode, as well as how to work with the filmstrip and toolbar and the heads-up displays (HUDs).

Exit Full Screen button

3.13 Full-screen mode showing the Viewer and the optional toolbar.

Using Browser and Viewer in full-screen mode

In full-screen mode, you can view a single image or multiple images (if you've set the Viewer mode to Multiple) in the Viewer with an optional filmstrip Browser or just the Browser showing a grid of thumbnails, as shown in Figure 3.14. To toggle between the two views, press V.

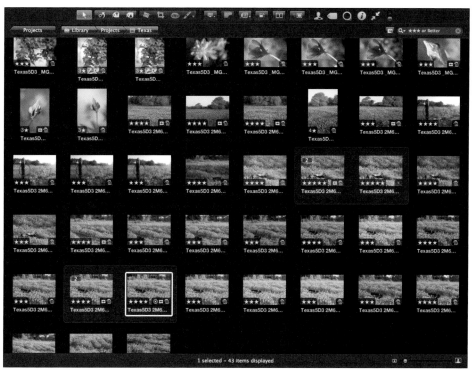

3.14 The Browser in full-screen mode.

Genius

Whether you're in full-screen mode or the regular interface, double-click an image in the Viewer to toggle between the Viewer mode and the Browser mode.

Caution

Initially, the full-screen background is black, which is dramatic against your images. If you're using full-screen mode to show your images to others, you may want to keep the background black. But if you're using full-screen mode to make adjustments to your images, it's a good idea to change the background to a shade of gray. That way your eyes won't be fooled by the increased contrast of the background, and you'll be more able to accurately adjust the contrast and saturation of your images.

To change the brightness of the background in full-screen mode, take these steps:

1. **Choose Aperture ➪ Preferences to access the Preferences dialog.**

2. **Click Appearance.**

3. **Drag the Full Screen Viewer brightness slider to the right.** We suggest setting it to 18 percent, which is the default setting for the Viewer in the regular interface. Note you can also change the brightness of the Browser background the same way.

Working with the filmstrip and toolbar

To navigate through the images while in the Viewer mode in full screen, you need to use the filmstrip. If the filmstrip is not visible initially, it's hiding. To see it, move your cursor to the left edge or the bottom edge of the interface, and it will appear, as shown in Figure 3.15.

Click and drag the Always Show Filmstrip control to the locked position to make the filmstrip always visible. When the filmstrip is locked, the image decreases slightly in size to make room for it without any overlapping. When you unlock the filmstrip, the image reverts to full size with the filmstrip overlapping it. When you move the cursor away from the filmstrip, it disappears.

To position the filmstrip at the left, bottom, or right edge of the interface, click in the gray area and drag it to the desired location.

Use the search field in the filmstrip to filter the display so that only certain images are visible in the filmstrip. For example, you can set it to show the four-star or better images, or the flagged images. To show all the images again, click the small X to the right of the search field.

To filter using more complex rules, click the Filter button to the left of the search field. This elicits the Browser Filter panel that we cover in Chapter 4.

Red Eye button
Crop button
Browser Metadata Overlays button
Straighten button
Quick Brushes button
Zoom Viewer button
Stamp button
Primary Only button
Show Original button
Lift button
Quick Preview button
Rotation button
Loupe
Viewer mode button
Keywords
Inspector
Selection button
Faces
Exit Full Screen
Lock

Sort pop-up menu

Filter button
Search file

3.15 The filmstrip is always available even if it's not initially visible.

To control the order in which the images are displayed, click the Sort pop-up menu shown in Figure 3.16 and choose the criteria to use to organize the images and whether they should be in ascending or descending order.

To adjust the size of the thumbnails in the filmstrip (and thus the size of the filmstrip as well), drag the small slider that's near the top of the filmstrip (or at the left if the filmstrip is at the bottom of the screen).

3.16 The Sort order options.

Drag the large slider to quickly scan among the images in the filmstrip.

Hovering your cursor near the top center of your monitor reveals the toolbar, as shown earlier in Figure 3.15. The key commands and tools you need are all right there. Just as with the filmstrip, slide the lock to make the toolbar always visible while in full-screen mode. Otherwise, it disappears when you move your cursor. When the toolbar is locked, the image decreases slightly in size and moves out of the way so nothing is hidden.

Working with heads-up displays

In addition to the toolbar and filmstrip, you can use a heads-up display version of the Inspector or the Keywords HUD, as shown in Figure 3.17. To access the Inspector HUD, click the Inspector button in the toolbar or press H. An Inspector appears that floats over your image. If you slide the lock, the HUD moves to a vacant side of the interface, and the image decreases in size to accommodate it. The

3.17 The Inspector HUD.

Inspector HUD has all the same controls and options as the Inspector does in the regular Aperture interface that is covered in Chapter 1. To hide the Inspector, press H or click the icon again.

If you hold down the Shift key while dragging any slider in the Adjustments HUD, everything in the HUD disappears except the slider so that you can see most of your image while making the adjustment, as shown in Figure 3.18. We love this feature!

To access the Keywords HUD, choose the icon in the toolbar or press Shift+H. A floating HUD appears that you can use to create and assign keywords. The Keyword HUD is covered in detail in Chapter 4. To hide the Keyword HUD, press Shift+H or click the icon again.

3.18 Hold the Shift key while dragging a slider to make the rest of the HUD disappear.

Additional Viewer Options

Regardless of whether you're using full-screen mode or the regular interface, there are three more Viewer options that you need to know: Primary Only, Quick Preview, and viewing originals, which we cover in this section.

Using Primary Only

When you have multiple images selected that are visible in the Viewer, any changes (other than adjustments) that you make are applied to all the selected images. So if you assign a star rating or

apply a label and so forth, you won't affect just one image; you modify all of them. But the reality is that at times while working you're likely to want to make changes to just one of the images. To do that, click the Primary Only button. Notice that when you select multiple images, one of them has a wider white border. That's the one that will still have a white border when you click Primary Only, as shown in Figure 3.19.

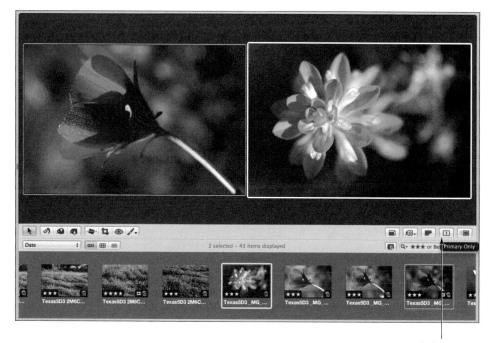

Primary Only button

3.19 Click the Primary Only button to apply changes to just one of several images that are selected.

Using Quick Preview

After you download your images, if you're like us you're impatient to start seeing them and perhaps making some preliminary edits. Although images load pretty quickly in Aperture 3.3, if you're uploading a lot of images it still takes time for Aperture to complete the download. If you try to go through the images too quickly you may discover that the spinning beach ball appears. If you hate

waiting and are willing to go through your images having Aperture use the initial previews rather than loading the full file, use Quick Preview mode.

To engage Quick Preview mode, click the Quick Preview button in the toolbar, as shown in Figure 3.20. A yellow border appears around the images you select. You won't be able to make any adjustments while you're in Quick Preview mode, and we suggest you not make any decisions about the final sharpness or exposure because the Quick Preview version may differ considerably from the actual file.

Still, it's a good way to quickly get a sense of the images you've captured. To exit Quick Preview, click the Quick Preview button again.

Viewing the original image

While you work in Aperture, as long as you're not using Quick Preview mode, the image preview in the Viewer updates to reflect all your edits. Although you can toggle any particular adjustment off and on using the check boxes in the Adjustments Inspector, sometimes it's helpful to glance at the original image to make sure you're heading in the right direction. The fastest way to do that is to click the Show Original button shown in Figure 3.21.

Quick Preview button

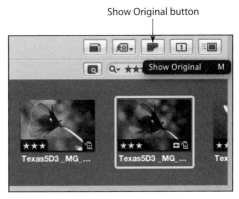

3.20 Use Quick Preview to view your images quickly.

Show Original button

3.21 Click the Show Original button to see the original file with no adjustments.

The image in the Viewer reverts to the original before you applied any adjustments, although all your adjustments are still intact. To return to edited view, click the Show Original button again.

Configuring and Using Metadata Overlays

Most of the time, you'll want to be able to see certain information about your images at a glance. For example, you'll want to see any ratings, labels, or flags that you've applied, whether you've assigned keywords, whether you've edited the image in a plug-in or external editor, and so forth. But some of the time you may want to just see the image without any distractions, and other times you may want to see even more information about the files. You can use the Metadata Overlays pop-up menu in the tool strip, shown in Figure 3.22, to control the display of metadata in the Viewer and the Browser as follows:

Browser & Viewer Metadata Overlay button

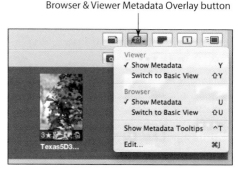

3.22 Click the Browser & Viewer Metadata Overlay button to apply metadata overlays.

- **Under Viewer, choose Show Metadata to have Aperture display a metadata overlay.** By default, the display uses the Basic View unless you choose Switch to Expanded View, and shows basic information such as ratings, labels, flags, and badges. (Aperture uses badges to convey a variety of information about the file such as if it's a referenced file, if the original is available, if you've assigned keywords to it, and so on. We cover this in detail in Chapter 10.)

- **Under Viewer, choose Switch to Expanded View to see more information such as any keywords that you've applied, the version name, the date the file was created, and even whether you've e-mailed the image or used it in a book.** Once you choose this, the option in the pop-up menu changes to Switch to Basic View. Choose that to return to an overlay with less information.

- **Under Browser, choose Show Metadata to see a metadata overlay in the Browser with each thumbnail.** By default, the display uses the Basic View unless you choose Switch to Expanded View, and shows basic information such as ratings, labels, flags, and badges.

- **Under Browser, choose Switch to Expanded View to see more information.**

Caution If the Browser is set to filmstrip, it may only show some, but not all, of the information in the overlay. To be certain the overlays show exactly the information you expect, use the Grid view or the List view in the Browser. Because the Browser has only limited area to display information, we suggest you only use the Expanded View in the Browser metadata overlay if the Browser is set to List view.

To specify what information is included in the Basic and Expanded View overlays in both the Viewer and the Browser, do the following:

1. **Choose Edit in the Metadata Overlays pop-up menu.** A new dialog appears, as shown in Figure 3.23.

2. **Choose which view to configure from the View pop-up menu.** The items that will be displayed are listed on the right under Display Order.

3. **To remove any items, click the minus (–) button next to the item in the Display Order list.**

4. **To choose additional items to include, use the expansion arrows next to the items on the left under Metadata Fields.** Select the check box next to that item and that field then appears on the right under Display Order.

5. **Select the Show metadata below image check box (at least in the Viewer) and the Show metadata labels check box.** We recommend choosing these options; otherwise the metadata blocks some of your image. The metadata labels help organize the metadata that you're seeing. A metadata label is a word such as *Keywords* that appears before the list of keywords in the overlay.

6. **Click OK to apply the changes.**

Genius To quickly apply or remove the overlays, use the following shortcuts: Press Y to toggle metadata on and off in the Viewer, press Shift+Y to toggle between the Expanded and Basic views, press U to toggle metadata on and off in the Browser, and press Shift+U to toggle between the Basic and Expanded views.

3.23 Customize the data that appears in the metadata overlay using this dialog.

Switching between RAW+JPEG Originals

If you've imported RAW+JPEG pairs with either the RAW or JPEG set as original, you only see one member of the pair in the Viewer. However, any metadata or adjustment changes you make to one are applied to the other as well.

Note

To switch an entire album of RAW+JPEG pairs to use the other format as the original, or if you have an album or project that contains RAW+JPEG pairs, some with RAW as Original and some with JPEG as Original, select the Album or Project in the library, then choose Photos ➪ Switch Album/Project to use RAW Originals, or Switch Album/ Project to use JPEG Originals.

To change the format that is used as the original, choose Photos ⇨ Use RAW as Original. If the original was already a RAW file, the option automatically appears as Use JPEG as Original, as shown in Figure 3.24. This enables you to change original formats on an image-by-image basis.

Working with Referenced Images

In earlier chapters, we talk about importing images as referenced files. As you already know, referenced files are convenient in some cases because you can store your original files outside the Aperture library where other programs can access them as well, and you can

Photos	Stacks	Metadata	View	Window	Help

Show Photo Info ⌥⌘I
Make Key Photo
Rotate Clockwise]
Rotate Counterclockwise [

Add Adjustment ▶
Add Effect ▶
Revert to Original

Edit with Adobe Photoshop CS6... ⇧⌘O
Edit with Plug-in ▶

Remove from Album ⌫

Duplicate Version ⌥V
New Version from Original ⌥G
New JPEG from Frame

Use JPEG as Original

Detect Missing Faces

Reprocess Original...
Generate Thumbnails
Update Preview
Delete Preview

3.24 You can toggle between the JPEG as Original and RAW as Original options to check metadata and changes.

store the images on external drives so that you don't run out of room on your computer. However, working with referenced files requires a bit more attention on your part. This section covers identifying and managing the original images for referenced files as well as reconnecting missing originals and relocating images.

Identifying and managing referenced images

Anytime you import a referenced image, Aperture places a badge on it, as shown in Figure 3.25, so that you can readily tell it's referenced. The badge is visible in the metadata overlay, as discussed earlier in this chapter. If the badge is green, the drive containing the image is connected, but if it's red, the original is offline.

Offline referenced image badge

3.25 The badge clearly identifies files that are referenced.

Once you identify an image as a referenced file, you need to make sure that the drive containing the original file is connected if you want to make any adjustments to the image or output it. Otherwise, you may be left wondering why the Adjustments Inspector is grayed out and why Aperture suddenly won't export an image.

If you use more than one drive to store your original files, the chances are that you won't remember which drive you need. To have Aperture jog your memory, select a file and then choose File ➪ Show in Finder. If the drive containing the image is connected and online, the Finder appears with the path to the file selected. If the drive is offline, Aperture tells you that, but it also shows you the name of the drive, as shown in Figure 3.26. All you have to do is find that drive and connect it. Aperture automatically sees it, and you're good to go.

3.26 Use the Show in Finder option to see where your original files are stored.

Reconnecting a missing original

If you accidentally move the original file from where it was when you imported the image as a referenced file or changed it in some way, Aperture may not know how to find it. We've noticed that Aperture 3.3 is far more able to locate files by itself than earlier versions, but it's still possible that it may not be able to locate the original. In that case you have to tell it where to look. To reconnect one or more missing original files, do the following:

1. **Reconnect the hard drive containing the referenced originals.**

2. **Select the project or album containing the referenced files.**

3. **Choose File ➪ Locate Referenced Files.** The dialog shown in Figure 3.27 appears. On the left is a list of the names of hard drives where you're storing referenced originals, as well as how many originals were found and any that weren't located. The next column tells you the specific location of the original file for each referenced file.

4. **Click Show Reconnect Options if they are not already visible.**

5. **Select the file at the top that you want to reconnect with its original.** A thumbnail of the image and some identifying metadata appear next to it.

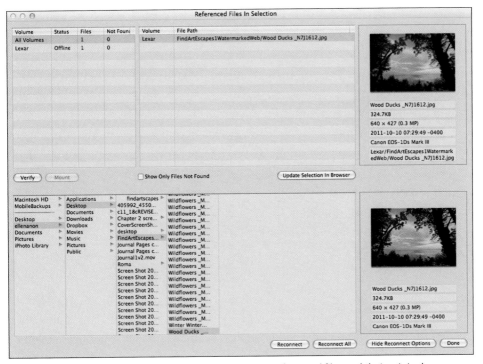

3.27 Use the Locate Referenced Files option to reconnect referenced files and their originals.

6. **In the bottom section of the dialog, navigate to the location of the referenced original and select the original.** A thumbnail of the image and some identifying metadata appear next to it so you can compare it to the image selected above and be sure that you're connecting the right original.

7. **Click Reconnect to reconnect a specific image.** Alternatively, you can select a group of images to reconnect and click Reconnect All.

Relocating referenced originals

If you decide that you need to move the originals for some (or all) of your referenced files — for example, to place them on an external drive — there's a way to do it so that Aperture knows exactly where to look for them. Then you won't have to spend time later trying to reconnect the originals and referenced files. To relocate the originals for referenced files, follow these steps:

1. **Select the referenced images in the Browser.**

2. **Choose File ⇨ Relocate Originals.** A dialog appears, as shown in Figure 3.28.

3. **Choose a location to store the images.** We often create a new folder in Pictures, but if you're moving the files to an external drive, you may just need a folder on that drive. Be sure to use a name for the folder that alerts you that it contains referenced originals. Consider putting the letters RO after the name or any other convention that works for you.

4. **Choose None from the subfolder pop-up menu to store each file individually within the folder you just selected in Step 3.** If you want Aperture to organize the images into subfolders, choose one of the subfolder presets or create your own by choosing Edit and following the prompts to configure a custom preset.

5. **Specify a naming convention to use.** Choose Original Filename to use the current original filename. This is the format we recommend so that you can easily identify the images. However, you can use any of the other formats such as Version or Custom.

6. **Click Relocate Originals.** Aperture moves the originals to their new location.

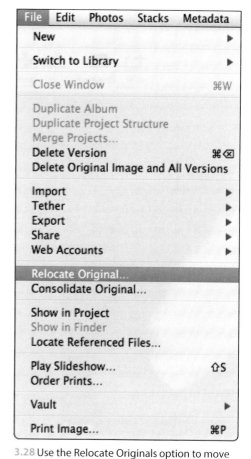

| File | Edit | Photos | Stacks | Metadata |

New ▶

Switch to Library ▶

Close Window ⌘W

Duplicate Album
Duplicate Project Structure
Merge Projects...
Delete Version ⌘⌫
Delete Original Image and All Versions

Import ▶
Tether ▶
Export ▶
Share ▶
Web Accounts ▶

Relocate Original...
Consolidate Original...

Show in Project
Show in Finder
Locate Referenced Files...

Play Slideshow... ⇧S
Order Prints...

Vault ▶

Print Image... ⌘P

3.28 Use the Relocate Originals option to move original files.

Note You can relocate originals that are managed as well. In that case, they become referenced files. To relocate managed files, follow the same steps you use to relocate referenced files.

Caution Although relocating originals is usually a very quick process, depending on how many files you're moving it could require some time. Be sure to leave the external drive connected while Aperture moves the originals to it. If you're not sure whether all the files have been moved, choose Window ⇨ Show Activity. If Aperture is still moving the originals, the task appears in this window.

Converting referenced originals to managed originals

You may find that you have a number of referenced files that you want to convert to managed files. For example, if you are traveling with a laptop and leave the external hard drives that contain all your referenced files at home, you might want to be able to make adjustments or export some files while you travel. To change referenced files into managed files, follow these steps:

1. **In the Browser, select the files you want to convert to managed files.**

2. **Choose File ⇨ Consolidate Originals.** In the dialog that appears, choose whether you want to move the files into the Aperture library or make a copy of them that is managed in the library.

3. **Click Continue.**

Deleting referenced files

When you delete a referenced file, you follow the same steps covered in Chapter 1 to delete files. However, when you press Shift+⌘+ Delete to empty the Trash, a dialog appears as shown in Figure 3.29.

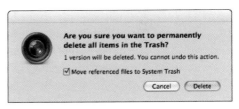

3.29 The Empty Trash dialog.

To delete the referenced original file as opposed to just deleting the version within Aperture, select the Move referenced files to System Trash check box. If you want to leave the original file intact but remove the version that's in Aperture, leave that check box unselected.

87

Working with Stacks in Browser

As we mention in Chapter 1, you can organize groups of related images into stacks. These can be images that are very similar, part of a panorama, part of a High Dynamic Range (HDR) series, different versions of the same image, or any images that you want to group together for any reason. Stacked images have a dark-gray box around them and a number in the upper-left corner of the first image indicating the number of images in the stack, as shown in Figure 3.30. Stacks can contain as many images as you want.

3.30 Stacks can organize groups of related images.

Aperture can auto-stack all the images in a project based on the time sequence in which you took them. To auto-stack images based on time, follow these steps:

1. **Select a project or album.**

2. **Choose Stacks ⟶ Auto-Stack.**

3. **Adjust the Auto-Stack Images dialog slider to the desired time frame from 0 seconds to 1 minute.** As you do, the images are organized into stacks.

4. **Choose Stacks ⟶ Close All Stacks.**

Aperture automatically creates stacks whenever you create a new version of an image, including when you use a plug-in or external editor such as Photoshop, so the files stay together. You can change this behavior by deselecting the Automatically stack new versions option in General Preferences, but we recommend you leave it selected.

To manually create stacks, select the images to include and then press ⌘+K, or choose Stacks ⇨ Stack.

When stacks are open, all the images are displayed. When they're closed, only a single image — the one farthest to the left — is visible. By closing stacks you reduce the number of files you have to visually sort through in the project or album, and that can save time.

Note

Stacks work in both the regular mode and full-screen mode.

You can drag the images around within a stack to reorder them as well as drag images in and out of existing stacks. To divide a stack, place your cursor on the thumbnail that you want to begin a new stack and choose Stacks ⇨ Split Stack.

To open and close a stack, click on the number in the first image. Alternatively, choose Stacks ⇨ Open All Stacks or Close All Stacks to open or close all the stacks within the album or project.

To set the image that appears on the top of a stack (called a stack pick), do one of the following:

- **Select the image and then choose Stacks ⇨ Pick.**
- **Select the image and press ⌘+\.**
- **Drag the image to the farthest left position in the stack.**

If the stack appears in multiple albums, such as one for a book and one for a web page or slide show, you may want different pick images for each album. To set an image as the album pick, select the image and choose Stacks ⇨ Set Album Pick. You can use a different image in each album.

To unstack a group of images, select the stack and choose Stacks ⇨ Unstack.

You can use the Compare mode within stacks to help you compare the images in the stack. This is similar to comparing individual images using the Compare mode, which is discussed earlier in the chapter. To compare images within a stack, follow these steps:

1. **Select a stack.**

2. **Choose View ⇨ Main Viewer ⇨ Stack, or press Option+T.** The stack pick is automatically set as the currently chosen image and has a green border.

3. **Compare images within the stack to the stack pick, and press Return if you want an image with a white border to become the new stack pick, which changes its border to green.** The next image in the stack appears for you to compare until you have reviewed all the images in the stack.

4. **Use the keyboard up and down arrows to move from stack to stack.**

Creating and Working with a Light Table

As great as it is to work with digital images, sometimes it feels like it would be easier if you could spread the images out in front of you and arrange then as if you were dealing with prints or slides. Using a Light Table enables you to work with your digital images in a very similar way with the advantages that you can resize the images as well as the Light Table itself. A Light Table can be particularly helpful when trying to organize images for a slide show or book, when color-correcting many related photos, or when creating a collage. To create a Light Table, take these steps:

1. **In the Library Inspector, choose the project or album where you want the Light Table to appear.** Then select the images you want to view in the Light Table. You can select more images than you ultimately need because the images you select initially only appear in the Browser for the Light Table.

2. **To create the new Light Table, click the New button in the toolbar and choose Light Table.** A dialog appears in which you give the new Light Table a name.

3. **In addition to typing a name for the Light Table, select the Add selected items to new light table option.**

4. **Click OK.** The new Light Table appears in the Library Inspector. The interface changes slightly, as shown in Figure 3.31. The Viewer is now a Light Table with a grid, and there are some different buttons above it and above the Browser.

5. **To add additional images to the Light Table, choose any image or images in the library and drag them onto the Light Table in the Library Inspector.**

To begin arranging your images, select one or more in the Browser and drag them onto the Light Table. As long as the group of images is selected, they all move as a unit on the Light Table. To move a single image, click anywhere on the Light Table except on an image. Then click the image. You'll see the image has a thick white border, as shown in Figure 3.31.

Light Table Zoom Navigator button

Light Table Scale to Fit button

Light Table Put Back Selected button Light Table Uncover button

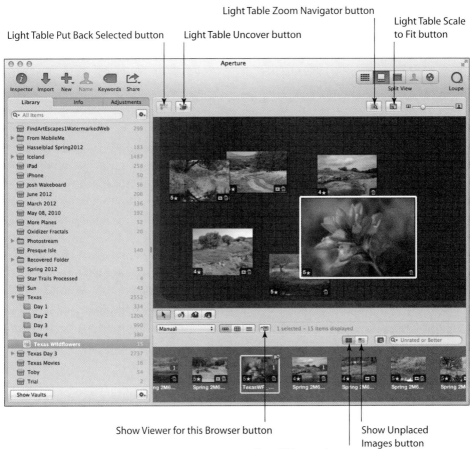

Show Viewer for this Browser button

Show Unplaced Images button

Show All Images button

3.31 Use the Light Table to arrange groups of images.

Drag the image wherever you want. As you do, the yellow alignment lines appear to help you align the image with the other images. In addition, small square handle boxes appear along the edges of the image. Click and drag these handles to resize the image. If necessary, use the slider in the top right of the interface to resize the Light Table or click the Light Table Scale to Fit button. Click the Light Table Zoom Navigator button to magnify a portion of the Light Table.

To have Aperture automatically arrange the images, Control+click on the Light Table next to the images and choose Arrange All from the pop-up menu. To restore an image to its previous size, Control+click the image and choose Reset Selected Size from the pop-up menu.

Genius

Click and drag the cursor over several images on the Light Table to select a group of images and move them as a unit.

To remove an image from the Light Table, click the Light Table Put Back Selected button shown earlier in Figure 3.31. If you can't see an image that's hiding under another image, select it in the Browser and click the Light Table Uncover button. The image will be visible even if it's completely under another image. Then you can resize or move one of the images.

Notice that a number 1 appears in the top right of the thumbnail for each image that you place onto the Light Table. To easily see any images that haven't yet been used, click the Show Unplaced Images button so that only the unplaced images appear in the Browser. To see all the images again, click the Show All button.

You can use the Adjustments Inspector to apply adjustments to the images while they're on the Light Table. However, some of the adjustments such as Straighten, Crop, Red-Eye, and Quick Brushes are not available in the toolbar. To use these adjustments, click the Show Viewer button that's above the Browser. The regular Viewer appears where you make the necessary adjustments. When you're finished making adjustments, click the Show Viewer button again to return to the Light Table.

If you've created a grouping of images that you want to print as a collage, deselect all the images by clicking on the background of the Light Table. Then choose File ⇨ Print Light Table to get the Print dialog so you can output the print, which is discussed in detail in Chapter 7. Note that you can use this same dialog to save the Light Table layout as a PDF by clicking the PDF button and choosing Save as PDF in the pop-up menu.

To delete a Light Table, select the Light Table in the Library Inspector and choose File ⇨ Delete Light Table.

How Can I Use Metadata to Organize and Find My Images?

Metadata is data about a file that helps describe the contents of the file. Aperture provides powerful tools to manage the metadata attached to an image, whether it's entering IPTC Core contact information, adding keywords to help you quickly find an image, or setting an image rating so that you can easily pull your top images from your library. This chapter helps you explore how to use metadata in Aperture to make it easier to manage your library.

Using Ratings to Sort Images . 96

Using Flags and Labels to Further Organize Images 99

Using the Info Inspector . 102

Adjusting Date and Time after Import. 109

Working with Keywords. 110

Adding Custom Metadata . 117

Applying Batch Metadata Changes . 117

Searching for Images . 120

Writing IPTC Information to an Original . 125

start to shoot, a keep/delete system is probably more than sufficient, but as you become a better photographer and your image collection grows, you will realize that keeping or deleting isn't enough to separate your best images. Ratings are incredibly useful because they let you quickly pull the best images from your library, separate the best from the good-enough-to-keep images, and identify the worst images that you can delete first when you run low on space.

Each image can have either no rating or a rating from one to five stars. Table 4.1 illustrates the system we use, which has proved rather useful over the years.

Table 4.1 Our Image Rating System

Rating	Meaning
5 stars	These are your absolute best images. Post them to your website, include them in slide shows, and show them to clients. Absolutely back these up.
4 stars	These images are above average, and you will most likely include some of these in a slide show or web gallery. While they are not quite as good as your five-star images, you don't want to lose them and back these up, too.
3 stars	These are your average images. You keep them to submit for various, specific image requests, even if you don't typically show them to clients. You back up three-star images, too.
2 stars	Two-star images are images that you keep for some particular reason, even though they're not good enough to show to a client. An example would be a below-average photo of a rare animal. You don't back them up because it doesn't really matter if these get erased.
1 star	One-star images are your lowest-quality images. Typically, you keep these for a specific part that you might consider compositing into another image, but they're not important enough to back up. If you run low on hard drive space, these are the first images that you delete.

Setting ratings

Setting a rating on an image is quite straightforward. Select the image and choose the appropriate rating by choosing Metadata ⇨ Rating. Assuming you have your metadata overlays (which we discuss in Chapter 3) configured to show a rating, you see the rating appear as a badge on the

image, such as in Figure 4.1. Alternatively, use the keyboard shortcuts 1–5 to set a rating of one to five stars on the selected images (note that you don't press the ⌘ key, just press the number). Use the minus (–) and equals (=) keys to decrease or increase the selected image's rating. Pressing 0 clears the rating and makes the image unrated, and pressing 9 gives the image a special rejected rating, which we discuss shortly.

4.1 Aperture can display an image's rating as a badge in both Browser and Viewer.

Note In the Albums group within the Library Inspector, there's a 5-Star Smart Album that shows you all the five-star images in your library. This is a great way to quickly display your best images.

The control bar, as shown in Figure 4.2, also provides buttons to reject an image, lower its rating, raise its rating, or to mark it as a five-star select. If the control bar is not visible, choose Window ⇨ Show Control Bar.

4.2 The control bar.

Working with rejected images

How often have you finished a shoot, started looking through your images, and become unhappy with what you shot, suddenly feeling the urge to just throw away everything? Fortunately, by marking an image as *rejected* rather than just deleting it, Aperture gives you a second chance to recover it so that if you change your mind, it's easy to restore your image.

If there's an image that you want to get rid of, choose Metadata ⟡ Rating ⟡ Rejected or press 9 on your keyboard. This command displays an X in the ratings badge, and when you move to the next or previous image, the rejected image disappears from the Browser (later in this chapter, when we discuss searching for images, we show you how to see your rejected images within an album or project).

Under the Recent group in the Library Inspector, there's a Rejected collection, shown in Figure 4.3. Clicking it shows all your rejected images in Browser, just like any other album. If you want to unreject an image, select it and set its rating to something other than rejected, be it unrated or one to five stars. If you really want to get rid of these images, click inside Browser and choose Edit ⟡ Select All. Then choose File ⟡ Delete Original Image and All Versions.

4.3 The Rejected collection in the Recent group and its contents.

Note

It's a good idea to periodically click on the Rejected collection to see if there are any images that you can delete to free up hard drive space.

Prior to Aperture 3, choosing Delete Original Image and All Versions would have removed the images from Aperture and moved the original files to your system's trash. However, as discussed in Chapter 1, this command instead moves your images to Aperture Trash in Aperture 3.

If you realize that you made a mistake deleting one of these images, follow these steps to retrieve it:

1. **Select Trash in the Library Inspector.**

2. **Select the image you want to retrieve.**

3. **Control+click on that image and choose Put Back.**

To empty the Trash, choose Aperture ⇨ Empty Aperture Trash. Empty Aperture Trash moves the images to your system trash, but the images aren't actually removed from your drive until you empty your system trash.

Using Flags and Labels to Further Organize Images

While ratings are a great way to start organizing your images, you will most likely quickly find that you want another level of organizing. For example, if you come back from a trip with 75 five-star images, you probably don't want to upload all 75 to your website. Wouldn't it be great if Aperture had a way to say "flag these images for my website"? If you work with a stock agency, perhaps you'd also like to be able to flag some images to send to your agent? Fortunately, Aperture 3 provides two levels of organization, flags and labels, which allow you to handle both of the previous examples, and it's also possible to customize the label names to be more applicable to your workflow.

Setting flags and labels

Flagging images is quite easy. Select the appropriate images and choose Metadata ⇨ Flag (or press the / key). When you do so, assuming you have your metadata overlays enabled and set to show flags, Aperture displays a flag icon in the top-right corner of the image (in Viewer) or thumbnail (in Browser), as shown in Figure 4.4. To unflag an image, select it and choose Metadata ⇨ Unflag.

Note To quickly flag and unflag an image in Browser, first make sure your metadata overlay is on for Browser and set to display flags. When you mouse over your image, a ghosted flag icon appears. Click on that icon to flag your image; click on the solid flag icon to unflag it.

There's a special item in the Library Inspector under the Recent group at the top for flagged images called, you guessed it, *Flagged*. This collection shows all flagged images in your library.

Genius

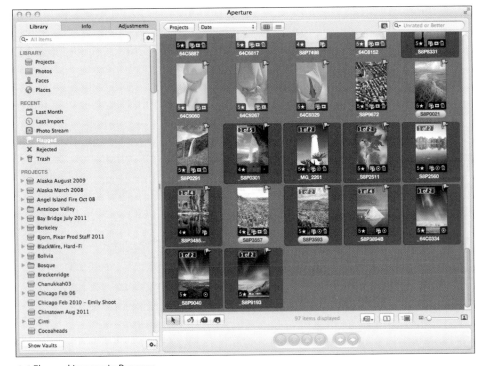

4.4 Flagged images in Browser.

While flagging provides an extra level of organization, it's a fairly straightforward and simple one — is this image flagged or not? While that's great for direct questions such as "Which images should I post to my website?" it doesn't provide the flexibility you need when really working with your images. That's where labels come in. Labels let you tag images with a specific status, such as "send all images with this label to my agent" in addition to the separate rating and flagged metadata.

Aperture has seven labels that you can apply to an image (as well as a *No Label* label). As you probably have come to expect from Aperture, it's easy to add a label to an image. Select the image, and from the Metadata menu move your mouse over the Label section shown in Figure 4.5.

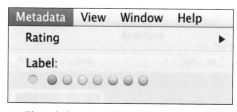

4.5 The Label section of the Metadata menu.

After you pick the label you want, let go. Control+clicking on an image displays a contextual menu with a similar Label control, too.

If you have Viewer or Browser set to display metadata overlays, you'll see one of two types of indicators for your image's label. Viewer's basic and expanded metadata overlays and Browser's basic overlay show the label as a small, colored circle on the right side of the image. Browser's expanded overlay shows the label color behind the version name, as shown in Figure 4.6.

4.6 Labels in Browser with the expanded metadata overlay.

Selecting an image and setting its label to *No Label* removes the label.

Customizing label names

Unfortunately, Aperture doesn't let you customize your label colors, but there's a good reason for that. The label colors within Aperture match the uncustomizable label colors within the Finder. When you export a version of your image, as we cover in Chapter 8, Aperture labels the file it creates with the same color it has in Aperture in the Finder. This is a wonderful feature because it means that if you use a label to indicate an image status in Aperture, that status is preserved when you export your image outside of Aperture.

You are able to customize the label name, though, so rather than saying something useless like *Green,* the label has the status name like *needs sharpening.* To customize a label name, follow these steps:

1. **Choose Aperture ⇨ Preferences.**
2. **Click the Labels tab, as shown in Figure 4.7.**
3. **Click in the text field next to the appropriate label and type the new label text.**

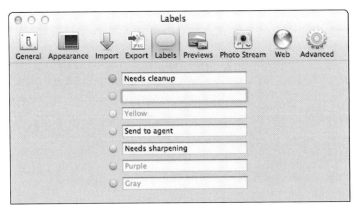

4.7 Custom label names allow you to adjust label meanings for your specific workflow.

Now when you select the label color from the Metadata menu, rather than seeing the color name below the label color you see your label name.

Using the Info Inspector

While ratings, flags, and labels are powerful pieces of metadata within Aperture, there are other types of metadata automatically associated with an image, starting when you first press the shutter button on your camera. Exchangeable Image File (EXIF) data consists of information that the camera records about the image, from shutter speed to GPS location (if available), into the file. Typically, you can view but not modify this data. International Press Telecommunications Council (IPTC) metadata is the next type of metadata. Consisting of fields like keywords, captions, and copyright, this is data that you will modify (and often will even set at import, as we discuss in Chapter 2). No matter which type of metadata you're working with, Aperture's Info Inspector is the

central place to view and edit image metadata. It's even possible to create preset metadata values, such as your contact info, that you can quickly apply to an image.

To view the Info Inspector, make sure the Inspector is visible; if it's not, choose Window ⇨ Show Inspector. Next, click the Info tab in the inspector or choose View ⇨ Inspector ⇨ Info.

At the top of the Info Inspector is the Camera Info panel, as shown in Figure 4.8. If it's not visible, select Show Camera Info from the Inspector's Action pop-up menu. The Camera Info panel is very useful because at a quick glance, it gives you access to essential EXIF information, such as shutter speed and ISO, as well as Aperture metadata, such as your image rating. Additionally, each of the Aperture metadata displays (label, rating, and flagged) is also a control that you can click on to adjust each item's respective value.

4.8 The Camera Info panel provides an easy way to see key image metadata.

Caution Although selecting multiple images in Browser and using the commands under the Metadata menu affect all the selected images, using the commands in the Info Inspector only affects the primary selection (the one with the bolder outline).

Another neat feature in the Camera Info panel is the focus points display. Mouse over the Focus Points button, which looks like a diamond made up of rectangles in the top-right part of the panel, and Aperture displays the selected focus point for the selected image (if it's available), like in Figure 4.9. Clicking this button makes the display stick so that you always see your focus point superimposed on the image, and clicking it again turns the focus point display off. Choosing View ⇨ Show Focus Points also toggles focus points on and off.

At the very bottom of the Info Inspector is the Maps pane (note that the Maps pane isn't available in the Metadata heads-up display [HUD], only in the windowed Info Inspector). If it's not visible, click the Reveal button to open the pane, and you'll see a map of the United States. If there's GPS information with the image, Aperture displays it on the map. Use the Action pop-up menu to switch map types (such as satellite or terrain). Working with place information is covered in depth in Chapter 5.

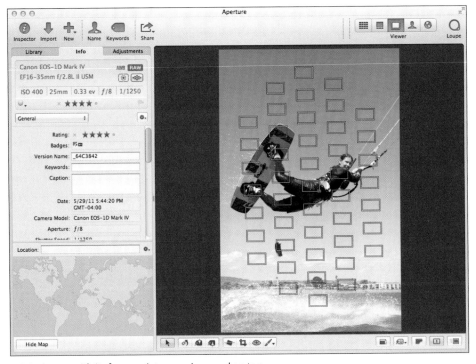

4.9 An image with its focus points superimposed on top.

Switching and customizing metadata views

In the middle of the Info Inspector, you find a bunch of different metadata fields and values, from caption information (which you can edit) to file size (which you can't edit). The collection of metadata fields displayed in this area is called a *metadata view*. Aperture ships with a number of default metadata views, but it's also possible to customize these views and to create your own.

The default view is called General. It contains a mix of Aperture, EXIF, and IPTC metadata, including rating, version name, shutter speed, aperture, and copyright notice. To switch views, use the pop-up menu at the top of the Info Inspector. Many of the metadata views are self-explanatory, such as *Caption Only*, but there are two special views toward the bottom of the list worth mentioning:

- **IPTC Core.** This is a special metadata schema that the IPTC group created to be widely compatible between different programs, and Aperture 3 supports it completely. The IPTC Core metadata view displays all the fields in this schema, and you can set values for all these fields.

- **Large Caption view.** Sometimes, if you're spending hours organizing your images, Aperture's small font can be tiring on your eyes. To make things easier, the Large Caption view, shown in Figure 4.10, has only one field in it, Caption, but the text and field sizes are larger.

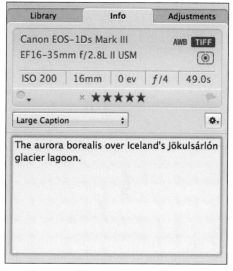

4.10 The Large Caption metadata view makes it easier on the eyes.

Fortunately, these metadata views are not set in stone and are quite customizable. The easiest way to customize them is to rearrange the items. Perhaps, for example, you want the File Name field to appear next to the Version Name field in the general view. To do so, move your mouse over the File Name label so that it's highlighted. Then drag and drop the field wherever in the list you want it to appear. The other fields animate out of the way to help you tell where you will drop the field.

However, Aperture's metadata view customization goes far beyond just rearranging preexisting fields. It's also possible to add and remove fields from views as well as to create a completely custom view. Here's how to get started:

1. **From the Metadata Views pop-up in the Info Inspector, choose the Edit item at the bottom of the menu.** The Metadata Views dialog opens, as shown in Figure 4.11. On the left side of this dialog is a list of your metadata views, and on the right side is a list of all possible metadata fields that Aperture knows about. When you click on a view in the list on the left, you see that certain fields become selected in the right list. A check mark next to an item means it's part of the metadata view.

4.11 The Metadata Views customization dialog helps you create exactly what you need.

2. **From here you can do the following:**

- **Add or remove a field from a preexisting metadata view.** Select the view on the left and select or deselect the field's check box on the right.

- **Rename a view.** Double-click its name on the left and type a new name.

- **Create a new view.** Click the Action pop-up menu on the bottom left of the window, choose New View, type its name, and select fields to include from the right.

- **Edit a copy of an existing view.** Select the view and choose Duplicate View from the Action pop-up menu.

- **Delete a view.** Select the view and choose Delete View from the Action pop-up menu or press Delete on your keyboard. Be careful, as Aperture does not prompt you about whether you're sure you want to delete this view.

- **Rearrange the views so that ones you use more frequently are at the top of the list.** Select the appropriate item in the Metadata Views list and drag and drop it to wherever you want it to be ordered.

3. **Click OK when you finish customizing your metadata views.**

Setting metadata

While some values, like image ISO, are read-only, it's possible and necessary in most cases to set most values manually. For example, the camera and computer can't automatically guess what the image caption should be. To set a value, simply click in the appropriate metadata field in the Info Inspector and start typing. When you finish, either press Tab to go to the next field or click outside the current text field.

There are a couple special fields where you don't type a value. To set a value for the Rating, Flag, and Label fields, click on the desired value. For the IPTC Core date created field, even though it's prepopulated with the image date, it's possible to change this value by either clicking on the date and typing a new date or by using the stepper buttons on the right side of the field to adjust the date and time up or down.

Caution Although Aperture lets you type long values for any metadata field, the IPTC Core specification limits certain fields. For example, a title can be at most 64 characters long, each keyword phrase can be at most 64 characters long, and instructions can be at most 256 characters long.

To quickly clear all IPTC metadata from an image, select the image and choose Clear IPTC Metadata from the Info Inspector's Action pop-up menu.

Genius If you're using referenced files and use another program such as Adobe Photoshop to update an image's metadata outside of Aperture, select the image and choose Metadata ➪ Update from Original to import the image's new metadata back into Aperture.

Managing and applying presets

As you start to work with metadata, you might find yourself typing certain values (such as your contact information) over and over again. To avoid always having to retype these values, you can create a Metadata Preset containing multiple values to apply when needed, even on import.

To start creating a preset, choose Aperture ➪ Presets ➪ Metadata or choose Manage Presets from the Info Inspector's Action pop-up menu. Aperture opens the dialog shown in Figure 4.12.

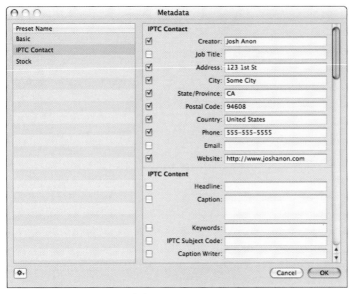

4.12 The Metadata Presets dialog.

Notice how this dialog is very similar to the Metadata Views dialog, but on the right side there are fields for setting values. To create a Contact Metadata Preset, follow these steps:

1. **In the Metadata Presets dialog, choose New Preset from the Action pop-up menu.**

2. **Type its name, *IPTC Contact Information,* into the table row on the left that Aperture automatically makes editable.**

3. **Select the check box next to each contact field on the right that you want to use, and type a value for each field.**

4. **Click OK when you finish.**

Now when you select an image and click the Action pop-up menu in the Info Inspector, you see your IPTC Contact Information preset under the Append with Preset and Replace with Preset menus. Selecting IPTC Contact Information from the Append with Preset menu adds the preset's information to whatever values you set for the image. Be careful — as if you manually typed a field like your e-mail address into the image's metadata — because choosing Append with Preset leaves you with duplicate values in your image's metadata. Choosing Replace with Preset clears out the image's values for all the fields in the preset, replacing them with the values in the preset.

If you type values onto an image and want to use those values to set up a new preset, select the image and choose New Preset from Version from the Action pop-up menu in the Info Inspector. Aperture opens the Presets dialog with this new preset selected and ready for you to rename.

A unique feature of the Presets dialog is that it's possible to export and import presets, making it easy to share them among multiple computers. To export a preset, do the following:

1. **In the Metadata Presets dialog, select the preset in the list.**

2. **Choose Export from the Action pop-up menu.**

3. **Choose a folder to export the preset to.**

4. **Give your preset a unique name.**

5. **Click Export.** Aperture creates an *.apmetadata* file that you can share with another computer.

Similarly, to import a preset, open the Metadata Presets dialog and choose Import from the Action pop-up menu. Find the *.apmetadata* file within the Import dialog, select it, and click Import.

Genius

If you already have the *.apmetadata* file selected in the Finder, drag and drop the file onto the Import panel. Aperture will automatically go to its folder and select it.

Adjusting Date and Time after Import

One of the most annoying pieces of metadata to work with is image date and time. It's very useful to figure out when a shot was taken and if it's a sunrise or sunset, and you've probably set the date and time on your camera, but what happens when you shoot outside your normal time zone or forget to update the time for daylight saving time? Fortunately, Aperture lets you adjust an image's capture date and time both while importing (see Chapter 2) and after the fact.

To adjust an image's date and time, follow these steps:

1. **Select either a single image or group of images.**

2. **Choose Metadata ⇨ Adjust Date and Time.** Aperture displays the dialog shown in Figure 4.13.

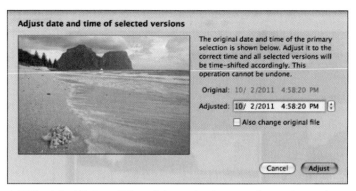

4.13 The Adjust Date and Time dialog makes it easy to fix your images' time stamps.

3. **Type the desired time into the Adjusted field.**

4. **Select the Also change original file check box if you want Aperture to adjust the creation date on the originals as well as the image time within Aperture.**

5. **Click Adjust.** Aperture adjusts the primary selection to the displayed time and adjusts any other selected images relative to how you changed the primary selection. For example, if you set the time to be an hour earlier, Aperture subtracts an hour from all the other selected images.

Working with Keywords

While many of the different metadata fields are simple and straightforward, keywords deserve special attention. Keywords are special identifiers that you put on an image to help describe it, from the scientific name of an animal in the photograph to a word to describe the image's overall mood. Keywords make it easy to search for an image or to make a Smart Album, web page, book, or more based on a particular keyword.

Aperture provides a number of tools to help you add keywords to your images, including the Info Inspector, Keyword control bar, and Keywords heads-up display (HUD), as well as a central Keywords library that stores your custom keyword hierarchy. Later in this section, we cover how to export your custom Keywords library to another computer.

Start with the simplest tool to set keywords and work your way up. In the Info Inspector, switch to the General view or some other view that shows the keywords field. Click in that field and start typing a comma-separated list of values that describe your image, such as *Pacific Ocean, surf, stormy sky*. When you finish, press the Tab key to move to the next field or click outside the keywords field to confirm the values you entered. To remove a keyword, delete it from the keywords field.

Note

We recommend selecting the Check Spelling While Typing option when typing keywords and captions. To enable it, Control+click on the keywords (or caption) field and choose Spelling and Grammar ➪ Check Spelling While Typing if it's not already selected.

When you start typing keywords for the next image, assuming you start with the same few letters, Aperture's AutoFill feature fills the rest of the keywords field with the same keywords you typed the first time. For example, if you typed *Pacific Ocean, surf, stormy sky* for the first image and start typing *Pac* for the second image, Aperture by default suggests auto-completing the keywords with *Pacific Ocean, surf, stormy sky*. This is useful when keywording very similar images because it can help save you typing. But it can also be frustrating if there's a typo in the suggested keywords, because Aperture continues to suggest that you auto-complete your typing with the typo. Fortunately, Aperture provides a way to edit the AutoFill values.

1. **Choose Metadata ➪ Edit AutoFill List.** Aperture displays the AutoFill Editor dialog, as shown in Figure 4.14, containing all the values you've ever typed for each metadata field.

2. **To adjust the keywords AutoFill values, scroll down until you see the IPTC Keywords group, and open the group.** Each table row represents a set of keywords that Aperture tries to auto-complete as you type.

3. **To edit a row, double-click on it and type any adjustments.**

4. **To remove a row, select it (or multiple rows), and click the Remove (–) button.**

5. **Repeat this process as needed, adjusting values for other fields such as IPTC Caption as well.** This dialog also lets you add new AutoFill values for some fields, though not IPTC Caption or Keywords. To do so, select the field name, click the Add button, and type a new value.

6. **Click Save when finished.**

4.14 The AutoFill Editor dialog allows you to edit the autofill values that Aperture uses when you enter metadata.

The Keywords control bar

Another way of adding keywords to images is to use the keywords controls in the control bar. To show the keyword controls, first make sure the control bar is visible by choosing Window ➪ Show Control Bar. Then show the keyword controls by choosing Window ➪ Show Keyword Controls. You see the area indicated in Figure 4.15.

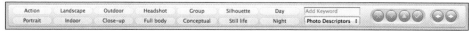

4.15 The keyword controls in the control bar.

There are three main controls in this area. The first control is the Add Keyword text field. Select an image, type a new keyword into this field (Aperture will auto-complete it if you've used the keyword before), and press Return to add the keyword to the selected image. To remove a keyword from an image, select the image, type the keyword into this field, and press Shift+Return.

The next control is the group of keyword buttons on the left. Select an image and click one of these buttons to assign that keyword to the image. The first eight (going top to bottom from left to right) are also assigned the keyboard shortcut Option+Keyword Number 1–8. The Metadata ➪ Add Keyword menu shows the same values as the keyword buttons with the hotkeys, and selecting a keyword in that menu also adds it to an image.

If you have multiple images selected, then by default Aperture adds the keyword to every selected image. If you have Primary Only (which is covered in Chapter 3) enabled, then Aperture only adds the keyword to the primary selection.

To remove a keyword, hold down the Shift key while clicking the keyword button or pressing the keyboard shortcut, or choose Metadata ⇨ Remove Keyword. To remove all keywords, select the image and choose Metadata ⇨ Remove Keyword ⇨ Remove All Keywords.

The last control is the Keyword Preset Group pop-up menu. A keyword preset group is a collection of related keywords, such as the People and Snapshots presets that Aperture ships with. This pop-up menu contains a list of presets, and switching presets changes the keywords assigned to the keyword buttons as well as the contents of the Metadata ⇨ Add Keyword and Metadata ⇨ Remove Keyword menus. Use the comma (,) and period (.) keys to switch between keyword preset groups.

Editing button sets and keywords

While the default keyword preset groups cover a wide range of common keywords, you'll more than likely want to create your own groups. To begin, choose Edit Buttons from the Keyword Preset Group pop-up menu. Aperture displays a dialog that looks like Figure 4.16.

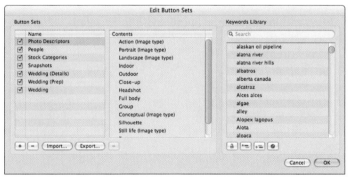

4.16 The Edit Button Sets dialog.

The left side of this window contains controls to manage your preset groups, which are called Button Sets in the dialog. The right side of this dialog is the Keywords library, which contains every keyword you've ever assigned to an image as well as some preinstalled keywords.

Keywords library

Before we can discuss creating new preset groups, we need to take a short detour to talk about the Keywords library. The Keywords library, which is also accessible via the Keywords HUD that is

discussed in the next section, is where you manage all your keywords. Here, you can add, remove, and change keywords as well as create hierarchy among keywords.

The first button on the left, Lock/Unlock Keywords, lets you lock your Keywords library so that you can't make any changes. At first it might seem odd that you'd want to lock your Keywords library. However, often photographers use a standard keywording vocabulary for their images. If you take the time to enter that vocabulary into Aperture, locking your keywords ensures that you don't accidentally use a keyword not in the keyword vocabulary. If you try to type a new keyword when your Keywords library is locked, Aperture prompts you to either cancel or unlock the library.

To find an existing keyword, either scroll through the list to find it or start typing the keyword in the Search field at the top to filter the list. Once you find the keyword you're looking for, double-click it to change it; for example, to fix a typo. Note that this is a live update, and if you're using that keyword in any image, Aperture prompts you to make sure you want to update that keyword in every image to which it's applied.

To delete a keyword, select it and click the Remove Keyword button or press the Delete key. Again, if this keyword is in use, Aperture prompts you to confirm that you truly want to delete it, as deleting it removes it from any image to which it's applied.

Adding a keyword is slightly complex because keywords in Aperture are hierarchical. For example, say that you create a *bird* keyword, and you have a bunch of shots of parrots to tag. Rather than having to apply *bird* and *parrot* keywords to each image, wouldn't it be great if you could make *parrot* a child of *bird* so that any time you applied *parrot* to an image, it automatically was also tagged with *bird*? Aperture's keywording structure lets you do this. Let's look at how:

1. **Click the Add Keyword button indicated in Figure 4.17 (on the left).**

2. **Type *bird*.**

3. **Make sure bird is selected, and click the Add Subordinate Keyword button.** Notice how a disclosure triangle appears next to *bird*.

4. **Type *parrot*.**

5. **Select *parrot*, and click the Add Subordinate Keyword button.**

4.17 The Add Keyword and Add Subordinate Keyword buttons.

6. **Type *eclectus*.**

7. **Select *bird* again.**

8. **Click the Add Keyword button.**

9. **Type *eagle*.** Notice how it's added at the same level as *bird*.

10. **Click and drag *eagle* onto *bird* so that *bird* becomes highlighted.** When you let go, Aperture makes *eagle* a child of *bird*.

What you just did was to make a new parent keyword, *bird,* with two children, *parrot* and *eagle.* Furthermore, *eclectus* was added as a child to *parrot.* Now, any image tagged with *eclectus* will also have the *parrot* and *bird* keywords, and any image tagged with *eagle* will also have the *bird* (but not *parrot* or *eclectus*) keyword. However, any images tagged only with *bird* will not be tagged with *eclectus* or *eagle.*

Genius

You can drag and drop keywords onto and above other keywords to easily change their hierarchy.

Any hierarchy updates you make are also live. If you make a keyword that's in use (*hawk*) or the child of another keyword (*bird*), Aperture prompts you to make sure you really want to do so. After you make the change, the images adjust accordingly (all the images you tagged with *hawk* are also now tagged with *bird*).

If you create a keyword hierarchy such as *bird/parrot* and then create another hierarchy, such as *parrot/eclectus/male* and *parrot/eclectus/female,* at the top level it's easy to merge the two together. Click and drag the top-level *parrot* onto *bird.* Aperture warns you that there's a keyword with the same name at the destination hierarchy level and asks if you want to merge hierarchies. Click Merge, and now you have *bird/parrot/eclectus/male* and *bird/parrot/eclectus/female* keyword hierarchies.

Customizing button sets

Under the Button Sets group are two columns: Name and Contents. The Name column represents the different groups of keywords you see in the pop-up menu. To temporarily disable a group so that it still exists but doesn't appear in the pop-up menu, deselect the check box by the group's name. The Contents column lists all the keywords that are part of each group.

Underneath the Name column are four buttons: Add (+), Remove (–), Import, and Export. To create a new keyword preset group, click the Add button and then give your preset group a name. Next, you need to add contents to this group. To do so, either find an existing keyword or add a new one. Once you find the desired keyword (which can be anywhere in a keyword hierarchy, too), drag and drop it from the Keywords library to the Contents column.

Rearrange items in the Contents column by dragging and dropping them to the desired location, and delete an item by selecting it in the list and either pressing the Delete key or clicking the Remove button below the Contents column. Remember, you can use the keyboard shortcut Option+1 through 8 to assign the first eight keywords to an image.

Once you're happy with your keyword preset group, click OK to close the dialog. Note that you can also export the keyword preset group by selecting it in the Name column and clicking Export. Aperture exports it as a PLIST file that you can import into Aperture on another computer by opening the Edit Button Sets dialog, clicking Import, and selecting the exported PLIST file.

The Keywords heads-up display

The last way to apply keywords to an image is by using the Keywords heads-up display (HUD) shown in Figure 4.18. Open the Keywords HUD by choosing Window ⇨ Show Keywords HUD (Shift+H) or by clicking the Keywords button in the toolbar. The contents of the Keywords HUD should look very familiar to you — they're identical to the Keywords library that was covered in the previous section. Rather than having to use the Edit Button Sets dialog to access your Keywords library, the Keywords HUD provides direct access, including all the features (add/delete/reorganize keywords) described previously.

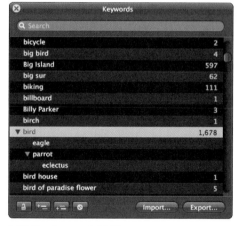

4.18 The Keywords HUD.

Genius Use the Export and Import buttons in the Keywords HUD to share your custom keywords between computers.

To assign a keyword to an image, drag and drop the keyword onto the image, either in Browser or Viewer. As described previously, if you have a hierarchy of keywords such as *bird/parrot/eclectus*, dropping *eclectus* onto your image also tags it with *bird* and *parrot*.

If you have multiple images selected, dropping a keyword onto one image adds it to all selected images. However, if Primary Only is selected, then Aperture only adds the keyword to the primary image.

Adding Custom Metadata

While there are many standard metadata tags, sometimes you really want to add a custom field to an image. For example, we add a *Stock Agent* field to our images to keep track of which agency represents which images. There are two parts to adding custom metadata: creating the field and adding it to a view. To create a new field, follow these steps:

1. **Open the Info Inspector.**

2. **Select Manage Custom Fields from the Action pop-up menu.** Aperture displays a dialog like you see in Figure 4.19.

3. **To add a new field, click the Add (+) button and type its name.**

4. **To delete a field, select it and click the Remove (–) button.** Aperture prompts you to confirm this deletion if you've set a value for this field in any image.

5. **Click OK to close the dialog.**

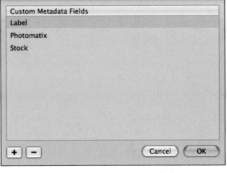

4.19 The Custom Metadata Fields dialog.

Use the techniques described earlier in this chapter regarding switching and customizing metadata views to add this new field to a metadata view.

Applying Batch Metadata Changes

While you will have to set some metadata values per image, such as *Caption*, there are others, such as *Copyright Notice,* that you'll want to set on a group of images. Aperture provides two ways to apply metadata in bulk: the Batch Change tool and the Lift and Stamp tool.

Using the Batch Change tool

To use the Batch Change tool, open the images whose metadata you want to change and choose Metadata ⇨ Batch Change. You will then see the Batch Change dialog, as shown in Figure 4.20. There are three main sections in this tool that allow you to adjust the time zone in your images, to change your images' filenames, and to add or remove metadata from your presets.

To adjust the time zone, select the Adjust Time Zone radio button. Then pick the time zone that your camera is set to from the Camera's Time Zone pop-up menu and the time zone you shot the images in from the Actual Time Zone menu. When you click OK, Aperture adjusts the time zone settings for your images.

The second block lets you rename your images using a naming preset (naming presets are covered in Chapter 2). Note that renaming a version only renames your image within Aperture. If you also want to rename

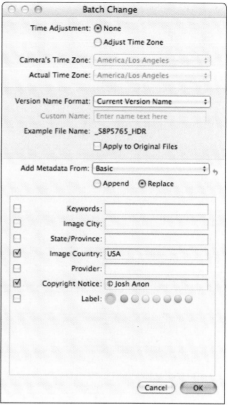

4.20 The Batch Change dialog allows you to adjust the metadata of many images at once.

your original files on the hard drive with this new name format, select the Apply to Original Files check box.

The last block is where you can change specific fields. Rather than giving you access to every possible field, Aperture displays a pop-up menu with your Metadata Presets. To set a new value, start by picking a preset that contains your desired field. Then choose whether you want to append the new value to the existing value or replace the existing value completely, select the fields for which you want to set values, type the value, and click OK. If you choose to replace the existing value, select a field and leave its value empty. Aperture clears the specified field from the selected images.

We've found that the built-in Basic preset has the fields we use most of the time (keywords, image city/state/country, and copyright notice) with batch change.

Using the Lift and Stamp tool

The other way to set metadata values in bulk is with the Lift and Stamp tool, which lets you lift values from one image and stamp them onto other images. Lift and Stamp is quite powerful because in addition to lifting metadata values like keywords and ratings, it also allows you to lift some or all of the adjustments you made to one image and to stamp those adjustments onto a group of images. We cover how to set adjustments in Chapter 6, and the procedure to lift and stamp them is identical to lifting and stamping metadata.

1. **Select the source image whose values you want to lift.**

2. **Choose Metadata ⇨ Lift Metadata and Adjustments.** Aperture opens the Lift & Stamp dialog, as shown in Figure 4.21.

3. **Select the check box next to each metadata value you want to lift.** For metadata groups, like IPTC in the previous figure, where Aperture only has a check box next to each group rather than each line, if there are fields that you don't want to lift, select the line with that value and press the Delete key.

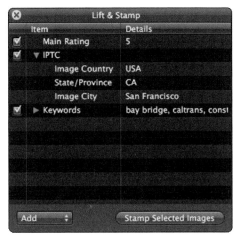

4.21 The Lift & Stamp dialog.

4. **Using the pop-up menu in the bottom left of this dialog, choose whether you want to add or replace the metadata on the destination images.**

5. **Select each image on which you want to stamp these values, and click Stamp Selected Images.**

Note

You don't have to select up front every image that you want to stamp. Simply leave the Lift & Stamp dialog open, select a new image, and click Stamp Selected Images until you've stamped every image.

Searching for Images

Throughout this chapter, we've talked a lot about how to add metadata to your images, but we've yet to talk about how to use that metadata to find images. There are two primary ways to search for an image in Aperture: using Browser's search field and filtering HUD to search within Browser's contents or making a new Smart Album that searches either within a project or your entire library. These two methods are quite similar and, in fact, use the same filter HUD to create a search query. The main difference is that using Browser's search field and filter HUD to search is a temporary operation. Typically, you'll search within Browser for a few particular images and then clear the search query. Smart Albums are more permanent, offering a way to essentially save a search query. The way Aperture searches within stacks isn't always obvious, and we clarify what happens for you after we explain basic searching.

Searching within Browser

In Chapter 1, the search field and Filter button were quickly pointed out but largely glossed over. As a reminder, you'll find them in the upper-right corner of Browser, but if they're not visible, choose View ⇨ Browser ⇨ Show Sort & Filter Controls.

Browser's search field is more than just a simple text search, though, providing easy access to common searches. When you click its pop-up menu, Aperture opens the menu, as shown in Figure 4.22, which has commands like Three Stars or Better and Rejected. Select one of these commands to filter Browser's contents, and click the Clear button that appears in the search field to clear the filter.

Earlier in this chapter, we mentioned how rather than deleting an image right away it's best to mark it as a rejected image first. If you look in the search field, you'll notice that it's set to *Unrated or Better* by default. This means that by default, Browser filters out and hides

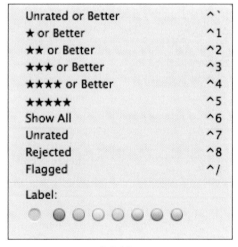

4.22 Browser's search field's pop-up menu.

your rejected images. If you want to also see your rejected images, either change the search field to show only your rejected images or set it to show every image within Browser's scope.

If you type some text into the search field and press the Return key, Browser also searches your image's metadata for the specified text.

To specify more complex search criteria, click the Filter HUD button to the left of the search field and Aperture opens the HUD you see in Figure 4.23. There are five key areas to this HUD. The title bar is the first, as it tells you the scope of this filter, whether it's a project, album, or library. The second significant area shows the controls at the top left that let you switch between matching all the selected criteria (meaning the results will meet every piece of criteria) or any of the selected criteria (meaning the results match one or more criteria). Near the top right is the Add Rule pop-up menu, which you use to add search criteria. The main, middle area of this HUD contains all your criteria. Last, the buttons at the bottom of the HUD let you create a new collection, whether it's an album, book, or other, from the search results.

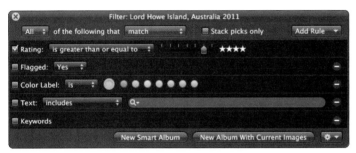

4.23 The Filter HUD.

Note
If the Stack picks only check box is selected, Aperture only examines the top image in a stack to see if it matches your search criteria. If it's not selected, Aperture searches within the whole stack.

Using the filter HUD is fairly straightforward. Pick whether you want to match all or any of the selected rules, add rules as needed by using the pop-up menu, select the rules that you want to be active, and specify the criteria for each rule, such as images with a yellow label and a four-star or higher rating. However, there are a few key rules that we want to point out:

- **Aperture Metadata.** Use this rule to search for custom metadata. Your custom metadata field appears in its field pop-up menu.

- **Attachment.** If your camera is capable of recording audio files, Aperture imports it as an attachment to an image (there's more on this in Chapter 9). The Attachment rule explicitly filters images that either have or don't have an attachment.

- **File Status.** This rule lets you search for managed, referenced, offline, online, or missing original images.

- **File Type.** The File Type rule allows you to find files that are video files, specific types of files (including RAW as a generic reference for all RAW files), and externally edited files.

- **Text.** While the Text rule should be fairly obvious, as it's a search for whether an image has a specific piece of text in its metadata, there's an option in the text field that we want to point out. If you click the pop-up menu in this rule's text field, you see the following useful options:

 - **Full text search.** This is the default; it searches all of an image's metadata.

 - **Limited text search.** This is faster, especially when searching a large collection of images, but it only searches caption, creation date, filename, keywords, project name, and version name.

If you want to save your search results as a regular album, meaning the contents won't be dynamically updated as you change your image's metadata, open the Filter HUD and click New Album With Current Images. If you want to save this search as a new Smart Album, whose contents will be dynamically updated as you change your images' metadata, open the Filter HUD and click the New Smart Album button. To make a book, slide show, Facebook album, and more, click the Action pop-up menu in the filter HUD and select the type of collection you want to create. When you finish searching in Browser, click the Clear (X) button in Browser's search field to clear the current search query.

Creating Smart Albums

To create a new Smart Album, start by selecting its scope in the Library Inspector. Specifically, if you want that Smart Album to only search within a project, select the project. If you want it to search within your whole library, clear your selection in the Library Inspector by clicking on the

word Albums right above the other library-level albums. Next, choose File ⇨ New ⇨ Smart Album, and Aperture opens Smart Settings HUD, as shown in Figure 4.24, which looks very similar to the Filter HUD.

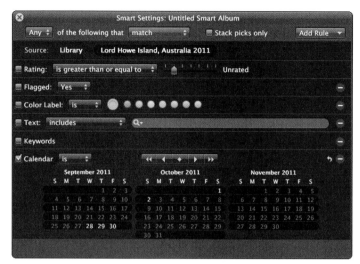

4.24 The Smart Settings HUD.

The Smart Settings HUD works almost exactly the same way as the Filter HUD, where you add rules and set criteria. The main difference is that it includes a Source row that tells you what scope the Smart Album's looking at. If you drag your Smart Album into a different scope within the Library Inspector, such as from the library level into a project and vice versa, the new scope's name appears as an option in the Smart Settings HUD for that Smart Album. Click the new scope's name to switch the Smart Album to only look at that scope. For example, if you drag a Smart Album you created at the library to a project named Odessa Canyon, click the Odessa Canyon button in the Smart Settings HUD's Source row to switch this Smart Album to only look at the Odessa Canyon project instead of your entire library.

The other difference is that the Smart Settings HUD doesn't have buttons on the bottom to create a new Smart Album or normal album because you're already creating a Smart Album when you see it. In fact, when you click New Smart Album within the Filter HUD, Aperture automatically closes the Filter HUD and opens the Smart Settings HUD for this new Smart Album with the exact same rules and criteria you selected in the Filter HUD.

Searching with stacks

Searching for images always gets a little confusing when you work with stacks, and we wanted to explicitly mention what happens.

By default, Aperture searches each image in the stack for a matching image. If it finds a match, it only displays the matching images from within a stack. However, it still displays a stack badge label and dark area around the image, as shown in Figure 4.25, indicating that the image is part of a stack.

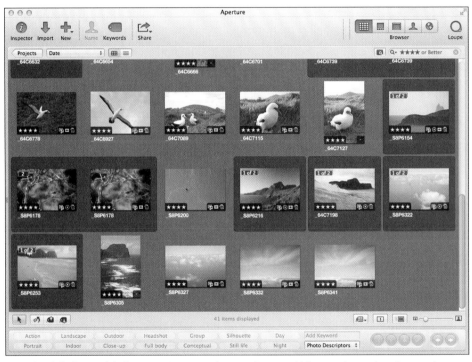

4.25 The default search behavior in Browser when one image within a stack matches the search criteria.

If you open the Filter HUD and select Stack picks only, Aperture only sees if the top image in a stack matches the criteria. If a three-star image is your stack pick but your stack contains a five-star image and you tell Browser to only display five-star images, it won't display this stack at all.

Writing IPTC Information to an Original

One frequent question people have is what happens to all their metadata if Apple stops support-ing Aperture down the road? Aperture 3 provides a command that lets you embed your IPTC metadata into an original file. To use this command, select your images and choose Metadata ⇨ Write IPTC Metadata to Original.

Caution Write IPTC Metadata to Original requires Mac OS X 10.6 or newer. It has no effect on OS X 10.5.

You might be wondering why you shouldn't use this command on all your images. While it should work fine most of the time, put simply, RAW was meant to be a read-only type of file. There's a chance that writing this metadata into the original will make the RAW file unreadable by other programs. While chances are that you'll be fine, we recommend testing this command with your RAW files and then making sure you can open that RAW file in another RAW converter before using this command on multiple images.

How Do I Use Faces and Places to Categorize My Images?

Faces and Places take advantage of cutting-edge face detection and face recognition technology as well as GPS information and Google Maps, even if your camera lacks these technologies. You use Faces and Places not only to identify people and places in your images but also to organize your images so you can see all the shots you have of a particular person or all the images you took in a certain location without having to keyword each one. Faces and Places now work across both iPhoto and Aperture, so once you identify and locate images in one app, the information is maintained if you open the same library in the other program.

Using Faces .128

Using Places .137

find photos of each person with a minimum of fuss. If you take advantage of Faces, years from now you'll be able to look at these photos and still know who's who. When you assign a name (or place) to a photo, Aperture automatically adds it to the keywords that are exported. If you've ever looked at old photos and wondered who you were looking at, it's easy to see why this feature is a huge advantage. In this section, we cover enabling Faces, using the interface, searching for photos of certain people, and changing names.

Enabling Faces

Aperture is set to scan every photo that you import as well as every image in your library if you update a library from an earlier version of Aperture for any and all potential faces. This is because the preference to enable Faces is selected by default. This search runs in the background but may slow some operations such as the initial import as well as the processing for extensive adjustments.

If you don't need to identify the people in your photos, or you want to speed up your import or adjustments, you can turn off Faces. Your downloads will be faster, and you can turn on Faces whenever you want to use it. To turn off Faces (or to turn it back on) follow these steps:

1. **Choose Aperture ⇨ Preferences.** The Preferences dialog opens.
2. **Click the General tab and select or deselect the Enable Faces check box.**
3. **Click the Appearance tab and select or deselect the Show corkboard background for Faces check box as desired.** This is completely a matter of personal preference, but we like the corkboard because it makes it obvious that we're in the Faces view.
4. **Close the Preferences dialog.**

Caution If you enable Faces after a period of having it disabled, Aperture automatically scans all your projects looking for faces. This occurs as a background task with minimal interruption to your activities unless you're trying to make image adjustments at the same time.

Using the Faces interface

There are two main ways to use the Faces interface: via the Faces button and via the Name button. Using the Name button is covered shortly. Keep in mind that the Faces interface is a Viewer mode like Split view and Places. The Faces view displays the photos with faces that Aperture detects, including those that you've named as well as those that are still unnamed. Images that you've named appear on the corkboard where the Viewer normally appears, and images with unnamed faces appear on the bottom where the Browser normally sets.

Do one of the following to access the Faces view via the Faces icon, as shown in Figure 5.1:

- Select a specific project, album, or folder in the Library Inspector to show the faces just for that entity and click the Faces icon.

- Select the Faces icon in the Library Inspector to display all faces in the entire library.

Faces in the Library Inspector

Faces icon

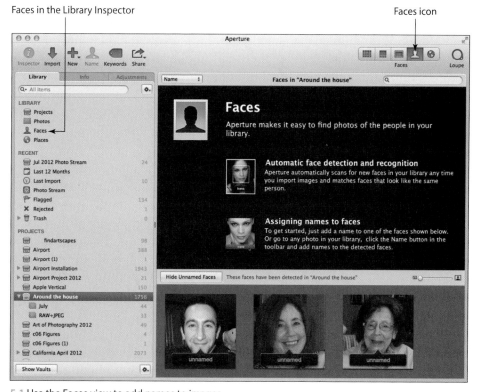

5.1 Use the Faces view to add names to images.

If you prefer shortcuts, press Shift+F to enter Faces.

Assigning names using Faces

You can assign names to images from within Faces or from within the Browser by clicking the Name button. We begin by showing you how to use Faces to name your photos.

To assign names using Faces, follow these steps:

1. **Click the unnamed overlay on an image.** The overlay changes to type name, and then you do so. Aperture tries to use the information in your Contacts and Facebook to auto-fill the information. In Figure 5.2, Jack's name is added to his photo.

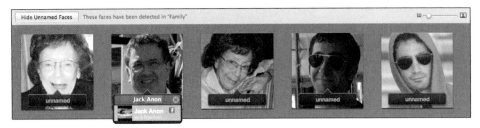

5.2 Click the unnamed overlay and type a name.

2. **Press Return and the image appears on the corkboard with the name you assigned.**

3. **As you mouse over the thumbnail on the corkboard, a small *i* appears in the lower right of the thumbnail, as shown in Figure 5.3.** Click the *i* to reveal the Info dialog also shown. Choose how much information you want to include such as the person's address and phone number, e-mail address, and so on.

5.3 Hover the cursor over the image until the *i* appears in the lower-right corner, and then click the *i* to fill in information about the person in the resulting dialog.

4. **Click View Photos to see other photos that you've identified (as Josh in this example) as well as any pictures that Aperture thinks might contain the same person, as shown in Figure 5.4.** You can also view other images of this person that you've previously identified by moving your cursor over the thumbnail in this dialog.

5.4 Use this dialog to see all the pictures of this person that you've named so far and any images that Aperture thinks might be that person. When you click Faces, Aperture displays close-ups of the Faces rather than the entire image. Click Photos to view the entire image.

Genius

To set one of the images as the key photo in the corkboard, click on the thumbnail. That image will be displayed whenever you open that dialog as well as in the corkboard.

5. **Click Confirm Faces at the bottom of the interface.** A new view appears with the images you've identified on the top and images that Aperture thinks might be that person on the bottom.

131

6. **Click the images to confirm as sharing the same name, as shown in Figure 5.5, and then click Done.** Aperture returns to the previous interface and those images join the original in the top part of the interface.

 • **To reject an image, hold down the Option key and the overlay changes to say Click to reject.** If you click, the overlay turns red and says Not the Person.

 • **If you mistakenly click an image and confirm the wrong identity, hover the cursor over the name and you'll see an option saying Click to reject as shown in Figure 5.6.** After you click, the bar at the bottom of the image turns red and says Not the person.

7. **Click All Faces to return to Faces to identify more photos.** To exit Faces and return to editing images, choose Split View, Viewer, or Browser.

5.5 Click Confirm Faces to verify the name on the photos.

Genius

To quickly assign names for unnamed images in the lower part of the Faces interface, select the images and drag them onto named images on the corkboard. The name is automatically assigned to the images without you having to type each one.

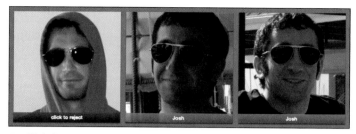

5.6 Click the name to reject the name if you make a mistake.

Sometimes Aperture misidentifies an image as having a face or if there is a face, it's not someone you want to identify. In that case, as you hover the cursor over the thumbnails in the bottom of the Faces view, the option Skip appears as an overlay on the thumbnail, as shown in Figure 5.7. Click Skip to remove it from Faces.

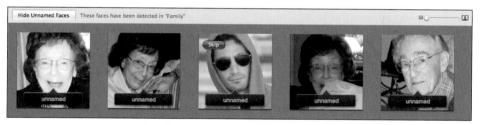

5.7 Hover the cursor over the thumbnail and click Skip to remove an image from Faces.

Assigning names using the Name button

If while going through your images in the Viewer and/or Browser you discover images with faces that Aperture missed or images to which you haven't assigned names yet, make sure Faces is enabled in Preferences.

Then to assign names using the Name button, as shown in Figure 5.8, follow these steps:

1. **Select the image(s) in the Browser.**

2. **Click the Name button.** An overlay appears that you use to assign a name, as shown in Figure 5.9.

5.8 Click the Name button to assign names while in Viewer mode.

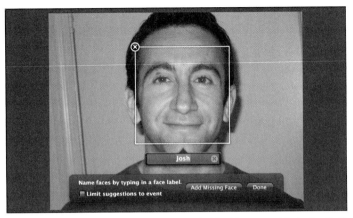

5.9 Use the overlays to assign names to individual images while in the Split view or Viewer mode.

3. **Click Add Missing Face, if necessary.** A rectangle appears that you drag and resize to frame the face. Then click the Click to Name button and type the name. If there's more than one person in the photo, click the button again and repeat the process.

4. **Click Done to exit and continue viewing your images, or click the right arrow next to the name to enter Faces.** Doing the latter opens Faces showing all images of that person that have been identified on top and images that might be that person on the bottom. Continue as described earlier to confirm or reject these other images.

Correcting a name

If while viewing images within a project or album you discover you've accidentally given someone the wrong name, you can easily correct it by taking these steps:

1. **While in the Viewer or Split view mode, select the image with the incorrect name.**

2. **Click the Name button in the toolbar.**

3. **Click the name, and then type the correct name in the text field.**

4. **To delete the name entirely, click the X in the upper-left corner of the positioning box overlay that's over the person's face.** The image becomes unnamed and is not included in Faces. To leave the image in Faces but have it become unnamed, click the X to the right of the text field containing the name.

5. **Click Done when you've renamed or unnamed the image.**

If you discover that you've misspelled someone's name on all the images in that project or album, select the Faces view, double-click the name on the corkboard, and retype it correctly. Aperture updates all the images associated with the name.

Finding people using Faces

One of the purposes of adding names to your photos is so that you can easily find pictures of that person. To find images of a certain person that you've already named using Faces, follow these steps:

1. **In the Library Inspector, choose Library ⇨ Faces.**

2. **Type the person's name in the search field at the top right.** Aperture limits the corkboard display to that person.

3. **Click the small *i* in the lower-right corner of the person's photo on the corkboard.**

4. **Click View Photos or mouse over the thumbnail to see the various photos of the person as well as photos that Aperture thinks might be that person.** Note that with this procedure Aperture displays all images of this person that it finds anywhere in the library, not just within a specific album or project.

5. **To add photos to the named photos, choose them in the Browser and drag them into the Viewer.** Aperture automatically adds the Faces information.

6. **Double-click to open a particular photo in the Viewer.** To view the image within its project, choose File ⇨ Show in Project. Aperture automatically displays the image within the project or album.

Another approach is to create a Smart Album for each person. To create Smart Albums for people, do the following:

1. **Name a photo in Faces as described earlier.**

2. **While in Faces, drag the thumbnail of the named photo to the word Albums to create a new Smart Album containing just images of that person found anywhere in the library, as shown in Figures 5.10 and 5.11.** If the Smart Album is at the library level, it will contain all images of that person and will update when you import new images of that person (and confirm the identity of the person in Faces). If you create the Smart Album at a more specific level by dragging the thumbnail to a specific folder, project, or album, then it will update only when new images are added at that level.

3. **To search for photos of a person, choose the appropriate Smart Album.** It doesn't get easier than that!

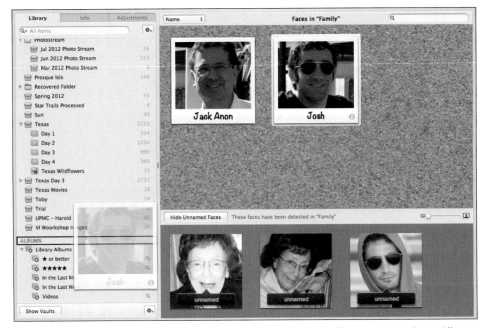

5.10 Drag an image onto Albums in the Library Inspector to automatically create a new Smart Album that updates to contain all images of that person when you import and identify more images.

5.11 Click the Smart Album to view all images of that person within the library.

Genius

Using Places

Knowing exactly where you took an image or choosing a location and quickly seeing all the photos you made there can come in handy. Places uses the built-in GPS information that some cameras offer to automatically plot where you took the images. But if your camera doesn't offer GPS data, you can still take advantage of Places. You can use GPS data from an iPhone or other GPS tracking device, or assign location information manually. In this section, we cover how to enable Places, how to assign locations to images regardless of whether your camera has a GPS feature, as well as how to search for images by location.

Enabling Places

By default, Aperture's Preferences are set to enable Places. However, you must have Internet access for Places to work. If you want to disable (or reenable) Places, follow these steps:

1. **Choose Aperture ⇨ Preferences.** The Preferences dialog appears.

2. **Click the Advanced tab.**

3. **In the Look up Places pop-up menu, choose Never to disable Places and Automatically to enable it, as shown in Figure 5.12.** In addition you can specify whether to include location information for published photos.

4. **Close Preferences.**

Assigning locations to photos

There are a variety of ways to assign locations to your images depending on your situation. If your camera embeds GPS data into the files, Aperture automatically assigns locations to each file as long as Places is enabled, as shown in Figure 5.13. (As you increase the magnification of the map, more individual pins appear.)

5.12 Set Preferences to enable or disable Places.

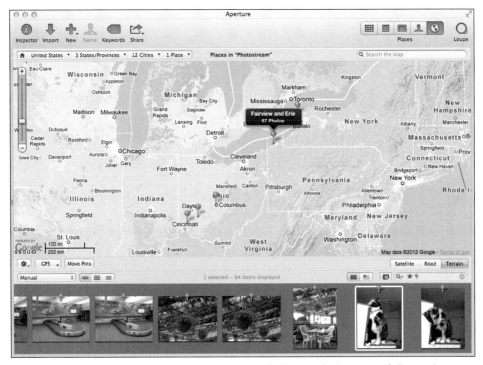

5.13 If your camera is GPS enabled, Aperture automatically displays the locations of all your shots.

In addition, click any of the sections of the Places bar at the top of the interface to see a list of all the locations that you've assigned so far. Then click any of the places to see the images you took at that location, as shown in Figure 5.14.

If your camera doesn't have a GPS feature, you can drag images to a location on a map, use a search feature within Places to assign a location, or use the search feature on the map located in the Info Inspector. You can also use GPS information from a handheld device. All of these methods are covered next.

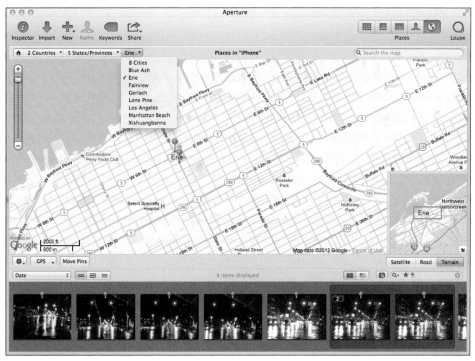

5.14 Use the Places navigation bar to display photos taken at specific locations and to see where you've taken shots.

Dragging images onto the map using Places

One of the easiest ways to assign locations is to just drag the images onto the map. To use this approach, do the following:

1. **Open Places by clicking the Places icon in the upper-right part of the interface, as shown in Figure 5.15.**

5.15 Click the Places icon to open Places.

2. **⌘+click and use the cursor to draw a rectangle over the area of the map you want to see in detail.** The map changes magnification to show that area in as much detail as possible. Then click and drag the +/− slider to increase or decrease the magnification as necessary, or drag two fingers up or down the trackpad to change the magnification.

3. **Select one or more images in the Browser and drag them onto the map.** A pin appears on the map with the name of the location and the number of images assigned to that pin, as shown in Figure 5.16.

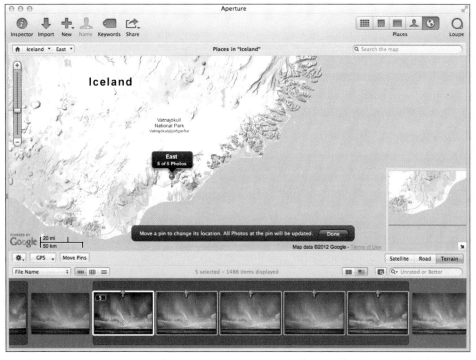

5.16 Drag one or more images to the map to create a new pin and assign the images to that location.

4. **Choose the Viewer, Split view, or Browser to return to the regular Aperture interface.**

If a pin already exists at a certain location and you want to add more photos to it, select the photos and drag them onto the existing pin. Initially, it may appear as though Aperture is trying to create a second pin, but if you superimpose the pins, the images will be added to the initial pin.

Using the Info Inspector map to assign a location

If you prefer to assign locations while still using one of the regular viewing modes, use the map on the Info Inspector to assign locations to one or more images at a time. To assign locations using the Info Inspector map, follow these steps:

1. **Select one or more images in the Browser.**

2. **Click the Info tab in the Inspector.**

3. **Click the Show/Hide Map button at the bottom of the panel, as shown in Figure 5.17.** A small version of the Places map appears.

4. **Type the location in the search field.** A list of possible locations appears. Choose the best one. The map zooms in to that location, as shown in Figure 5.18. Click the +/– buttons as needed to increase or decrease the magnification of the map.

5. **Click the check mark to assign the location or click the X to cancel.** If you click the check mark, Aperture assigns the location to the images.

Show/Hide Map button

5.17 Click the Show/Hide Map button to reveal the map in the Info Inspector.

5.18 Use the map in the Info Inspector to assign locations.

Note

If you create multiple pins that are close together, as you decrease the magnification of the map, Aperture merges the pins together to keep things more orderly. As you increase the magnification, the number of pins expands to show all the pins that you've created.

Using the search option in Places to assign a location

At times it can be awkward to manipulate the map to show you the precise location that you need. For those times you can use the search feature in Places to have Aperture suggest a list of possible places.

To use the search feature to find and assign locations, do the following:

1. **Click the Places icon to open Places.** The Viewer changes to a map.

2. **Select one or more images in the Browser.**

3. **Type the location in the search field.** A list of possible locations appears. Choose the best one, then the map zooms in to that location, as shown in Figure 5.19.

4. **Click Assign Location at the bottom of the pop-up menu.**

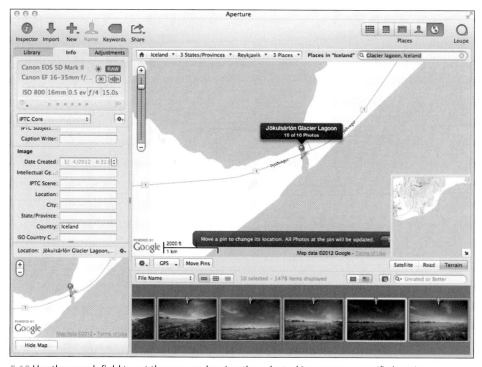

5.19 Use the search field to set the map and assign the selected images to a specific location.

Creating and assigning custom locations

If you take a lot of photos in a certain area, you may want to be very detailed about the locations you assign or you may want to create a custom name such as "Home" or "Joe's House" and so on. To create and assign custom locations, do the following:

1. **Select the image or images to assign to the new location in the Browser.**

2. **Choose Metadata ⇨ Assign Location from the main menu bar, as shown in Figure 5.20.** A new dialog appears.

3. **Type a location in the search field.** In some areas, this can even be a local landmark or a national park and so on, although in other areas you may be limited to the name of a town. A list of possible locations appears under Google Results on the left.

4. **Choose the nearest location.** The map changes to a highly magnified view centered on that location with a large blue circle indicating the area included in that location, as shown in Figure 5.21. Click and drag the double blue arrows on the edge of the circle to expand or limit the area. If necessary, drag the blue circle precisely where you want it. Note that you can choose a satellite view, road view, or terrain view for the map.

5. **In the Place Name text field, type a custom name if desired.** This is where you can rename a place "Home" or anything else.

5.20 Choose Assign Location from the Metadata menu to assign custom locations.

6. **Click Assign to create a pin with that name for the images that you selected.** When you return to this dialog at any time in the future, all the custom places and names appear initially.

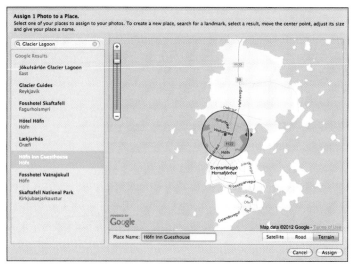

Assign 1 Photo to a Place.
Select one of your places to assign to your photos. To create a new place, search for a landmark, select a result, move the center point, adjust its size and give your place a name.

Google Results

Jökulsárlón Glacier Lagoon
East

Glacier Guides
Reykjavik

Fosshotel Skaftafell
Fagurhólsmýri

Hótel Höfn
Höfn

Lækjarhús
Öræfi

Höfn Inn Guesthouse
Höfn

Fosshotel Vatnajokull
Höfn

Skaftafell National Park
Kirkjubaejarkaustur

Place Name: Höfn Inn Guesthouse Satellite Road Terrain

Cancel Assign

5.21 Modify the size and location of the blue circle to define the precise location you want, and then add a custom name.

Genius If you discover you've assigned the wrong location to a group of images, select those images and use the Assign Location dialog to reassign a new location to those images.

Assigning locations using iPhone GPS information

One of the really cool features in Places is that if your camera doesn't record GPS information but you have an iPhone, you can use the GPS information from the iPhone and assign it to the rest of your photos. You don't even have to upload the images from the iPhone!

To use the GPS location from your iPhone to assign a location to your images, do the following:

1. **In the field, take a quick shot with your iPhone.** Be sure you photograph something that you'll easily recognize as being a shot of the location. If you take a close-up of a person, you may not recall that you intended to use the GPS information from that shot.

2. **After you upload the rest of your images into a project or album, click Places from the toolbar.**

3. **Connect your iPhone and then choose the GPS pop-up menu beneath the map.** Choose Import GPS from iPhone Photos. The display changes to show photos that are on your iPhone, as shown in Figure 5.22.

4. **Select the photo or photos that have the GPS information you need, and click OK.** Aperture adds each of the GPS points to the map.

5. **To assign photos to the points, select one or more images and drag them to the desired point.**

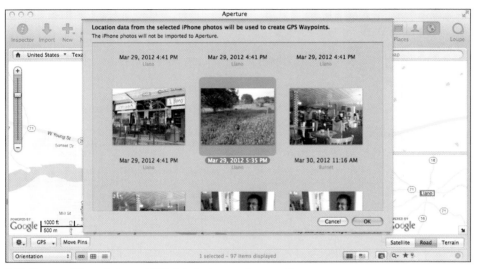

5.22 Use your iPhone to import GPS data for images from another camera.

Caution You must physically attach the iPhone. You can't download iPhone pictures and then try to retrieve the GPS information directly from them to apply to other photos. You can, however, use the pins Places creates for iPhone images that you've already downloaded and drag the new images from your camera onto those pins to assign location information.

Assigning locations using GPS receivers

If your camera doesn't support GPS but you have a separate GPS unit, use the GPS unit to record your locations while you're out shooting. It's helpful to make certain that the time setting in your camera matches the time settings on the GPS unit because Aperture can use the time information to determine which photos should be assigned to which locations. Otherwise, you'll need to manually assign images to the various locations. After you download your images into a project and the GPS tracks from the GPS unit, you need to import the GPS track file into Aperture.

Some GPS receivers allow you to download the GPS tracks directly, while others require that you use third-party software such as rubiTrack (www.rubitrack.com) to download the files to the computer first.

To import the GPS track files and assign images to waypoints, do the following:

1. **Select the project that needs the GPS file and then click Places in the toolbar to open the Places interface.**

2. **Click the GPS button and then select Import GPS Track.** A dialog appears showing your GPS tracks.

3. **Click the Choose Track File to navigate to the GPS track.** When the track is imported into the project, it appears as a purple line on the map when you're in Places view.

4. **In the Browser, select the image or images that you want to assign to a location.**

5. **Control+click the waypoint that you want to use as a location for the images, and then choose Assign Photos from the shortcut menu that appears as an overlay on the waypoint.** The waypoint's location information is assigned to the images.

To have Aperture automatically assign locations based on time information in the GPS track, do the following:

1. **Select a project containing a GPS track.**

2. **Select an image in the Browser and drag it onto a waypoint in Places.** A dialog appears at the bottom of Places asking if you want to assign location information to other images in your project based on time.

3. **Click Assign Locations to have Aperture automatically match the time stamps from the GPS files with the time stamps on the camera so that your images are automatically assigned to their correct locations on the map.**

Assigning location information using Projects view

If you shot all the images in a project at the same location, the fastest way to assign location information to them is to use the Projects view. To assign a single location to all the images in a project, do the following:

1. **Choose Projects in the Library Inspector to change to the Projects view.**

2. **Click the Info button on the lower right of the project thumbnail, as shown in Figure 5.23.** The Info HUD appears.

3. **In the Info HUD, click Assign Location.** The Assign Location interface appears, as shown in Figure 5.24. Choose a location from the list of custom places you've created under My Places, or type a location in the text field and then choose the closest match from the list that Google generates. To give the location a custom name, fill in the Place Name text field.

4. **Click Assign.** Each image in the project is assigned to that location.

5.23 Click the Info (*i*) button that appears over the project thumbnail while in Projects view to access the Info HUD.

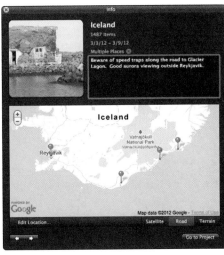

5.24 Use the Info HUD to assign a location as well as to add any other notes about the project.

Moving a pin

If you notice that a pin is not in precisely the right location as you zoom in, you can move the pin, and all the images that are assigned to that pin will move as well. To move a pin, do the following:

1. **While in Places view, click Move Pins.** A small overlay appears, as shown in Figure 5.25, and the pins change to purple.

2. **Use the +/– slider on the left to zoom in as far as necessary.**

3. **Move the pin to the more accurate location, and then click Done in the overlay.** All images move to the new location and the pin returns to red.

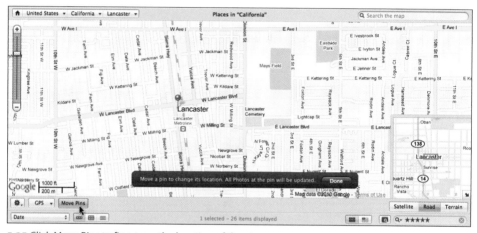

5.25 Click Move Pins to fine-tune the location of the pins.

Removing location information from an image

It's conceivable that you might want to remove location information from some images, particularly if you're sending an image to a client or contest or in a similar situation where you prefer to keep the precise location confidential. (Remember that you can also opt to have Aperture not include location information with exported images by setting the option in Preferences ⟡ Advanced.) To remove location information, do the following:

1. **Select the image in the Browser.**

2. **Open the Info Inspector, and click the Show Map button at the bottom of the panel to reveal the map.**

3. **Choose Remove Location from the Map Pane Action pop-up menu, as shown in Figure 5.26.**

You may find it even easier to remove a location from one or more images by selecting the image and then choosing Metadata ⇨ Remove Locations.

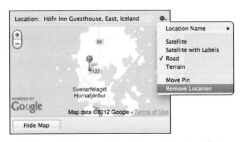

5.26 Use the Remove Location option to delete the place assigned to an image.

Finding images using Places

After you assign locations to your images, you can locate all the images you've taken at specific locations by using Places, creating a Smart Album, or using the Smart Settings HUD and the Filter HUD. To find all your images at a specific location using Places, as shown in Figure 5.27, do the following:

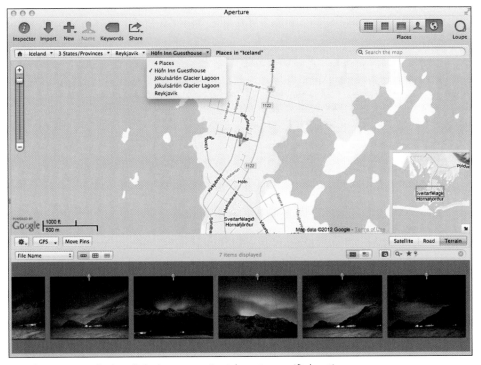

5.27 Aperture can display all the images you've taken at a specific location.

1. **Click Places in the Library Inspector.**

2. **Click the location from the bar at the top to limit the images displayed in the Browser to just the images at that particular location or click a pin directly.** This step automatically creates a Smart Settings filter in the Filter HUD.

 Alternatively, type the location in the search field. Any locations you've created whose names match the text appear at the top of the search results, while additional results generated by Google appear in the Google results at the bottom.

3. **Select the correct location.** Places view changes to display the pin for that location and the bar across the top.

4. **Click the pin to have Aperture select those images within the Browser.**

When you opt to show all the images taken at a certain location by clicking on the location from the Places menu bar at the top of the interface, Aperture automatically creates a Places filter setting for the Viewer, as shown in Figure 5.28. To create a Smart Album based on that location, click the Filter button to access the dialog and then click the New Smart Album button. A Smart Album is created within the albums section of your Library Inspector. Aperture automatically updates this album anytime you identify additional images as being from this location. That way, you can just click on the Smart Album from a particular location to see all the images you've taken there. We find this the easiest and most useful way to search for images from a particular location.

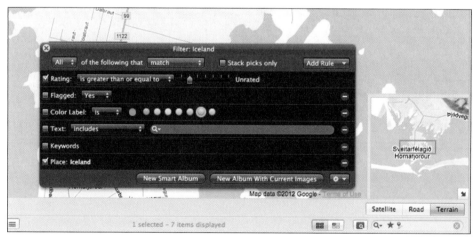

5.28 Use the filter that Aperture creates when it displays images taken from a specific location to create a new Smart Album.

If you didn't create a Smart Album, you can still search for images using the Smart Settings HUD and then create an album or Smart Album populated with images sharing a certain location. This can be helpful if the images from that location are currently stored in a variety of projects or albums and you want to create a book, slide show, or other project using those images. To use the Smart Settings HUD to search for images, do the following:

1. **From the Split view or Browser view or the filmstrip in full-screen mode, click the Smart Setting Filter button, as shown in Figure 5.29.** A new dialog appears.

2. **Click the Add Rule pop-up menu and choose Place.** A new rule appears at the bottom of the dialog for Place.

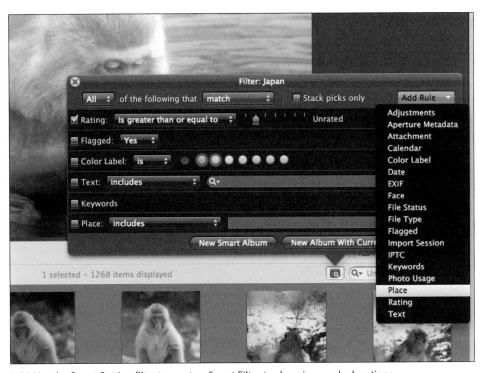

5.29 Use the Smart Setting filter to create a Smart Filter to show images by locations.

151

3. **Select the Place rule, and from the includes pop-up menu, choose the desired category, and then complete the text field with the location.** Aperture filters the current view to display only those files meeting the criteria.

4. **Click New Smart Album or New Album with Current Images to create albums containing the images that meet your criteria.** That way you can continue to work with those images and not have to search for them again. Click the X in the top-left corner to close the filter. Note that the filter text field reflects your search criteria. To return to seeing all the images, click the small X at the right of the filter text field.

Using Places and Faces gives you unparalleled power to organize your images and retrieve them in ways that would have been nearly impossible — and certainly cumbersome — before Aperture 3.

What Tools Can I Use to Make My Images Better?

Although it's always wise to take the time to make the best photos possible while shooting, Aperture has a lot of tools that you can use to make your images even better. By clicking a button, setting a few sliders, or applying a few brushstrokes, you can optimize your shots and add impact without spending excessive amounts of time on your computer. That way you can make the most of your images and still have time to go about your life!

Getting Started with Adjustments . 156

Making Adjustments . 162

Using Quick Brushes . 202

Creating and Using Effects . 211

Using an External Editor . 214

Using Third-Party Editing Plug-Ins . 215

Getting Started with Adjustments

Before you jump in and start adjusting your images, there are a few basics that are helpful to understand. That way you'll be able to get the most out of the adjustment tools as efficiently as possible.

Reprocessing originals for Aperture 3.3 or later

If you are upgrading to Aperture 3.3 or later from a version of Aperture prior to Aperture 3.0, or opening a library created prior to Aperture 3.0, you'll discover that Apple modified the algorithms it uses for better noise processing, sharpening, and highlight recovery with RAW files as well as adding brush tools for localized adjustments (that we cover later in this chapter). In the Aperture 3.3 upgrade, the library changed to enable unified libraries, as we cover in Chapter 2, as well as to add even more new and improved adjustments. When you first launch Aperture 3.0 or later, you see the message in Figure 6.1. You can opt to update the library as well as reprocess your images or just update the library.

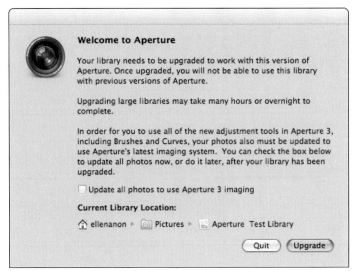

6.1 You need to update your library when accessing a library created prior to Aperture 3.0, but by default Aperture lets you wait to reprocess the images or you can opt to do it all in one step.

Any time algorithms change, the appearance of images you've already processed may change when you update them to the new algorithms. Apple realizes that even though the new algorithms enable you to perform some great new functions including selectively brushing adjustments in or out, you may not want the appearance of all your images to change when you upgrade. Therefore, when you upgrade your Aperture or Aperture 2 libraries, the images use their original algorithms by default, so that their appearance remains the same. You then have the option to upgrade images one at a time, or to update groups of images, projects, or the entire library. Of course, all new images that you import into your library automatically use the new algorithms.

Note Although your entire library must be updated when you upgrade from Aperture 3 to Aperture 3.3, images that you have adjusted using tools that have changed, such as the Highlights & Shadows tool, will maintain your original adjustments.

To upgrade one or more images in a project from a library prior to Aperture 3.0, do the following: Choose the image and choose the Adjustments Inspector, and then click Reprocess, as shown in Figure 6.2.

To upgrade groups of images from a library prior to Aperture 3.0, do the following:

1. **Select the images or project, album, book, slide show, and so on, that you want to reprocess.**

2. **Choose Photos ⇨ Reprocess Masters.** A new dialog appears, as shown in Figure 6.3.

3. **In the new dialog, specify whether to reprocess all the images or only those with or without adjustments, and whether you want to create a new version for each image or just reprocess the original version.** If you are worried whether you'll like the results, choose the option to keep the existing versions and reprocess new versions. That way you can keep whichever version looks better and delete the others. You cannot "unreprocess" an image.

4. **Click Reprocess Photos.**

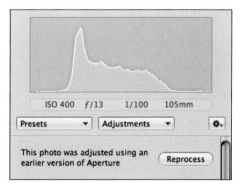

6.2 Click the Reprocess button in the Adjustments Inspector to reprocess images as you need.

You can opt to reprocess the entire library by following the same steps just described but choosing Photos in the Library Inspector initially.

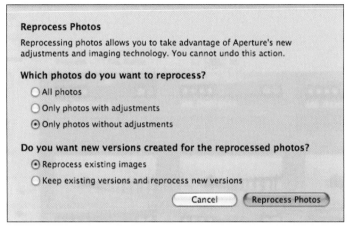

Reprocess Photos

Reprocessing photos allows you to take advantage of Aperture's new adjustments and imaging technology. You cannot undo this action.

Which photos do you want to reprocess?

○ All photos
○ Only photos with adjustments
⦿ Only photos without adjustments

Do you want new versions created for the reprocessed photos?

⦿ Reprocess existing images
○ Keep existing versions and reprocess new versions

Cancel Reprocess Photos

6.3 Specify the criteria to use while reprocessing images, including whether to create a new reprocessed version while retaining the original version.

Note Reprocessing images takes time, so the more images you select to reprocess at once, the longer it will take. We find it more efficient to reprocess images as needed than to try to do all our older images. If we need to reprocess a lot of images, we let Aperture work on it at night or when we're away from the computer.

Setting preferences for making adjustments

By taking a few minutes initially to set your preferences, you'll be sure that Aperture behaves the way you expect. First, specify your external editor. For most people, this is Adobe Elements or Photoshop, but it could also be a program such as Nik Software's Snapseed. You use your external editor to perform tasks that you can't do within Aperture, such as creating a composite. To set your external editor, take the following steps:

1. **Choose Aperture ⇨ Preferences ⇨ Export.**
2. **Click the Choose button to the right of External Photo Editor.**

3. **Navigate to the desired application in the window that appears and click Select.** When Aperture returns to the Preferences dialog, the name of your external editor is displayed, as shown in Figure 6.4.

4. **Specify the file format.** Aperture creates a new TIFF or PSD file for each file that you send to the external editor, and you can choose 8- or 16-bit as well. We normally use 16-bit files because that gives more tonal options to use when making further adjustments.

5. **Specify the color space to attach to the file.** This should be whatever color space you use as your RGB setting in your external editor, usually Adobe RGB (1998) or ProPhoto RGB. However, if your output is for the web or e-mail only, you can choose sRGB.

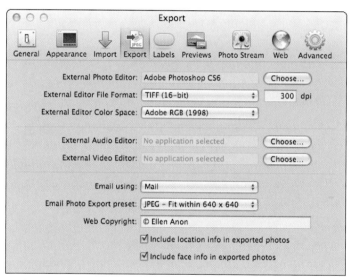

6.4 Set your external editor in Preferences.

Next, click the Advanced tab in the Preferences dialog, as shown in Figure 6.5, to set additional preferences. Follow these steps:

1. **Specify the Hot and Cold Area threshold settings.** These settings determine what areas Aperture will show as clipped (so dark or light that there are no visible details) when you choose View ➪ Highlight Hot and Cold Areas. (Hot areas are highlights lacking

detail and appear with a red overlay; Cold areas are shadows lacking detail and appear with a blue overlay, as shown in Figure 6.6). Highlighting the clipped areas makes it easy to see if an adjustment is too extreme and is causing the image to lose important details. The numbers that you set in Preferences establish whether the highlights and shadows must be completely clipped before they appear as hot or cold areas, or whether the overlay warning appears when an area is almost clipped. We prefer to set our Hot Area threshold at 100 percent and our Cold Area threshold at 0 percent, but for some outputs such as slide shows, you might prefer to set those numbers to be less extreme so that you don't run the risk of the image appearing too contrasty.

6.5 Use the Advanced tab in Preferences to set clipping preferences and whether to automatically create new versions for adjustments.

2. **Set the Auto adjust Black Clip and Auto adjust White Clip settings.** We prefer to set the Black Clip to 0.05 percent and the White clip to 0.00 percent rather than the default settings of 0.10. That way, if we use an auto adjustment it introduces only minimal clipping in the shadows, which is just enough to add some shadow definition and no clipping in the highlights.

3. **Leave the Clipping overlay pop-up menu set to Color because for most images it's easy to see that way.** If the image has a lot of pure red or pure blue, you may prefer to select the Monochrome option so clipped areas appear as a medium gray.

6.6 Highlighting hot and cold areas makes it obvious where an image is losing detail.

4. **Leave the check box to create new versions when making adjustments deselected.**
If you select it, Aperture automatically makes a copy of the original image and shows
your adjustments on that version. Then if you opt to use the external editor, Aperture
automatically creates another new version. That way you can easily compare the before
and after results and won't have to start all over. Similarly, if you then add adjustments in
Aperture, you see another new version. However, we find this can be quite cumbersome
and prefer to manually create new versions when we want them. Nonetheless, we sug-
gest that when you choose Preferences ➪ General you select the option to automati-
cally stack new versions so that it's easy to keep different versions of an image together.

Caution

If you select the option to have Aperture create new versions, Aperture creates a
separate version to use with a plug-in, but if you then opt to open the results in your
external editor or a different plug-in, Aperture does not make a separate version
unless you also apply some Aperture adjustments in between. You can manually
create a new version whenever you want by choosing Photos ➪ Duplicate version.

Creating versions of an original file for adjustments within Aperture requires only minimal memory space because the original pixels are not duplicated. Each version just contains a series of instructions of what adjustments to apply to that version. However, versions that are created for use with plug-ins or external editors require considerably more space because they are new original files and contain pixels. We cover plug-ins and external editors later in this chapter.

Making Adjustments

Aperture offers a comprehensive set of adjustment tools that we cover in depth. All of Aperture's adjustment tools are located in the Adjustments Inspector, but a few frequently used ones are also located under the Viewer. In this section, we explain in detail how to use all the various tools, but we begin with some general information.

Commonalities of all the adjustment bricks

No matter which type of adjustment you use, each one shares some common features, as shown in Figure 6.7:

- **Disclosure triangle.** Use this to expose or hide the settings for each adjustment. We normally leave the adjustments exposed, but that means we have to scroll through them; hiding the controls means less scrolling. That's strictly a personal preference.

- **Check box.** When its check box is selected, the adjustment is applied to the image. To see the image without the effect, deselect this box — it's an easy way to be sure you're heading in the right direction with your improvements — then toggle it back on. All sliders can be continuously readjusted.

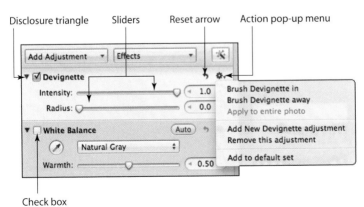

6.7 All the adjustment bricks share some common features.

- **Sliders.** Most adjustments contain sliders that can be directly adjusted, but double-clicking the knob resets that slider back to the default setting. In addition, many have a *scrubby number field* in which you can type a specific number or click and drag the cursor to quickly set the slider.

- **Reset arrow.** Use this to reset an adjustment to the default settings.

- **Action pop-up menu.** This menu contains the following settings:

 - **Add to default set/Remove from default set.** To add an adjustment to the default series of adjustments that appears for each image, choose Add to default set from the Action pop-up menu. Normally this would apply to adjustments that are not in the default set of adjustments but are available from the Add Adjustment pop-up menu, as shown in Figure 6.8. Similarly, to remove an adjustment that you don't use often, choose Remove from default set.

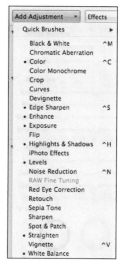

6.8 Any of the additional adjustments can be added to or removed from the default set of adjustments that appears in the Adjustments Inspector.

 - **Add New *X* adjustment (where *X* is the adjustment name) is included in most of the bricks.** To add an additional brick of the same type, click the Action pop-up menu in the brick and choose Add New *X* adjustment. This is helpful when you want to brush the adjustment in one way to parts of the image and use the same controls to make a different adjustment to affect other parts of the image.

Genius

With some adjustments, you can use the arrows at either end of the scrubby field to type values that are more extreme than those that are possible by using the slider.

Working with the histogram

One of the advantages of working with digital files is being able to use histograms. Histograms show the distribution of the tonal values in an image and can be set up to show individual channels; a combination of the Red, Green, and Blue channels (RGB); or the luminosity information. This

enables you to see factually whether an image is taking advantage of the complete tonal range or whether it's lost a lot of information in the highlights or shadows, and more. A complete discussion of histograms is beyond the scope of this book.

Note When making a Curves adjustment you can choose a different type histogram to appear superimposed on the curve by going to the Action pop-up menu in the Curves brick. In Levels, you can choose RGB or Luminance from the Channel pop-up menu to control the type of histogram that appears in the dialog.

To specify the type of histogram you want Aperture to display on the top of the Adjustments Inspector, do the following:

1. **Select an image, and then choose the Adjustments Inspector.**

2. **Click the Action pop-up menu at the bottom of the Adjustments Inspector, as shown in Figure 6.9.**

3. **Scroll to the bottom of the pop-up menu and choose the type of histogram you prefer.** We prefer to use an RGB histogram for the overall image histogram because it provides the most information.

6.9 Choose the type of histogram to appear in the Adjustments Inspector.

Straightening an image

With digital images, there's just no excuse to show pictures with a crooked horizon. Whether you're handholding or carefully composing a shot on a tripod, it's all too easy to accidentally hold the camera at an angle. Then when anyone looks at your photos, the first thing they notice is the tilt rather than the subject. Fortunately, it's easy to fix crooked images in Aperture.

To straighten an image, follow these steps:

1. **Click the Straighten button from the group of tools beneath the Viewer, as shown in Figure 6.10, press G to use the keyboard shortcut, or choose Add Adjustment ⟨⟩ Straighten from the Adjustments Inspector.** The cursor changes to a double triangle.

2. **Click on the image.** A yellow grid appears superimposed over your image.

3. **Drag the cursor to rotate the image using the yellow grid as a guide to align any vertical or horizontal items.** Aperture simultaneously straightens the image and crops it.

Alternatively, you can drag the Angle slider in the Straighten brick, but we find this more difficult because the grid overlay doesn't appear this way. You can also set a specific amount in the Value area if you need to rotate an image by a specific amount.

Red Eye button Quick Brushes button

Crop button

Straighten button

Stamp Metadata and Adjustments button

Lift Metadata and Adjustments button

Rotate button

Selection button

6.10 Use the Straighten tool to quickly correct tilted horizons.

165

Genius

You'll have more control over the straightening if you click and drag near the sides of the image rather than near the center.

Cropping images

Sometimes you need to crop an image, whether to remove distracting items around the edges, to help emphasize the subject, or to output the image at a specific aspect ratio that's different from the one your camera uses. Aperture enables you to crop images while maintaining the same aspect ratio your camera uses, to apply other preset crop sizes, or to create a custom crop. To crop an image, follow these steps:

1. **Click the Crop button (shown earlier in Figure 6.10), press C to use the keyboard shortcut, or choose Add Adjustment ⇨ Crop.** A new dialog appears, as shown in Figure 6.11, in which you choose the aspect ratio for the crop.

2. **Initially, the Aspect Ratio pop-up menu is set to Original Aspect Ratio.** To use a preset ratio or to create a custom crop, click the pop-up menu and choose a preset or click Do Not Constrain. The Crop dialog displays the aspect ratio. The crop tool is "sticky" and will open with the last setting you used whenever you open it.

6.11 Use the Crop dialog to set an aspect ratio for the crop or to create a custom crop.

3. **To toggle the height and width aspect ratios, click the double arrow that's between the height and width displays.**

4. **Select the Show Guides option to superimpose a Rule of Thirds grid while you drag out the crop.** This grid can help you place the crop for the best composition following the basic Rule of Thirds principles.

5. **Click and drag on the image to establish the crop.** Click and drag in the center of the crop area to reposition the crop. Click and drag any of the rectangular handles on the edges of the crop to change the size of the crop. When you're satisfied with the results, press Return to crop the image or click Apply in the Crop dialog. A Crop brick appears in the Adjustments Inspector.

Genius
If you want to modify the crop after you've applied it, click the crop icon that's in the top right of the Crop brick. That restores the crop overlay on the image and makes it active.

You can modify the crop at any time by clicking the Crop tool again and repositioning the crop. To remove the crop entirely, deselect the Crop brick check box in the Adjustments Inspector.

Caution
The size of the cropped image appears at the bottom left of the Crop dialog. Be careful to leave enough pixels that you can still create high-quality output. If you crop too aggressively you may find that there are only enough pixels to create a very small print or to put on the web.

Using Auto Enhance

Auto Enhance was completely reworked in Aperture 3.3 and now is a quick way to optimize an image or, at the very least, provide a one-touch preview of the potential of your image as shown in Figure 6.12. Over the years we've shied away from Auto tools because usually it's better to take the time to choose and set adjustments individually for each image. But Auto Enhance employs sophisticated *smart* algorithms that you can individually tweak after using Auto Enhance. By smart we mean that although Auto Enhance is programmed to use certain adjustments (White Balance, Enhance, Curves, and Highlights & Shadows), if Aperture analyzes the image and decides a particular adjustment is unnecessary, rather than add the adjustment set at zero, it doesn't add the adjustment at all.

To use Auto Enhance, select an image and then press the Auto Enhance button located just beneath and to the right of the histogram in the Adjustments Inspector, as shown in Figure 6.12. You can also access it by choosing Effects ➪ Quick Effects ➪ Auto Enhance, which means you can apply it during import by choosing the Effect in the Import dialog, as covered in Chapter 3.

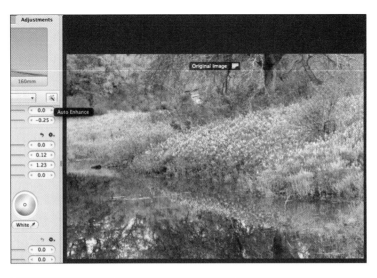

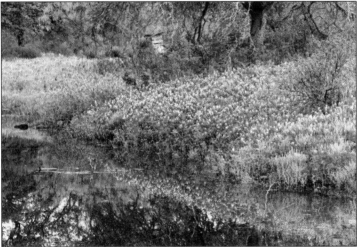

6.12 Using the Auto Enhance tool can be a timesaver as shown in this before and after image

If you use Auto Enhance, glance at all the bricks in the Adjustments Inspector to see which ones are selected. Then consider fine-tuning them if necessary.

Using the adjustment bricks

The remainder of the adjustment tools are found only in the Adjustments Inspector. Some are included in the set of tools that is visible by default, whereas the others are available from the Add Adjustment button below and to the left of the histogram.

Of course, no image needs every adjustment. Before you begin adjusting your image, we highly recommend that you take a minute to assess the strengths and weaknesses of the image and develop a game plan for what you need to do to make the image pop. That way you won't waste time floundering, randomly trying different adjustments, and instead will select only the adjustments you need for each image. (For more about this, we refer you to our book *See It: Photographic Composition Using Visual Intensity,* Anon & Anon, Focal Press, September 2012.)

One of the really convenient things about using Aperture to optimize your images is that every edit you make within Aperture (not a plug-in) can be modified at any time in the future. It's all nondestructive. As mentioned earlier, you can create multiple versions of an image using different adjustments or crops. These versions require only minimal additional hard drive space, and that means you can feel free to create and experiment while creating multiple renditions of an image.

Note The order that the adjustments appear in the Adjustments Inspector is the order in which Aperture applies them to your image. You cannot rearrange the order they appear in the brick, but you can select them and work on them in any order you choose. However, with some processor-intensive adjustments such as the Retouch Brush, you may find that your computer works better if you apply those adjustments before making other adjustments.

Setting white balance

Many photographers leave their cameras set to Auto White Balance, which usually does a good, but not always perfect, job of balancing the light so that the colors in your image appear the way you expect. Some photographers use white balance effects such as Daylight, Cloudy, Shade, Fluorescent, and so on, offered in their camera presets. These settings often do a good job as long as the lighting conditions don't change without your changing the preset. Still other photographers set a custom white balance in-camera that works perfectly, as long as the lighting remains

identical to the conditions in which they created the preset. The bottom line is that no matter which approach to white balance you take in-camera, you may want to tweak the white balance settings on the computer.

Aperture 3.3 expanded the white balance options to make it even easier to achieve the optimal color balance in each image. There are two places to adjust the white balance settings — in the White Balance Effects and in the White Balance brick where there are automatic as well as manual options.

If the overall color of your image appears too cool or too warm, or is just off in some way that you can't quite identify, a good way to start to fix it is to click the Auto button in the White Balance brick. Aperture analyzes the image and if it detects a face, it uses a white balance algorithm to preserve the skin tones no matter what race. If no faces are detected, then Aperture tries to identify something that should be neutral gray and adjusts the image accordingly. Of course, you may want to tweak the results manually.

Whenever you want to tweak the white balance of your image, regardless of whether you use the Auto button, you can adjust the sliders in the White Balance adjustment brick. First, use the pop-up menu shown in Figure 6.13 to choose which white balance method to use: Natural Gray, Skin Tone, or Temperature & Tint.

6.13 Specify which approach you want to use to correct the white balance.

The Temperature & Tint method is the classic method based on color temperature, and you visually adjust the sliders until you're pleased with the results. Use the Temp slider to warm or cool the image by dragging it toward the blue or yellow side. This is a common adjustment to add a bit of warmth. Some images also benefit from adjusting the tint, making it more magenta or more green, but in most cases we find we make fewer adjustments to the tint and when we do, the adjustments are usually smaller than those we make to the Temp slider.

If there are people in your image, choose Skin Tone and then click the eyedropper and drag it over a skin tone in the image, as shown in Figure 6.14. If you don't like the results, press ⌘+Z to undo the change and then try again. You can also manually tweak the warmth by adjusting the Warmth slider.

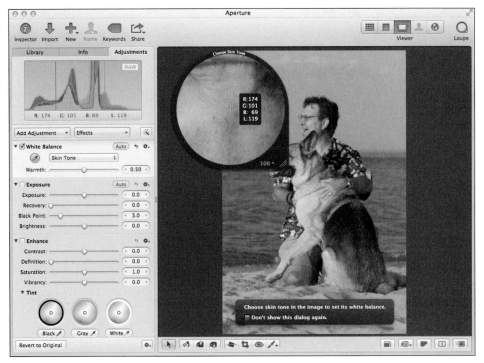

6.14 When there are people in an image, set the white balance by using their skin tone.

If there's something in your image that should be neutral gray, choose Natural Gray and then use the eyedropper to click on something in the image that should be gray, whether light gray or dark gray or somewhere in between, but pure gray without a colorcast. This might be a gray rock, a gray card, an item of clothing, a road, a bird, or whatever is in your image that should be neutral gray. If you don't like the results, press ⌘+Z or manually tweak the slider.

Genius

You can opt to brush in a white balance correction in selective areas of your image. That way you can have more warmth in some areas such as your subject and less in the background (or vice versa).

The other approach to correcting a colorcast is to use the White Balance Effects. The advantage is that you can preview the results of each choice, which makes it easier to see which one does the best job of balancing the colors. To apply a White Balance Effect, follow these steps:

1. **Click the Effects pop-up menu and then choose White Balance.** A list of six preset white balance settings appears.

2. **Hover the cursor over an effect and a thumbnail of the image appears with that white balance setting, as shown in Figure 6.15.** Being able to preview the results of each effect makes it easy to select the best one.

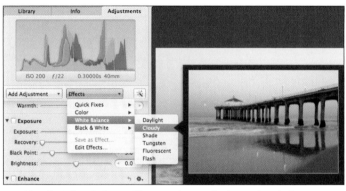

6.15 Use the White Balance Effects to choose the best white balance settings.

3. **If the result is not perfect, continue on to the White Balance adjustment brick to fine-tune the results.**

Using the Exposure controls

The Exposure brick has four sliders that enable you to adjust the overall exposure of the image as well as to recover detail in some of the lightest areas of the picture, to set the black point, and to adjust the overall brightness of the image. There's an Auto button to use if you want Aperture to set the sliders for you automatically. (Of course, you can fine-tune the results manually as well.)

To use the Exposure controls manually, begin by setting the Exposure slider so that most of your image is exposed correctly. Before you set the other sliders, it's possible that the overall image may still be a little too bright or too dark, and in some cases there may be a small amount of highlight clipping. The idea is to get the bulk of the image correctly exposed using this slider in such a way that you can use the other sliders to refine the results and improve the exposure of the image. This image was initially underexposed by about 1/2 stop, as shown in Figure 6.16.

Genius

While adjusting the Exposure, Recovery, and Black Point sliders, hold down the ⌘ key to have the image temporarily replaced by a grayscale version. This makes any clipping more obvious as well as helps you see precisely which pixels are being set to black or white. That can help you set the sliders more accurately. After you release the ⌘ key, check the results visually on the image and make any refinements that are needed.

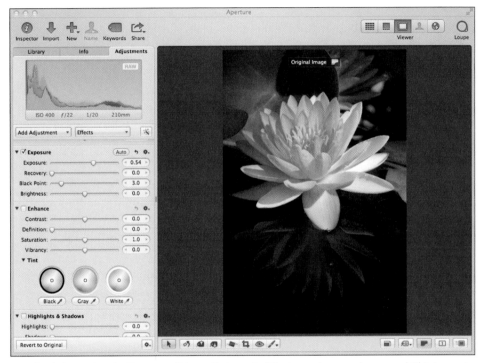

6.16 Begin by setting the Exposure slider so that most of the image is properly exposed. This image is underexposed by about 1/2 stop.

If there is some highlight clipping, use the Recovery slider. In some cases, highlight detail has been recorded by the sensor, but that isn't currently visible. This is the information that you use the Recovery slider to access. Adjusting the Recovery slider also makes some of the brightest pixels slightly darker to enable more highlight details to become visible.

173

Use the Black Point slider to determine which pixels will be pure black, as shown in Figure 6.17. (This is called setting the black point.)

Adjust the Brightness slider to change the overall brightness of the image. This makes the majority of the pixels lighter or darker but has less effect on the lightest and darkest pixels.

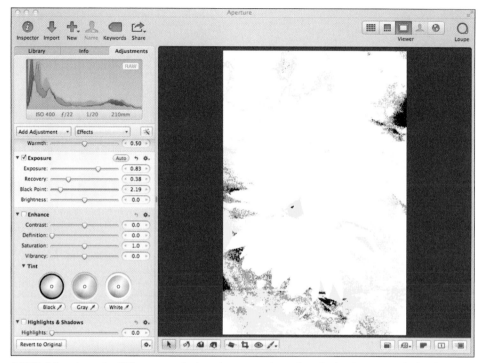

6.17 Holding down the ⌘ key can make it easier to see where there is clipping, particularly when setting the black point.

By using the four sliders in the Exposure brick, as shown in Figure 6.18, you should be able to set an acceptable exposure level in the overall image even though you may still need to use other tools to add (or reduce) contrast or to improve highlight and/or shadow detail.

Genius

You can also set the black point using Curves or Levels, but doing so darkens more of the pixels. Setting the black point using the Black Point slider affects less of the tonal range. Which way is better depends on the particular image. If an image just needs some true blacks for definition and pop, then use the Black Point slider. If the image feels too light and needs to be darker or denser, then set the black point in Curves or Levels.

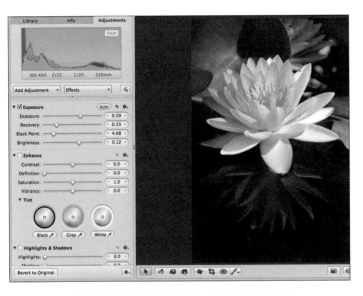

6.18 This image looks considerably better after using the Exposure controls but will also benefit from using the Shadow slider to slightly lighten the reflection.

Taking advantage of the Enhance tools

The Enhance brick contains four sliders as well as tint controls that enable you to modify aspects of the color and contrast of the image, thereby increasing the impact of many images. As we describe each control, we suggest you experiment by pulling the sliders to their extreme positions in both directions. That way you'll visually see the effect each control has and can then set the slider to the best position for the particular shot.

The first slider is the Contrast slider, which enables you to increase or decrease the overall contrast within the image. Increasing the contrast this way spreads the pixels across a wider tonal range, but primarily increases the range of darker tonalities that are included. You can see the change not only in the image, as shown in Figure 6.19, but also in the histogram. Notice that the white point is only minimally modified. With images that are overly contrasty, try slightly reducing the overall image contrast.

Note

For most images, we find we rarely use the Contrast slider, preferring instead to use Levels and Curves adjustments where we can increase the contrast in particular parts of the tonal range such as the midtones, or the revised Mid Contrast slider in Highlights & Shadows.

The next slider is the Definition slider. We use this adjustment on many of our images to increase the pop of the image and to reduce haze. Increasing the definition increases local contrast as well as creates the impression of increased saturation and sharpness, as shown in Figure 6.20. Although it can be tempting to use this slider aggressively, as we have done here, we suggest you use it carefully and check the results at 100 percent magnification to ensure you don't accidentally add artifacts.

Genius

The Definition slider is very similar to the Clarity slider in Adobe products such as Camera Raw.

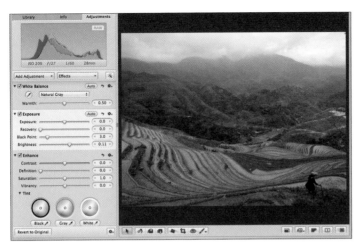

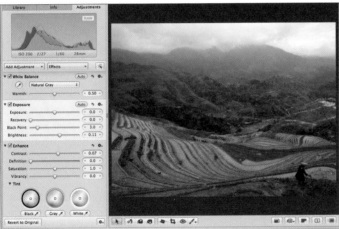

6.19 Increasing contrast by using the Contrast slider moves the black point more than the white point but can be used to boost the contrast of overly flat images.

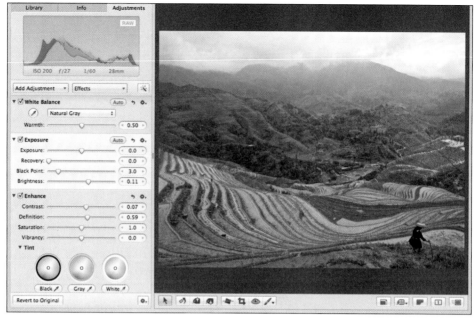

6.20 Use the Definition slider to add pop to your images.

The Saturation slider increases or decreases the saturation of all the colors in the image, as shown in Figure 6.21. If you want to modify the saturation of a particular color, use the Color controls instead. Although you can convert an image to black and white by completely decreasing the saturation, we find it's better to use the Black & White adjustment or presets that we cover later in this chapter.

The Vibrancy slider increases (or decreases) the saturation of some of the colors in the image, but it is geared toward helping skin tones remain more natural looking while increasing (or decreasing) the saturation of other colors. This means that some yellow and orange tones are less affected by adjusting the Vibrancy slider, while the blues and greens will be noticeably modified, as shown in Figure 6.22. You can take advantage of the Vibrancy slider not only with photos of people, but with any photo where you want to increase or decrease the saturation of the greens and blues while having less impact on the yellows.

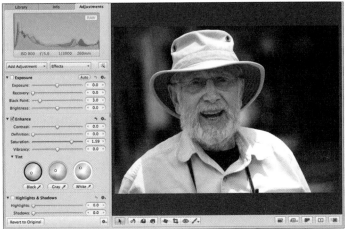

6.21 Using the Saturation slider increases (or decreases) the saturation of all the colors in the image. This can result in unnatural skin tones.

Genius

With some images you may want to use the Saturation and Vibrancy sliders in opposite directions to create different effects on the colors in your image. Don't hesitate to experiment to create just the right balance for each particular picture.

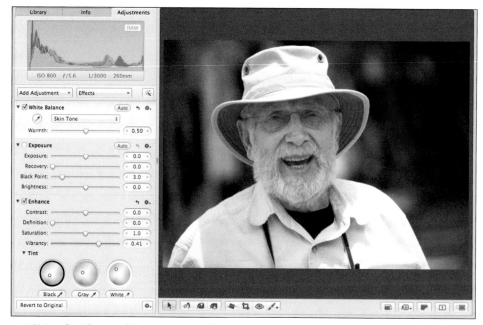

6.22 Using the Vibrancy slider increases (or decreases) the saturation of colors in the image while trying to protect skin tones.

The Tint controls enable you to modify the colorcast of the highlights, midtones, and shadows separately. To access them, click the disclosure arrow to reveal three Tint wheels, as shown in Figure 6.23.

Think of these controls as joysticks. To use them, click the center white circle and drag it to the desired position. To reset the wheel, double-click the white circle; it snaps back to its default setting.

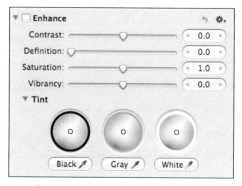

6.23 The Tint wheels enable you to alter the colorcast of the highlights, midtones, and shadows separately.

Alternatively, to have Aperture help set the wheels for you, use the eyedropper beneath the wheel and click the corresponding pixels in the image. Use the Black eyedropper to click on the darkest area in the image that you want to be a neutral black. Similarly, use the White eyedropper to correct the colorcast of anything that should be white by selecting it and then clicking on anything white in the image. Use the Gray eyedropper to balance the colorcast in areas that should be a shade of gray without a colorcast. As you use each eyedropper you'll see the position of the center point on the Tint wheels move as well as see the color change in the image. Of course, you can still manually drag the position of the Tint wheels to suit your taste.

Although we don't use the Tint wheels often, we do find them helpful for modifying the colorcast of shadows or highlights, especially when we want to warm the highlights slightly. The Tint wheels can also be helpful if your image was shot with a mix of lighting types such as fluorescent, tungsten, and daylight.

Using the Highlights & Shadows adjustments

The Highlights & Shadows controls were extensively reworked in Aperture 3.3 and enable you to reveal more detail in the highlights and/or shadows of your image while maintaining realistic appearance and appropriate levels of midtone contrast. We find the Highlights & Shadows adjustments very helpful with contrasty images where detail has been recorded in the highlights and shadows, but was initially too light or too dark to easily see, as shown in Figure 6.24.

6.24 Use the Highlights & Shadows controls to reveal more detail in the lightest and darkest areas of your image.

To use the Highlights & Shadows controls, you can adjust one or more of the sliders:

- To recover highlight detail, adjust the Highlights slider.
- To recover shadow detail, adjust the Shadows slider.
- Use the Mid Contrast slider to restore the midtone contrast within the image. Be careful not to reintroduce clipping into the highlights or shadows.

You can use the Mid Contrast slider even if you don't use the other two.

Note Other ways to restore midtone contrast in the image are to use the Levels quarter tone controls or make a Curves adjustment, both of which are covered in this chapter.

Caution If you adjusted an image using the Highlights & Shadows controls available in earlier versions of Aperture, the legacy Highlights & Shadows tool appears in the Adjustments Inspector. You'll also see an Upgrade button to click to update to the newer version. We suggest that if you like the results you've achieved on a particular image, don't update the Highlights & Shadows tool on it, but if you think the image could be better, then go ahead and update it.

Using Levels

Levels enables you to have finer control of the exposure of your image and has some sophisticated features not found in the Levels controls in most other software programs.

To begin, set the Channel pop-up menu to RGB. That way you see a histogram of the Red, Green, and Blue channels superimposed on the Levels controls to help you adjust the settings, and when you set Levels you'll be adjusting the Levels for all three channels simultaneously.

Genius If you set the pop-up menu in Levels to Luminosity to adjust the overall luminosity of the image, you may accidentally introduce clipping in one or two channels without being aware of it and lose detail in the highlights or shadows. This is more of a risk with images containing highly saturated colors. Alternatively, you can set the pop-up menu to a single channel and use Levels to modify colorcasts.

To use Levels in its most basic form, do the following:

1. **Hold down the ⌘ key, and click and drag the triangle on the right end of the histogram.** The image preview turns black. Continue dragging to the left until colored pixels begin to appear and then back off until the preview is pure black. The colored pixels show you where you're starting to introduce clipping in one or more channels. If the pixels appear white, then you're introducing clipping in all three channels.

2. **Release the ⌘ key and then visually tweak the position of the triangle.** This sets the white point of the image or, in other words, determines which pixels appear as pure white in the image, and then the rest of the pixels are adjusted accordingly.

3. **Repeat Steps 1 and 2 using the triangle on the left.** This time the image preview turns white as you set the black point or which pixels will appear as pure black.

4. **Adjust the middle triangle to adjust the overall brightness of the image.** Setting these three controls can greatly improve your image, as shown in Figure 6.25.

Note

Setting the black point in Levels affects a wider tonal range than by setting it using the Black Point slider in the Exposure brick.

Genius

The boxes beneath each triangle show the numeric setting of each Levels control, with the default position of the left triangle being 0 and the right being 1. Don't get too caught up in the precise numeric readouts. Primarily, Levels is a visual adjustment.

6.25 Setting the white and black points and midtone brightness can make a huge difference in an image.

Aperture offers additional controls for Levels called *quarter tone controls.* The quarter tone controls allow you finer control over the exposure, enabling you to lighten or darken parts of the tonal distribution. To access them, click the button shown in Figure 6.26 and two additional bars appear on the Levels display. Once you get used to using them, they're an easy way to quickly add some midtone contrast.

To use the quarter tone controls, do the following:

Quarter tone control button

6.26 Use the levels quarter tone controls to modify midtone contrast in the image.

- Click the triangle beneath the three-quarter tone controls near the highlights and move it toward the center to lighten the corresponding pixels and toward the highlight end to darken them.

- Click the triangle beneath the quarter tone control near the shadows and move it toward the center to darken the corresponding pixels and toward the shadow end to lighten them.

- To increase midtone contrast, move both quarter tone controls slightly toward the middle.

- To have the quarter tone controls affect a wider or narrower range of tonalities, hold down the Option key, and click and drag the associated bar to the right or left. Then adjust the triangle associated with the bar as usual.

Note

The Levels brick has two buttons to use to apply Levels automatically. The Auto button with the half-black, half-white circle uses the RGB mode to automatically set Levels in a way that allows clipping in individual channels but doesn't introduce any luminosity clipping. The Auto button with the colored circle sets Levels for each channel individually. This can help correct some colorcasts. We rarely use the Auto buttons because we usually prefer not to introduce any clipping into our images.

Taking advantage of the Color controls

The Color brick allows you to fine-tune the colors in your image. Use it to modify the hue and/or saturation and luminance of specific colors within your image. That way if you want a different shade of red or blue and so on, you can make it happen.

When you first open the brick you see six color blocks and an eyedropper. You can adjust up to six colors in the Color brick. (To adjust more colors, add an additional Color adjustment by going to the Action pop-up menu in the brick and choosing Add New Color adjustment.) Although you can click on any of the color blocks and adjust those colors, in most images you'll want to adjust specific colors that are in your image.

To use the Color controls to modify specific colors in your image, do the following:

1. **Click a color swatch.** If you're going to adjust multiple colors, you can choose the first one and go in order, or you can try to choose the swatch closest to the problematic color. It won't matter whether you completely change the color of the swatches — the colors are just placeholders. In Figure 6.27, we chose to adjust the color of the pinkish red mop first, so we used the red swatch and then used the cyan swatch to adjust the teal and make it greener. In most images, you'll want to adjust the specific colors that are in your image rather than the more generic colors that appear by default in the color swatches.

2. **Click the eyedropper and drag it over your image to the problematic color.** As you do so, a loupe appears to help you see the area in detail.

3. **Click the problematic color to choose it.** The color swatch in the Color brick updates to reflect the color you chose.

4. **Adjust the hue, saturation, and luminance of the color as desired, as shown in Figure 6.27.** If necessary, also adjust the Range slider to limit how far the effect extends from the color you selected.

5. **Repeat as needed to adjust other colors, choosing a different color block in Step 1 each time until the image looks the way you want.**

Genius

To see all the color adjustments at once, click the Expanded View button. This is helpful when you're adjusting several colors and may need to tweak the adjustments of one as you set another. However, most of the time it's easier to use the more compact view.

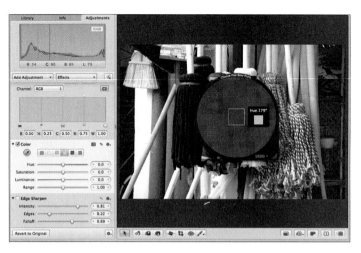

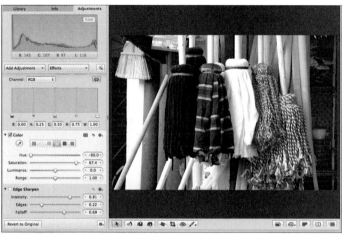

6.27 Use the eyedropper to select the color you want to modify.

Sharpening the image

Aperture 3.3 has two sharpening adjustments that are available from the Add Adjustment pop-up menu: Sharpen and Edge Sharpen. Sharpen is available primarily for legacy reasons because it was the first sharpening adjustment that was available in Aperture 1. It exists in case you need to modify the settings you used on images that you adjusted using Aperture 1. However, you should use Edge Sharpen for all your newer images because it offers more control over the sharpening process. We use Edge Sharpen so often that we've opted to add it to the default set of adjustments that appears

whenever you open the Adjustments Inspector. To add Edge Sharpen to the default set of adjustments, choose Add to Default Set from the Action pop-up menu in the Edge Sharpen brick.

To apply sharpening to an image, do the following:

1. **Click the Edge Sharpen box in the Edge Sharpen adjustment brick to apply sharpening.**

2. **Zoom in to critical areas to be able to accurately judge the effects of the sharpening settings.** It's very difficult to accurately determine the amount of sharpening to apply if you don't zoom in.

3. **Adjust the Intensity slider to control the amount of sharpening to apply.**

4. **Adjust the Edges slider if necessary.** This slider determines which parts of the image are considered edges. The higher the setting, the more areas that are considered edges, and thus the more sharpening that's applied.

5. **Tweak the Falloff slider as desired.** Aperture applies the sharpening in three passes and by default it applies less sharpening on the second and third pass. Use this slider to increase or decrease the amount of sharpening applied on the second and third pass.

Note

When you sharpen a digital image you are adding contrast to the edges to give the impression of increased sharpness. You are not actually refocusing the image. Digital sharpening can't fix poor shooting techniques such as camera or subject movement while shooting or inadequate focus. It's important to always use the best camera techniques possible to create the sharpest images possible in-camera.

Adjusting the Raw Fine Tuning

The Raw Fine Tuning brick is only available for RAW files. Although it used to appear in the default set of adjustments, because most people rarely use it, you now access it by clicking the Add Adjustment button and then choosing Raw Fine Tuning. (As with any of the adjustment bricks, if you want it to appear in your default set of adjustments, click the Actions icon in the top right of the brick, and choose Add to default set.

Raw Fine Tuning contains controls that let you further customize the algorithms used to decode the RAW file. Aperture uses algorithms that Apple has developed for each supported camera as well as DNG files, but your individual camera may differ from the one the engineers used and you

may want to modify the settings used for specific types of shots, such as those with higher ISOs, or individual images. The available sliders are as follows:

- **Boost.** This slider controls the amount of overall contrast by making the lighter tonalities lighter at its default setting of 1.00 and reducing the brightness of the middle and lighter tones when the slider is moved left toward zero. In most images, the darkest tones are minimally affected at most.

- **Hue Boost.** This slider controls some color shifts that may appear when the Boost slider is used. At settings of 0.00, the original hues are preserved, whereas at 1.00 some color shifting is applied. The Hue Boost may make it possible to see more color differentiation and seems to work best with nature photographs. We find that settings of 1.00 often reveal additional hues in bright sunsets or highly saturated subjects such as sunsets, as shown in Figure 6.28. You may need to experiment with various Boost settings as you modify the Hue Boost slider.

- **Sharpening.** This slider controls the amount of sharpening applied to the image during the RAW decode. This is to counter the small amount of softening that occurs as digital images are captured and is a very subtle effect.

- **Edges.** This slider controls how much sharpening is applied during the RAW decoding at "hard" edges where there are clear-cut color changes. Move it to the right to increase the sharpening and to the left to decrease it.

Note

View your image at 100 percent magnification before adjusting the Sharpening and Edges sliders. Experiment with a variety of combinations of settings, but remember that this sharpening is not intended as output sharpening; there are other specific adjustments for output sharpening.

- **Moire.** This slider controls the anti-aliasing correction applied to control some high-frequency issues. In plain language, that means that it can be used to correct some digital artifacts that occasionally appear in images with certain types of linear repeating details such as window screens. If it looks like a silk moiré pattern (and thus the name) appears somewhere it shouldn't in your image, try adjusting the Moire slider. However, most of the time you won't need to touch this slider at all.

- **Radius.** This slider is used in conjunction with the Moire slider to determine what areas of the image are considered to be high frequency and thus control where the Moire correction is applied.

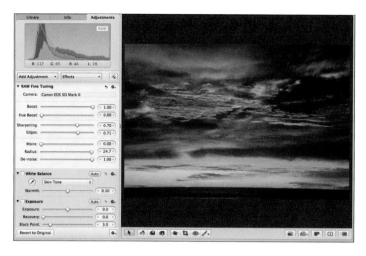

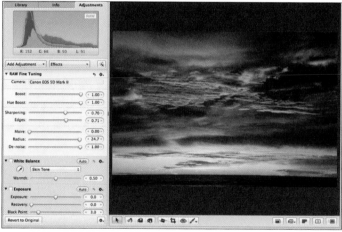

6.28 Setting the Hue Boost slider to the far right often reveals additional colors, particularly in areas with highly saturated reds and yellows. The image on the top has a Hue Boost of 0, whereas the image on the bottom has a value of 1.0.

- **De-noise.** This slider controls the amount of smoothing applied to the image to reduce noise. At 0.00, no noise reduction is applied. Because the smoothing is likely to reduce any fine details in the image, we recommend against using this slider whenever possible. We prefer to apply noise reduction only where needed and use the De-noise adjustments or plug-ins for this. However, in certain images shot at high ISOs or with very long exposures, especially with older digital cameras, the De-noise slider may be helpful. As with sharpening, be sure to view the image at 100 percent magnification to accurately see the effect.

Note

With files from some cameras, an Auto Noise Compensation option may appear rather than the De-noise slider.

If you adjust the sliders and create a group of settings that you want to save to apply to other images shot with the same camera under similar conditions, do the following:

1. **Click the Action pop-up menu in the top right of the brick and choose Save as Camera Default.** A new dialog appears.

2. **Assign a descriptive name for the new preset so that you easily recognize it in the future.**

3. **Click OK to save the effect and have it appear in the Camera pop-up menu at the top of the brick.** When you want to use that series of settings for one or more images, select the images and choose the preset. The RAW decode for the images changes accordingly.

Taking advantage of Curves

The Curves adjustment was introduced in Aperture 3.0 and, in our opinion, is a great addition. Using Curves, you can modify the lightness or darkness of various areas of the image and increase or decrease the contrast in different segments of the tonal range, as well as recover highlight data. To begin, select Normal in the Range pop-up menu and RGB in the mode pop-up menu.

Initially, you see a histogram superimposed over the curve. To use curves, do the following, bearing in mind that with any particular image you may need to omit a step:

● **Hold down the ⌘ key and begin to drag the White Point control (the triangle on the right edge.)** The preview goes black, and as you move the white point to the left, colored pixels appear indicating where data is being clipped in one or more channels. If the pixels appear white, then data is being lost in all three channels. Move the control back so that there is minimal, if any, clipping. With images that have specular highlights or that are quite contrasty, you may not be able to fully remove the clipping this way, but be certain you don't accidentally introduce any clipping.

- **Hold down the ⌘ key and begin to drag the Black Point control (the triangle on the left edge.)** The preview goes white, and as you move the black point to the right, colored pixels appear indicating where data is being clipped in one or more channels. If the pixels appear black, then data is being lost in all three channels. Move the control back so that there is minimal, if any, clipping. With images that have blocked-up shadows or that are quite contrasty, you may not be able to fully remove the clipping this way, but be certain you don't accidentally introduce any clipping.

- **Click on the curve and drag it slightly up or down to lighten or darken pixels in that area.** With curves, points closer to the tonality that you adjusted are affected more than those farther away.

- **To add some midtone contrast, consider adding a point about one-fourth of the way up the curve and pulling this point slightly down.** Add another point about three-fourths of the way along the curve and pull it up slightly. This increases the contrast in the middle half of the tonal range and decreases it slightly at the extreme ends. Of course, you can set these points anywhere along the curve to add contrast to as small or large a portion of the tonal range as you desire.

- **To remove a point that you've added, select it and then press Delete.** The point disappears.

- **To protect a range of tones so that they are not affected by changes you make at other places along the curve, lock the curve in that area by placing three points fairly close together.** That way when you adjust other points along the curve, that portion of the curve remains unaffected.

Figure 6.29 shows a Curves adjustment and Figure 6.30 compares an image before and after applying this Curves adjustment.

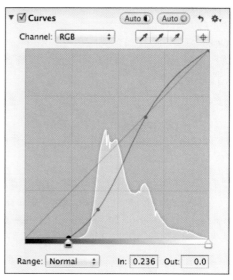

6.29 The Curves adjustment used in the "after" version in Figure 6.30.

6.30 Using Curves is an excellent way to bring out detail in your image and correct exposure issues.

Aperture's Curves adjustment is unique in that it enables you to work more specifically with the shadows and highlights in the image. To magnify the shadow portion of the curve so that you can make finer adjustments within it, choose Shadows from the Range pop-up menu. The curve display changes, as shown in Figure 6.31, to show just the lower quarter of the tonalities, meaning the shadow portion of the image. Make any adjustments that are needed and then change back to Normal range to make adjustments elsewhere on the curve.

The Extended range option enables you to recover highlight information that was recorded in the file but that is not currently visible. Although most of the time you want to use the Recovery slider and/or the Highlights slider for this purpose because they're easier, if you're not getting the results that you hoped for, you can use Curves in the Extended range. One of the advantages of this is that you can apply highlight recovery per channel, which may yield better results with some images. In addition, you can opt to brush the effect in or out, thereby controlling where highlights are recovered and leaving specular highlights in other areas for more natural results. To use the Extended range to recover data, do the following:

1. **Choose Extended from the Range pop-up menu in Curves.** The curve changes so that it occupies only one-fourth of the dialog and shows how much information is not currently visible. Most of the time we set the Channel pop-up menu to RGB and primarily affect the luminosity of the image; however, you can also opt to work in one channel at a time by choosing the individual channel and alter the color of the image.

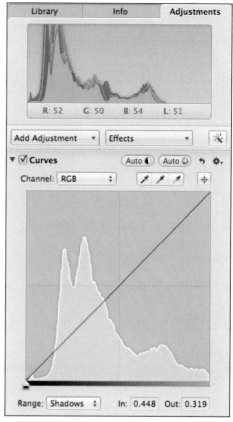

6.31 Using the Shadows option enables you to make more precise adjustments to the shadows.

2. **Move the White Point control over the right edge of the histogram data.** Initially, this decreases the contrast in the image.

3. **Move the point that's already on the curve up to the original line of the curve.** This restores contrast to the image.

4. **Lock down the curve to the left of that point by carefully adding three points close together to make sure that the changes you make in the extended range don't affect the rest of the image.**

5. **Grab the curve near the top corner and pull it down as far as necessary to recover the data, as shown in Figure 6.32.** This will vary by image and the amount of detail that needs to be recovered.

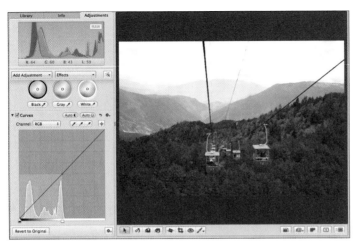

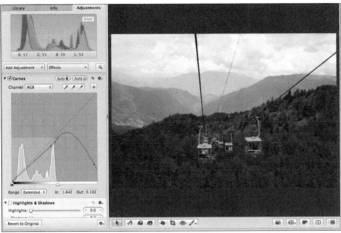

6.32 Using Extended Curves can help recover highlight detail such as the clouds in this image.

Converting an image to black and white

Many images take on new life when converted into monochromatic images. Although you may like a particular image in color, you may be surprised to see how effective it is in black and white. Rather than simply desaturating an image, use Aperture's Black & White adjustment or Black &

White effects for more control over the final result. To convert an image into black and white using the Black & White adjustment, do the following:

1. **Choose Black & White from the Add Adjustment pop-up menu.** A new brick appears and the image immediately becomes monochromatic.

2. **Adjust the Red, Green, and Blue sliders as desired.** Moving a slider to the right lightens the pixels with those tones in the original, and moving it to the left darkens them, as shown in Figure 6.33. So if you want the areas that were blue in the original image to be lighter, move the Blue slider to the right. If you want them to be darker, move it toward the left.

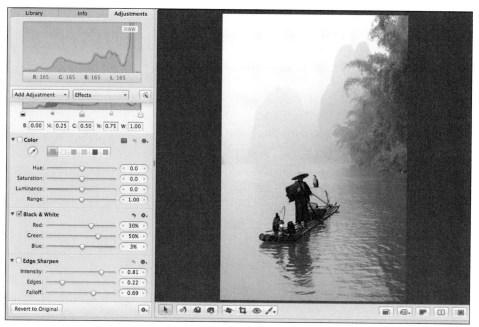

6.33 Adjust the Red, Green, and Blue sliders to tweak the appearance of the black-and-white conversion.

Converting an image to a color monochrome or sepia

The Color Monochrome brick can be used with or without the Black & White adjustment. To use it, do the following:

1. **Choose Color Monochrome from the Add Adjustment pop-up menu.** A Color Monochrome brick appears. By default, the monochrome choice is set to a sepia tone.

2. **Adjust the Intensity slider to control the strength of the sepia effect.**

3. **Click the arrow to the right of the sepia color swatch if you want to choose a different color for the color monochromatic effect.** A new color palate appears. As you hover the cursor over the colors in the color palate, the image preview updates to reflect the color monochrome using that particular color.

To specifically add a sepia effect, choose the Sepia adjustment from the Add Adjustment pop-up menu. A small brick appears containing an Intensity slider that you use to control the intensity of the sepia effect. We prefer the Color Monochrome option because it offers more control over the final effect, but the Sepia adjustment is faster if you like the tone of it.

Adding or removing a vignette

The Vignette and Devignette tools are separate controls available from the Add Adjustment pop-up menu. Although they seem to be opposite ends of the same spectrum, they're separate adjustments because Aperture applies them at different stages of the adjustment process and they work slightly differently. You can use them whenever you want, but you can see from their location in the series of adjustment bricks that Aperture applies devignetting early on, whereas vignetting is added near the end when the final image is output.

Vignettes can be helpful to help guide your viewers' eyes toward your subject and away from any distractions near the edges of your image, as shown in Figure 6.34. Ansel Adams was a master of vignetting in the traditional darkroom.

6.34 Adding a vignette can improve an image by helping guide your viewers' eyes to the main subject.

To apply a vignette in Aperture, follow these steps:

1. **Choose the Vignette option from the Add Adjustment pop-up menu.** A new brick appears.

2. **Choose either Gamma or Exposure from the Type pop-up menu.** Gamma yields a stronger overall result whereas Exposure is more subtle.

3. **Set the desired intensity of the vignette.** We often begin by setting the Intensity to the maximum so we can easily see the effect and then back it off to a pleasing level. That helps us set the Radius slider as well. Note that pulling the slider to the right adds a dark vignette, whereas pulling it to the left creates a light vignette similar to the Devignette tool.

4. **Set the Radius slider to determine how far the effect should extend into the image.**

Devignetting is helpful to reduce any darkening around the corners or edges of an image that can occur with some lenses that were originally designed for film cameras rather than digital, or with some wide-angle lenses with lens shades or filters. Usually this type of accidental vignetting is not flattering to the image. To reduce vignetting, follow these steps:

1. **Choose Devignette from the Add Adjustment pop-up menu.** A new brick appears.

2. **Set the Intensity slider to determine how much lighter to make the corners.**

3. **Set the Radius slider to determine how far into the image the effect should extend.** Sometimes you'll need to readjust the Intensity slider as you adjust the Radius slider to achieve a good balance.

Genius

The results from a negative Vignette Intensity setting may differ from those obtained by using the Devignette tool if you have cropped or straightened the image. This occurs because the Devignette tool is applied before cropping while the Vignette tool is applied after cropping. The Vignette tool is creating an artistic effect on your final image whereas the Devignette tool was designed to remove lens artifacts.

Removing chromatic aberration

Chromatic aberration appears when the Red, Green, and Blue channels do not focus on precisely the same spot. The result is a colored halo edge along high-contrast edges in the image, as shown in Figure 6.35, particularly near the edges of the image, although it can appear anywhere in the image.

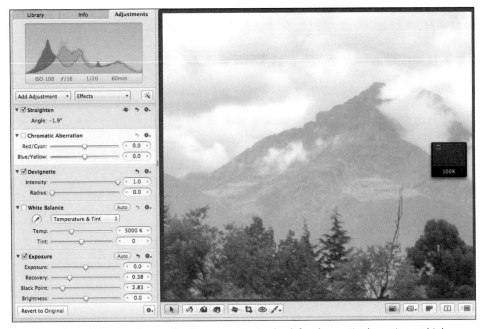

6.35 Zoom in to 100 percent magnification or greater to check for chromatic aberration on high-contrast edges.

To remove chromatic aberration, do the following:

1. **Choose Chromatic Aberration from the Add Adjustment pop-up menu.** A new brick appears.

2. **Increase the image magnification to see the chromatic aberration clearly.**

3. **Adjust the Red/Cyan and/or Blue/Yellow sliders to remove the colored edge, as shown in Figure 6.36.**

Removing noise

Aperture offers a Noise Reduction adjustment that primarily reduces chromatic noise (magenta, green, and blue blobs that appear in areas that should be smooth colors). The adjustment contains two controls: a Radius slider to control how much noise reduction is applied and an Edge Detail slider that controls how much edge detail to retain. The higher the Edge Detail setting the less noise reduction that's applied.

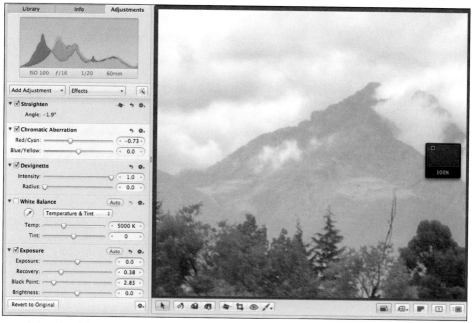

6.36 Adjust the sliders to remove the colored halos.

We find this adjustment can be helpful with some images, particularly when brushed in, but with images that have major noise issues, we tend to prefer third-party noise-reduction plug-ins that offer more controls.

Using iPhoto Effects

One of the features introduced in Aperture 3.3 is that you can take advantage of some Adjustment Effects such as an Antique effect or an Edge Blur that previously were only available within iPhoto and apply these effects directly within Aperture. If you previously worked in iPhoto and had applied these adjustments to any of your images, and now you're an Aperture user, you can fine-tune the settings in Aperture.

To apply the iPhoto Effects, do the following:

1. **Choose Add Adjustment ⇨ iPhoto Effects.**

2. **From the Effect pop-up menu, choose an effect: None, Black & White, Sepia, or Antique.**

3. **If you choose Antique, an Amount slider appears to control the intensity of the effect.**

4. **Set the Matte, Vignette, and Edge Blur sliders as desired to create edge treatments.**

5. **Set Fade or Boost to change the intensity of the colors in the image.**

Although there are fewer options available to control these effects, sometimes they enable you to quickly finish an image and add impact, as shown in Figure 6.37.

Brushing adjustments in or out

Most (but not all) adjustments have the option to be brushed in or out from the Action pop-up menu, while some also contain a brush icon to directly access the brush in or out of the dialog. The ability to brush the effect in or out without needing to make a separate selection is a huge advantage. To brush an adjustment in (or out), do the following:

1. **Apply an adjustment.** Initially it affects the entire image.

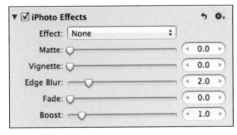

6.37 Using the Edge Blur and Boost sliders increased the impact of this image.

2. **Choose Brush adjustment In or Away from the Action pop-up menu at the top right of most adjustment bricks.** A new, small dialog appears, as shown in Figure 6.38. If you opt to brush the adjustment in, the brush is selected and the effect disappears from the entire image preview, whereas if you opt to brush it out, the eraser is selected and the effect remains.

3. **Set the brush parameters in the dialog.**

 - **Choose the size of the brush.** Normally, we work using a magnified view so that we can work accurately

 - **Choose the softness of the brush.** The softer the brush, the more the changes blend into the background; the harder the brush, the more discrete and obvious the edges are. Usually, we work with a soft to mostly soft brush.

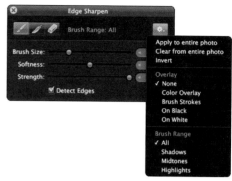

6.38 This dialog contains a lot of powerful controls to help you make localized adjustments.

 - **Specify the strength of the adjustment.** The setting you use here controls the initial strength of the change, but you can modify it after the fact in most cases by adjusting the settings in the adjustment brick. In addition, you can vary the strength setting for each brushstroke to apply the effect in differing intensities.

 - **Select the Detect Edges check box to have Aperture automatically limit your brushstrokes to certain areas.** That way you can quickly modify one or more discrete areas of the image without having to use an external editor and make a selection. When you select Detect Edges, the size of the brush is smaller than it would be otherwise.

4. **Choose from several other controls located in the Action pop-up menu in the upper right of the small dialog to control how the effect is applied.**

 - **Choose whether to apply the effect to the entire image, clear the effect completely, or invert which areas show the effect.**

 - **The next group of options controls whether to apply an overlay to make it easier to see where you've applied the effect.**

 - **The last group of options limits the brush to applying the effect to just the highlights, middle tones, or shadows.**

When you take advantage of the option to brush an effect in or out, be sure to zoom in and work carefully so you don't accidentally leave sloppy edges around the effect. Remember that you can apply an effect in one area and then open another adjustment of the same type, with slightly different settings, and apply that adjustment to a different part of the image by choosing Add New adjustment from the Action pop-up menu in the adjustment brick. The ability to brush adjustments in and out to create localized adjustments gives you a huge amount of control over your images without ever having to leave Aperture and without having to make difficult and time-consuming selections.

Genius

Press ⌘+Z to undo previous adjustments. Repeating the keystroke combination continues to step the adjustments back in time if you discover you're heading in the wrong direction. You can also use the curved arrow near the top right of each of the bricks to reset the brick to its default settings.

Using Quick Brushes

Quick Brushes are very similar to the brushes you use when you brush an adjustment in or out. The main difference is that Aperture has additional adjustments that are only available as Quick Brush adjustments. These adjustments are designed to be brushed in or out but not necessarily applied to the entire image. In this section, we describe using the Quick Brushes, including the Retouch tool and the other Quick Brushes.

Using the Retouch Brushes

Without a doubt, the Quick Brush that we use the most frequently is Retouch in order to remove dust spots due to dirt on the sensor. We also use the Retouch Quick Brush to remove other distractions. To use Retouch, follow these steps:

1. **Zoom in to 100 percent magnification when removing dust spots.** Otherwise it's quite possible that you'll miss some of the smaller spots and then be embarrassed when they suddenly are more visible when you output the image at a larger size. Begin in one corner and then move in a uniform way across the image and then down, making sure not to miss any areas.

2. **When you encounter a dust spot or streak, press X to access the Retouch tool or click the Brushes icon beneath the Viewer to the left, as shown in Figure 6.39 and choose Retouch.** A small dialog appears.

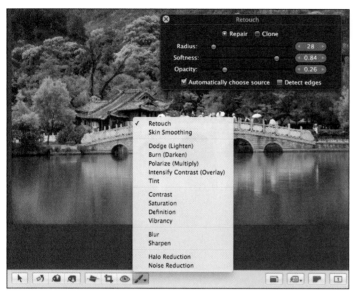

6.39 Access the Retouch tool from the Brushes icon and the Retouch dialog appears.

3. **Select Repair or Clone.** In Clone mode, Aperture makes an exact copy of the good pixels and places it over the area you want to hide. At times this is exactly what you need, but you have to be careful not to create obvious repetitions of areas because that will broadcast that you cloned something out. In the Repair mode, Aperture copies the texture from good pixels but blends the color with the color in the problematic area. Often this leads to more subtle results, but which mode is better depends on the area of the image that you're fixing, how detailed the area is, and whether the detail in the surrounding areas is similar or totally different. There are no hard and fast rules to follow as to which mode to use, and the best advice we can offer is that if the surrounding area is fairly similar in detail, begin by trying Repair mode. If you're removing a dust spot from a highly detailed area of an image where the nearby detail is of something else, then you may be better off with Clone mode and work at a very high magnification and with a tiny brush.

4. **Choose the Radius of the brush.** Normally, you want a brush that's fairly small because you can click and drag the brush to cover an area. You don't need to use a huge brush and cover large spots in a single click.

5. **Set the Softness of the brush.** The softer the brush, the more gradually the effect is feathered in, whereas the less soft, or harder the brush, the more discrete the edges of the clone

or repair. In highly detailed areas, you may need a harder brush while retouching areas of low detail, such as sky or water or other backgrounds, may require a very soft brush.

6. **Set the Opacity of the brush.** To cover an area completely, set the opacity to 100 percent, but if you need to blend a retouched area to help it look more natural and to hide any obvious cloning and repetition of patterns, you can retouch using a series of repairs and/or clones at partial opacities.

7. **When you use Repair mode, choose whether you want to have Aperture automatically choose the source.** We often begin by selecting this check box, but if the results are unexpected and we discover that Aperture is using a source that doesn't work the way we have in mind, we leave that check box unselected. In that case, as well as when using the Clone mode, hold down the Option key and click on the source pixels to load the brush with pixels.

8. **In Repair mode, select the Detect edges option to have Aperture automatically detect edges.** We find this option extremely helpful.

When you've set all the parameters for the Retouch tool, click and drag to cover the area. The direction that you drag the brush when using the Repair mode can make a difference in how well it works. If you aren't pleased with the initial results, try increasing or decreasing the radius slightly and/or dragging in a different direction. Often that fixes the problem.

After you use the Retouch tool, a new brick appears in the Adjustments Inspector. You can delete your retouches sequentially by clicking the Delete button in the brick, but you can't skip over several retouches and delete just one that was several steps back.

Using the remaining Quick Brushes

All the other Quick Brushes share a common control dialog and can be accessed either by choosing Quick Brushes from the Add Adjustment pop-up menu in the Adjustments Inspector and then choosing the specific Quick Brush, as shown in Figure 6.40, or by clicking the Brushes icon under the Viewer.

Once you choose a specific Quick Brush other than Retouch, the dialog for that brush appears, such as the one for the Dodge Quick Brush shown in Figure 6.41. Although compact, this dialog includes a lot of important options and controls.

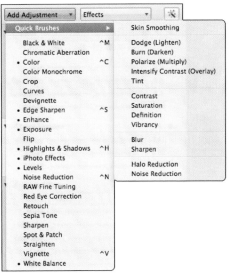

6.40 Access most of the Quick Brushes from the Add Adjustment pop-up menu in the Adjustments Inspector.

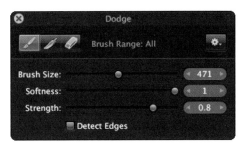

6.41 A lot of controls that make it even easier to brush on localized adjustments are packed into this small dialog.

At the top are three choices: a brush to brush in the effect, a feather to use to help smooth the edges of the areas you brush, and an eraser to remove the effect. The feather and eraser are actually special types of brushes. All three brushes are controlled by the options in the rest of the dialog as follows:

- **Brush Size slider.** To increase or decrease the brush size, adjust the slider accordingly or drag two fingers up or down on a Multi-Touch trackpad.

- **Softness slider.** This determines how discrete or feathered the edges of the brush are. The softer the brush, the more the effect blends in gradually with areas that you haven't modified, whereas the less soft or harder the edges, the more abrupt the transition is. While often a soft brush is most helpful, there are times when you need the change to begin and end more abruptly, and in those cases you need to set this slider for a harder brush.

- **Strength slider.** This determines how strongly the affect is applied. Because you can reduce the strength of most of the Quick Brushes in the associated brick in the Adjustments Inspector after the fact, you could opt to apply the effect at full strength.

However, if you start to brush in the effect and it's clearly too strong, it makes sense to reduce the strength of the brush initially. Keep in mind that you can set the strength at one setting for one stroke and at a different setting for the next stroke. That way you can work precisely and get exactly the results that best suit your image.

- **Detect Edges.** Selecting this check box causes Aperture to automatically constrain your brushstrokes to areas similar to where you initially begin the brushstroke. That way the effect doesn't accidentally seep into adjacent areas of the image. We use this option a lot and find it helps us to work more efficiently.

Use the Action pop-up menu in the upper right of the dialog to access additional controls, including the options to see the brushstrokes. This is helpful when you make subtle adjustments that are difficult to see on the image. Taking the time to use the overlays, as shown in Figure 6.42, means you won't accidentally forget to include an area. Which overlay you use depends in part on personal preference and on the effect you're using.

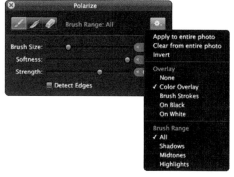

6.42 Take advantage of the overlays to see precisely where you've applied a Quick Brush.

Having the ability to limit the effect to the highlights, midtones, or shadows gives you a great deal of control. Although often you may opt to use the Quick Brushes set to All, keeping in mind the option to limit the effect to a specific tonal range enables you to use greater control over the various effects when needed.

There is also the option to apply the effect to the entire image, whether you want it to apply to the whole image or use that as your starting place and then use the Eraser to remove it from a few areas. In cases where you want the effect to apply to the bulk of the image, it's a lot easier to begin that way rather than having to brush it in nearly everywhere.

There are a variety of Quick Brush effects. Use them as follows:

- **Skin Smoothing.** This Quick Brush reduces skin imperfections such as wrinkles and large pores. The blur effect is somewhat subtle even when applied at full strength. Using Skin Smoothing on portraits can make you popular with your subjects as you make their skin look even better.

Note

When using Skin Smoothing, remember to leave areas such as eyes, nostrils, mouth, teeth, hair, and earrings untouched. That way the image appears sharp, yet the skin appears smooth(er).

- **Dodge and Burn Quick Brushes.** Use Dodge to lighten areas and Burn to darken areas, as shown in Figure 6.43. We find it best to work at a reduced strength and increased magnification and then repeat the strokes using a higher strength setting as needed.

6.43 Using the Dodge and Burn Quick Brushes, you can brush in highlights and shadows to increase the sense of depth in your images.

- **Polarize.** Use this Quick Brush to deepen colors and shadows, as shown in Figure 6.44. This uses a Multiply blend effect that is supposed to simulate using a polarizing filter; however, it does not remove glare from reflective areas. We find the results can be helpful but are not identical to what you'd expect if you were using a polarizing filter on the camera.

6.44 The Polarize Quick Bruch applied at full strength to part of the image (right) and without (left).

Note

To simulate a polarizing filter, we like to use the polarizing filter in Nik Software's Color Efex Pro 4. We find that it gives a more realistic effect.

- **Intensify Contrast.** You can use this Quick Brush to increase the contrast by deepening the shadows while leaving the highlights mostly untouched. This adjustment uses the Overlay blending mode to create the effect and differs from the Contrast Quick Brush in that the Contrast brush causes the highlight tones to become noticeably lighter in addition to creating deeper shadows. The difference between the two brushes is shown in Figures 6.45 and 6.46, where both types of contrast have been applied to the entire image. If you don't want to risk blowing out any highlight values, choose the Intensify Contrast Quick Brush, whereas if you want darker areas to become darker and lighter areas to become lighter, choose the Contrast Quick Brush.

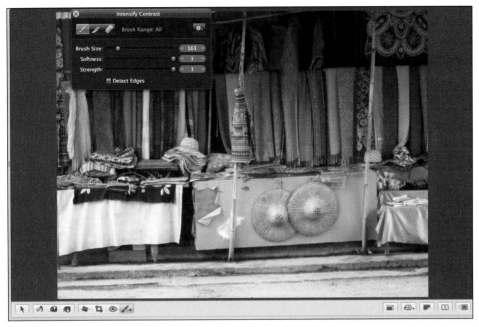

6.45 The Intensify Contrast adjustment has been applied to the entire image.

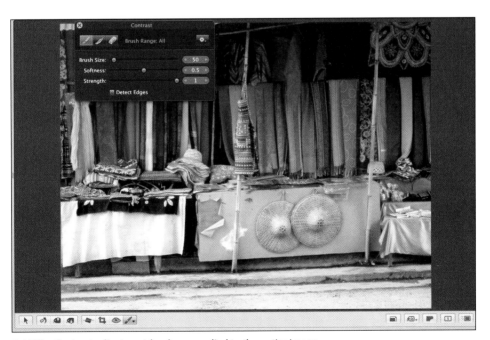

6.46 The Contrast adjustment has been applied to the entire image.

- **Saturation or Vibrancy.** Use these Quick Brushes to intensity saturation or vibrancy in certain parts of your image. Using the Saturation or Vibrancy brushes on your subject can help subtly guide the viewer's eye to your subject matter, as shown in Figure 6.47. By using the Quick Brush, you can brush in these effects separately from the other Enhance brick adjustments.

- **Definition.** Use this Quick Brush to brush in the Definition Adjustment Effects. The Definition adjustment is the same as what's available in the Adjustments Inspector, but by using the Quick Brush you can brush the Definition in separately from the other Enhance brick adjustments. That way you can add midtone contrast, some saturation, and sharpness just where you want it in the image to help encourage the viewer's eyes to go there.

6.47 Use the Saturation, Definition, and Vibrancy brushes to help draw attention to your subject, as in the "after" version of this image on the right.

- **Blur.** Use this Quick Brush to blur any areas as desired. You might try blurring the background to help draw attention to the foreground in your image.

- **Sharpen.** Use this Quick Brush to apply a basic sharpening effect to localized areas of the image. We suggest you use this option sparingly because you have less control over the sharpening parameters this way than if you use the Edge Sharpen adjustment.

- **Halo Reduction.** This Quick Brush removes any halos such as purple fringing that may occur with certain lenses. Halo Reduction is slightly different from the Chromatic Aberration adjustment and is not necessary with most lenses. However, if you check your image at an increased magnification of 100 percent or more and discover purple fringing, this Quick Brush can be invaluable.

- **Noise Reduction.** Use this Quick Brush to remove noise from specific areas of the image.

Creating and Using Effects

The Adjustment Effects in Aperture 3.3 and later are major time-savers, as we've already mentioned with the White Balance Effects. There are a series of effects that Apple includes by default, and additionally you can create your own effects that contain a combination of various adjustments. In addition, you can add effects that you download from other sites. All effects can be applied to your images as they're being imported, or you can apply them to one or more images as you edit the images in Aperture. Using effects is a quick and efficient way to optimize images or at least get the adjustments close to where they need to be. After you apply an effect, you can always tweak the individual adjustment settings for any particular image.

To use the effects, open the Adjustments Inspector and choose the Effects pop-up menu. As shown in Figure 6.48, you see a menu of the types of effects that are available. As you hover over the individual effects within each category, you see a preview of the image with the effect applied. Those previews are huge time-savers because you instantly see whether an effect is helpful.

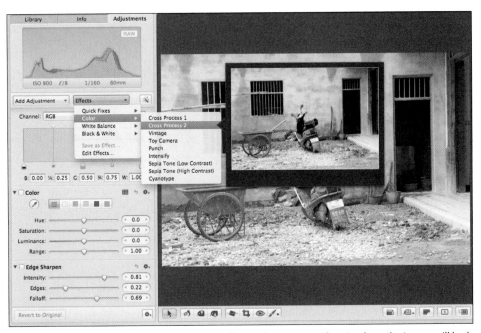

6.48 Hover the cursor over any of the presets and a preview appears showing how the image will look if you apply that preset.

The effects are divided into groups. The first group is called Quick Fixes and primarily adjusts the exposure of the image. We've been pleasantly surprised that in many cases Auto Enhance does a good job of getting an image quite close to the way we want to see it. Unfortunately, it sometimes introduces clipping into one or more channels, so we often modify the white and black point Curves settings it creates after applying it. Nonetheless, as discussed earlier, Auto Enhance can provide a great starting place, particularly with low-contrast images, and helps when you initially view your images.

You can apply additional effects by selecting them. The image preview will update, indicating when they've been applied. For example, we might use Quick Fix ➪ Auto Enhance and then opt to brighten the Shadows to see more shadow detail, and then perhaps use one of the White Balance Effects to correct the colorcast of the image. With any of the presets, you can tweak the settings in the appropriate adjustment brick.

Genius

To remove an earlier effect and apply a new one to an image, hold down the Option key while choosing the new effect. That way the new effect will be applied to the image *instead of* the earlier one, rather than *in addition* to it.

The Color Effects offer a variety of trendy effects you can apply. Seeing the previews is a huge help because it makes it very obvious when something is not a good choice.

As we discussed earlier, the White Balance Effects offer access to the traditional white balance settings such as Sunny, Cloudy, Shade, and so on, that are commonly used in cameras but that have been missing in earlier versions of Aperture.

The Black & White Effects offer not only an additional method of converting the image to black and white, but a variety of presets that simulate the presence of various types of filters and infrared. If you want to convert your image to a monochrome, we highly recommend you check out the Black & White Effects at least as starting places.

If you have downloaded effects they also appear in the list of effects. The image preview updates to show the effect of each downloaded effect as well.

As helpful as all the default effects are, many people find the ability to create and apply custom effects even more useful. To create a custom effect, do the following:

1. **Open an image and make one or more adjustments to the image.**

2. **From the Effects pop-up menu, choose Save as Effect.** A new dialog appears, as shown in Figure 6.49.

3. **In the new dialog, assign the effect a name that is easily recognizable.** In our example we created an effect to be able to use the legacy Highlights & Shadows adjustment.

4. **In the right section of the dialog, remove any adjustments that you don't want to include in the effect.** For example, if you've modified the white balance in your image and applied a small S curve but only want to save the S curve as an effect, you'd select the White Balance adjustment in the right column and click the minus icon (–) to remove it. Only the Curve adjustment remains.

5. **Click OK to save the new effect.** The new effect appears in the Effect pop-up menu and can be applied to images upon import or within Aperture.

6.49 Create custom effects using this dialog.

Genius

If you want to access the legacy Highlights & Shadows tool, open an image that contains that adjustment. Duplicate the image, reset the Highlights & Shadows sliders to their default positions. Then click the Effects button and choose Save as Effect. Name it accordingly. That way you can access the legacy tool via Effects.

Note

To apply a series of adjustments to multiple images, you can use the Lift and Stamp tool that we cover in Chapter 4.

Using an External Editor

As full featured as Aperture is, there are still times when you want to open your images in an external editor such as Photoshop. We primarily do this when we want to create composite images. To use an external editor you first need to specify the editor in Preferences as we cover earlier.

After you establish the external editor, it's very easy to use it. To edit an image in an external editor such as Photoshop, after you've completed setting the Preferences, do the following:

1. **Select the image or images you want to open in the external editor.**

2. **Choose Photos ⇨ Edit With Photoshop CS6 (or whatever application you specified in Preferences) or press Shift+⌘+O.** Aperture creates a new version of the file as either a TIFF or PSD, depending on what you specified in Preferences, that contains all the pixel and adjustment information. The new file then opens in the external editor software. Make the desired changes.

3. **When you complete the adjustments in the external editor, choose File ⇨ Save or press ⌘+S.** Saving the image updates the file in Aperture. When you close the external editor, you can work on the image in Aperture again.

Caution

You must do a Save in the external editor, not a Save As. If you do a Save As, the file is stored outside the Aperture library and the image does not update in Aperture.

Using Third-Party Editing Plug-Ins

Numerous third-party editing programs can enhance the optimizing options that are available within Aperture itself. There are plug-ins for sophisticated noise reduction, advanced sharpening, converting to black and white, creating HDR (High Dynamic Range) images from several exposures or HDR Toning from a single image, adding creative effects, adding creative borders, and so on. Apple has a list of the various plug-ins at the App Store. We often use the plug-ins from Nik Software, particularly Silver Efex Pro for converting to black and white, Color Efex Pro for creative effects; Dfine for Noise Reduction, HDR Efex Pro or HDR Soft's Photomatix for HDR imagery; and some of the Topaz plug-ins. Many of these programs offer free trials so you can see the effects for yourself and decide which ones are the most helpful for you.

Note

We're able to offer our readers discounts on all Nik Software programs. Use the promo code EANON, and on Photomatix, use the promo code EllenAnon.

Caution

Starting with Aperture 3.3, Aperture no longer provides support for 32-bit plug-ins.

Once you download the plug-ins and install them, they automatically go into the right place.

To use a third party plug-in that you've installed, do the following:

1. **Select the image and then choose Photos ⇨ Edit With Plug-in.** A list of the plug-ins you've installed appears.

2. **Choose the plug-in you want to use.** Aperture creates a new version of the file complete with all the pixel information as well as any adjustments you've added in Aperture. That version of the file opens in a new dialog for the plug-in, as shown in Figure 6.50 where we used Color Efex Pro 4.

3. **Use the plug-in to make the desired changes and then click OK.** The file is saved into the Aperture library and visible with your other images. You can continue to modify it in Aperture if necessary.

6.50 Plug-ins open their own interface. When you're happy with the settings, click OK or Save (depending on the plug-in).

Caution

Even if you make no additional changes to the file in Aperture, you can't reopen the file in an external plug-in and edit the settings you used. Once you click OK or Save, those changes are saved into the file.

What Options Do I H
to Create a Physical
Copy of My Photos?

Ultimately, the reason we shoot is to share our best images with other people, whether digitally or as a printed image. However, getting a great print is a little more involved than just clicking the Print button. In this chapter, you learn everything from how to make sure your print on paper looks like the image on your screen to how to create different types of prints and even a custom book.

Color Management . 220

Using Aperture's Print Dialog . 224

Ordering Prints. 235

Creating a Book . 236

Color Management

One of the industry-defining features of the early Mac and LaserWriter was how the page on the screen in Aldus PageMaker looked just like the page that came out of the LaserWriter. This consistency spawned the desktop-publishing revolution. Over the years, we've all become used to What-You-See-Is-What-You-Get (WYSIWIG) printing, but setting your computer up so that you get prints at exactly the right size, layout, and color is still a little complex. The first step is making sure you have a color-calibrated workflow, and once set up, the next step is setting Aperture's Print panel to give you the size and layout of images you want. However, if you don't have a printer, Aperture has a built-in way for you to order high-quality prints. If you really want to go above and beyond to impress a client (or your grandparents), Aperture also has tools to enable you to build and order a beautiful, custom book.

Depending on a number of factors, including how old your monitor is, the quality of its internals, whether sunlight or tungsten bulbs illuminate it, and more, the exact same image file can look completely different on two different monitors. Furthermore, if you just click the Print button without doing anything, the resulting print will most likely look completely different than what you see on your monitor, and if you switch paper types, it will look different still. You might get lucky and get a print that matches your monitor fairly well, but this will be the exception and not the rule. Unless you're willing to do a little bit of work to create a color-calibrated workflow, you will always be playing Russian roulette when you click Print.

There are a few reasons for this complexity. One is that your monitor is capable of displaying far more colors than your printer can print, and you need to help your computer determine the best way to go from the wider color space your monitor has to the more limited color space that your printer has. When we talk about a color space, we are talking about a subset of all possible colors created for some particular reason. For example, sRGB was designed to be a small color space (meaning it has fewer shades of each color than other color spaces) that looks roughly the same on all uncalibrated monitors. Adobe RGB (1998) is a color space that Adobe created to contain most colors that printers can output but that can also be displayed identically on a monitor. Figure 7.1 shows a CIE 1931 diagram (which represents all possible colors) with a triangle indicating the colors in the Adobe RGB (1998) and sRGB color spaces.

Genius

The set of colors that a device can reproduce is referred to as the device's *gamut*.

Setting up a calibrated workflow so that your computer knows how your printer and monitor render each color is key to getting consistent prints of your photos. This process involves two key steps: calibrating your monitor and calibrating your printer. Although setting up a calibrated workflow might sound very complex, it's actually rather easy.

Calibrating your monitor

The first part of setting up a calibrated workflow is to figure out how your monitor renders colors. For example, a shade of red could look darker or bluer or more orange, and so forth, on your monitor than on another monitor. Calibrating your monitor lets your computer (and Aperture) know that it needs to correct this shade of red so that it matches the red standard.

To calibrate your monitor, you need a special device called a colorimeter. This device reads the light coming out of your monitor and uses it to build a color profile for your monitor. A color profile is a file that describes a device's color space. At the time of writing, there are three devices that we suggest checking out. The X-Rite Pantone Huey is a low-cost tool that can give reasonable results, although its results are not as accurate as other tools. The Datacolor Spyder 4 is a great midrange tool that generates very good profiles and can automatically adjust them as the ambient light in your office changes. The X-Rite ColorMunki (see Figure 7.2) is a very high-quality spectrophotometer that is capable of

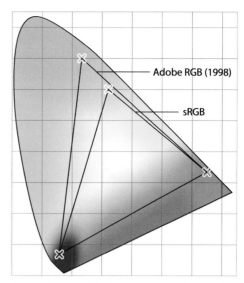

7.1 The larger Adobe RGB (1998) and the smaller sRGB color spaces on top of a CIE 1931 diagram with all colors.

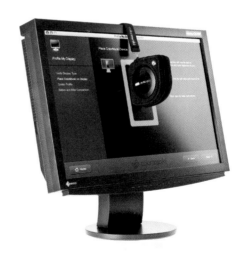

Courtesy X-Rite

7.2 The X-Rite ColorMunki spectrophotometer.

calibrating your monitor, projector, and printer. Although more expensive than the other two devices, the ColorMunki is our currently recommended calibration device.

Although these devices have very impressive names, they're fairly easy to use. Follow the directions for the device you purchase. In general, you'll install a piece of software, launch it, hang the device from your monitor when prompted, and then save the resulting profile (and switch your system to use it).

Caution Pay attention to the lighting conditions in your room when calibrating your monitor. Even a calibrated monitor will look different in sunlight and under artificial lighting. We recommend making your room as dark as reasonable when calibrating your monitor and judging color, as it's easier to make a room dark than to match a specific lighting level.

Calibrating your printer

A monitor color profile tells your computer how to properly display the colors in an image file, and a printer color profile tells your computer how to convert the colors in the file into your printer's color space. Most printer manufacturers have profiles available on their websites for their printers and paper types. Make sure you pay close attention to the paper type specified in the profile name, because if you use a printer profile based on one type of paper such as glossy to print onto another paper type such as matte, your colors will be off. Many times, third-party print labs have their printer profiles available for download on their websites with instructions on how to use them.

While these generic profiles are usually pretty good for printers, you can create a custom printer profile to get the best results. Do so either by using a device like the X-Rite ColorMunki or by using a service such as Cathy's Profiles (www.cathysprofiles.com). Note that you need a custom profile for each ink and paper combination you use with your printer.

Soft proofing

Even if you are very careful in creating your monitor and printer profiles, it's still possible that you will see a small difference between the image on the screen and the printed image. This difference can happen for a number of reasons, but the main reason is that we sometimes perceive a printed image differently than a displayed image. This difference can be more extreme with certain types of paper; for example, watercolor paper causes prints to appear less saturated.

Soft proofing is a way to preview how you perceive the print before actually printing it, as shown in Figure 7.3. As we explain next, you can then use Aperture's adjustment tools to modify the image so that the final output looks as good as possible.

7.3 The original image and how it appears soft proofed. Sometimes the difference is insignificant, but sometimes it is substantial.

Follow these steps to soft proof and adjust an image:

1. **Select the photo to print.**

2. **Choose Photos ⇨ Duplicate Version.**

3. **Choose View ⇨ Proofing Profile, and select the appropriate profile for your printer and paper type.** Note how the image changes. You are now soft proofing this image.

4. **Toggle soft proofing temporarily off by choosing View ⇨ Onscreen Proofing.** Pay close attention to how the image changes from the original as you turn soft proofing back on by again choosing View ⇨ Onscreen Proofing.

5. **Select the original version so that both versions are displayed, but change the primary selection back to the new version.**

6. **Open the Adjustments Inspector and adjust this new version so that it looks the same with soft proofing on as the original does with soft proofing off.** Unfortunately, when soft proofing is on, Aperture turns soft proofing on for every image in Viewer — you can't select both the original image and this new version and have Aperture only show a soft proof for this new version. Instead, you need to keep toggling Onscreen Proofing on and off as you adjust this new version. Your setup will look similar to Figure 7.4.

7.4 A soft proofing setup with the original image on the left and the soft-proof version you're adjusting on the right.

7. **Use this new version to print from rather than the original version as you follow the rest of the printing instructions in this chapter.**

Using Aperture's Print Dialog

After you finish soft proofing and adjusting your images, select them and choose File ▷ Print Image. A print dialog like the one in Figure 7.5 appears. There are three key parts to the Print dialog. On the top left, you find all the different print style presets, including contact sheets and

custom preset layouts (which we cover shortly). On the bottom left are all the print options (which we also cover shortly), but by default Aperture only shows a limited set. Click More Options to see the complete set of options as already done in Figure 7.5 (note that the button changes to read Fewer Options). The right side of the dialog contains a preview of your print.

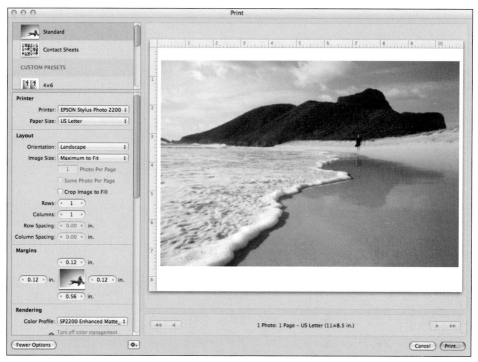

7.5 The Print dialog with the print style presets and options on the left and the print preview on the right.

Configuring a standard print

Typically, when photographers talk about wanting to make a print, they want to print one image per sheet of paper at a specific size. Aperture calls this type of print a *standard* print. Select Standard from the presets area to begin. Notice how the preview on the right displays your image as filling the page as much as possible. Next, you set a variety of options to control how Aperture places the image on the page and prints it.

This is where you set which printer you're using and what size paper you're using. To add a new printer, choose Add Printer from the Printer pop-up menu, and Aperture opens the system-wide

Add Printer dialog (which you can also access through the Print & Fax system preference). Choose your paper size from the pop-up list, but if you don't see the right size in the list, choose Custom and type the paper's dimensions.

Layout and Margins

The next controls are the Layout options and the Margins options, as shown in Figure 7.6. These options control how your image is placed onto the page. Switch the orientation from Portrait to Landscape to change how the page is displayed in the preview area. Image Size lets you set your image to be a specific size, or choose Maximum to Fit to make the image take as much of the paper as possible (taking your margin settings into account).

If you select an image size that's smaller than the paper size, Aperture automatically increases the number of photos per page when possible. For now, set this number to 1 (we cover the settings related to rows, columns, and number of photos per page when we discuss contact sheets). If you mouse over the preview, guidelines appear around your image. Move your mouse over one of these guides, and when the cursor turns into a double-arrow,

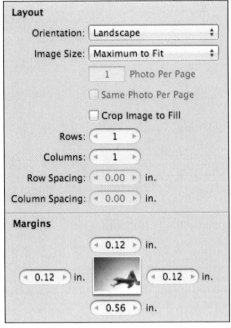

7.6 The Layout and Margins print options let you adjust where the image is on the page.

click and drag to adjust the margin sizes interactively, controlling where on the page Aperture prints your image. Alternatively, if you know the exact margin that you want to use, type its size into the Margins options area.

Although you won't typically use this next feature, it's good to have it in your bag of printing tricks just in case. When you click on your image in the preview area or make a pinch gesture on a Multi-Touch trackpad, Aperture displays a heads-up display (HUD) that lets you scale up your image. Then you can click and drag your image to control which specific part Aperture prints. We

recommend cropping your image beforehand when you have more control, and printing your full image rather than using the Print dialog to crop into an image.

Pay close attention to the Crop Image to Fill check box. Deselect this option. If this is selected, Aperture will crop your image to match the printable area's aspect ratio. For example, if you try to print a panorama onto a square sheet of paper, it will crop the panorama into a square image. While this is great for maximizing paper use, it's typically not what you want when printing an image.

Rendering

Aperture has three groups of options to control your image and color. They are the Rendering, Image Adjustments, and Image Options groups, as shown in Figure 7.7.

The Rendering options control the color profiles and conversions that Aperture uses for your print, and these settings are crucial for having color-accurate prints. The first pop-up menu is to select whether you want Aperture or your printer to handle the color management. If you want your printer to manage color, choose Printer Managed. Aperture also displays a tip, reminding you to enable printer color management in the System Print dialog that appears when you click Print. If you choose to let Aperture manage color, which we recommend, select your printer and paper combination's profile from the list. In this case, Aperture displays a tip reminding you to disable color management in the next System Print dialog so that you don't accidentally double-convert your print's color.

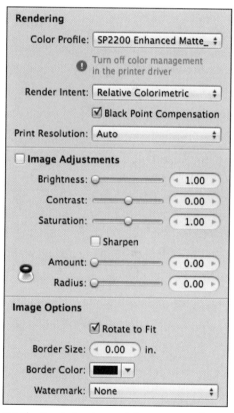

7.7 The Rendering, Image Adjustments, and Image Options groups let you adjust your image's color.

When you choose to have Aperture handle color, you'll also see a Render Intent pop-up menu and a Black Point Compensation check box. As discussed earlier in the chapter, your printer, monitor, and image file all have different gamuts. To help your computer move between color spaces and to deal with these gamuts, it's helpful to give it a hint as to what part of the color space conversion is most important to you. Picking a rendering intent (see Figure 7.8) is how you provide this hint.

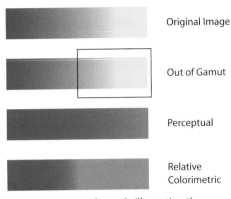

Original Image

Out of Gamut

Perceptual

Relative Colorimetric

7.8 An exaggerated sample illustrating the original image and how it might be printed with perceptual or relative colorimetric rendering intents, assuming part of the original is outside the printer's gamut.

- **Perceptual.** This method takes all the colors in one device's space and scales them to fit within another device's space. This is useful for printing because it preserves the relationships between colors so that a color that appears more saturated on your monitor than a neighboring tone also appears more saturated on your print. However, perceptual rendering will cause all your colors to shift slightly — a specific shade of red on the printed page will not be the exact same color as what's displayed on your monitor.

- **Relative Colorimetric.** This intent maps each color from the source (your displayed image) into the closest color that the destination (your printer) can reproduce. This means that a specific shade of red will match almost, if not perfectly, between a print and the display. However, if you have a lot of colors in the source that are outside of the destination's gamut, they might appear different on the screen yet the same in the print. For example, two different shades of very saturated orange could appear identical in a print because relative colorimetric rendering decided that the closest very saturated orange that the printer could create happened to be the same value.

In general, both methods will do a very good job, and you might not be able to tell the difference. However, if you have an image with a lot of very saturated colors or with very subtle color gradients, we recommend using perceptual rendering.

For Print Resolution, Auto automatically determines the best resolution for your print based on the print and image sizes, but you can also pick a standard size (Aperture uses 72, which is typically too low for high-quality prints) or type a custom resolution such as 360 for high-quality printing.

Image Adjustments

The Image Adjustments group provides two useful functions. The first is that sometimes, despite your best efforts at color management and soft proofing your prints, you'll find that your prints look a little better if you boost the brightness, contrast, or saturation before printing them. While you could make a new version, make those changes, and then print this new version, using these three sliders in the Print dialog is far easier.

The second part of the Image Adjustments group is the sharpening settings. As you've probably heard, you want to sharpen the image you're going to output after it's resized to the final print size. If you sharpen it before resizing, then your image won't appear to be sharpened properly because it's going to be scaled from the size you used to pick your settings. By selecting the Sharpen check box and setting the desired Amount and Radius settings (click the Loupe button to the left to open the Loupe tool so that you can zoom into your image and pick appropriate sharpening settings), Aperture sharpens your image appropriately now that it's scaled to its final print size. Similar to settings in Photoshop, Radius controls the size of the area around each object's edge that will be affected, and Amount controls how much the contrast in each edge will be exaggerated. Be careful not to set your Radius too high, as you might see halo artifacts around each object, especially with higher Amount settings.

Image Options

The last set of image and color options that directly affects how your image is printed is called, appropriately, Image Options. We recommend always leaving Rotate to Fit selected so that if you have a landscape image but your layout settings are set to portrait, Aperture will rotate your image to fit on the page. The border size and color controls let you add a solid line border around your image. Lastly, to add a watermark to your image, select it from the pop-up menu, or if it doesn't appear, select Choose and browse for your watermark.

Metadata & Page Options

The final set of print options controls whether you see metadata with your print, and if so, what type of metadata, as shown in Figure 7.9. This can be useful if you're printing a selection of images to discuss with clients, and you'd like to have image information such as the filename available with the image.

From the Metadata View pop-up menu, select the metadata view that contains the metadata fields you want to see printed with your image (we cover creating custom views in Chapter 4). Use the Position and Font pop-up menus to determine where and with what font style Aperture will print your metadata. If you have a company logo that you want to

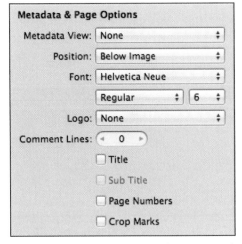

7.9 The Metadata & Page Options let you control the text that's printed with your image.

add to each printed page, select it from the Logo pop-up menu (if it's not there, select Choose to browse for the logo image).

Comment lines provide the specified number of blank lines below the metadata text for you to write comments onto. The Title and Sub Title check boxes control whether you see the project or album name as the title and a subtitle, which defaults to your name, in a larger font on the page. If you want a different title but don't want to rename your album or project, Aperture also lets you click on the title and subtitle text and to then type new text. Selecting the Page Numbers check box adds page numbers to each page, and selecting Crop Marks displays small crop marks where your page margins are.

Creating a contact sheet

To print a contact sheet, do the following:

1. **Select all the images that you want on the contact sheet.**

2. **Choose File ⇨ Print.**

3. **Choose Contact Sheets from the print presets area.** The Print dialog changes its preview and looks similar to Figure 7.10.

The print options covered earlier about configuring a standard print still apply, with a few small differences.

The biggest difference in print options is that under the Layout options group, the Photos Per Page and Same Photo Per Page options (as well as a couple Layout group sizing options) have disappeared, and the row and column controls are now relevant. As you probably guessed, the Rows and Columns fields control how many rows and columns your contact sheet will have, and the Row Spacing and Column Spacing fields control the space between each row and column.

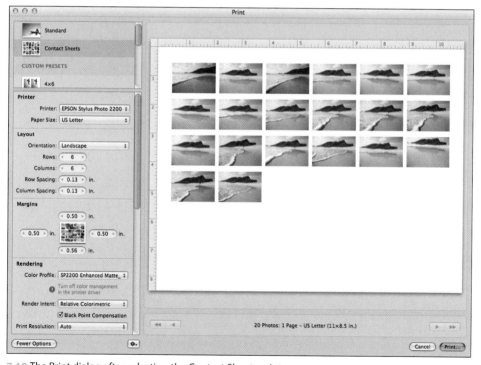

7.10 The Print dialog after selecting the Contact Sheets print preset.

231

The next difference is that under Image Options, selecting the Rotate to Fit check box causes each thumbnail to rotate to match the page's orientation. For example, if you have portrait thumbnails on a page set to print in landscape mode, selecting Rotate to Fit causes the portrait thumbnails to rotate to have a landscape orientation. We recommend deselecting this check box.

Furthermore, the border and metadata options now apply to each individual image, although options like Title and Page Numbers still apply to the print page as a whole.

Use the arrow buttons under the print preview to switch pages, assuming your contact sheet has more than one page, to make sure that everything looks as you expect before clicking Print.

Caution When printing a contact sheet, you'll want to use a light touch with any Image Adjustments, especially sharpening, as the settings are applied to each image. The settings that work for one image will most likely not work for all images.

Using built-in custom presets and creating your own

While the Standard and Contact Sheets print presets will meet most of your needs, sometimes you'll have custom print layout needs, such as printing two 4-x-6-inch images on one sheet of paper. Custom presets provide this flexibility.

Aperture provides a number of built-in custom presets. We recommend that you click these presets and look at what options Aperture changes to achieve each print style. For example, the 4 × 6 preset is based on the Standard print preset but has the image size fixed at 4 × 6 inches and automatically adjusts the number of photos per page to fill the selected paper size as completely as possible with 4-x-6-inch images. Same Photo Per Page is selected so that each page has two 4 × 6 prints of each image, and Crop Image to Fill is selected so that the print is guaranteed to be 4 × 6 inches and to have that exact aspect ratio, regardless of the original image's aspect ratio.

Sequence is similar, but rather than using a standard Image Size setting, it has a custom setting and Crop Image to Fill is selected, which creates a sequence of images that you might use to promote a show, for example. Again, remember that you can click on each image in the print preview and adjust how Aperture crops the image (and scale the image up or down as needed, too).

Review Sheet is based on the Contact Sheets preset. You can tell because under Layout, it doesn't have any individual image size options. Unlike the Contact Sheets preset, Review Sheet has no space between the rows, fewer rows and columns overall, and a few settings changed under Metadata & Page Options.

While these different custom presets provide some diverse printing options, chances are they're not exactly the settings you want, and you'll still want to create your own presets for your specific needs.

The Action pop-up menu at the bottom of the Print dialog provides three commands to help you manage your custom presets: Save Preset, Duplicate Preset, and Delete Preset.

To create a custom preset, follow these steps:

1. **Select an existing preset that's closest to the preset you want to create, even if it's just the straightforward Standard or Contact Sheets preset.**

2. **Choose Duplicate Preset from the Action pop-up menu and give the new preset a name.** Note how Aperture displays a dot, as shown in Figure 7.11, to the left of the preset's thumbnail. This dot means that the preset has unsaved changes.

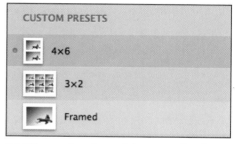

7.11 The small, embossed dot means that the preset has unsaved changes.

3. **Change whatever print options you need to change for your preset.** While you might save certain Image Adjustments, such as brightness, to account for how your printer prints, we recommend not saving sharpening settings as part of a preset to avoid accidentally oversharpening an image.

4. **Choose Save Preset from the Action pop-up menu.**

5. **Click Print to print your image using this preset.** In the future, you'll be able to select this new preset from the Custom Presets list to quickly print another image (or group of images) with the same settings.

As you might expect, at some point if you want to remove a preset, select it and choose Delete Preset from the Action pop-up menu.

Note

Often, you'll change a setting in a custom preset just for a particular image or group of images, such as adjusting a sharpening setting. You don't need to save the preset each time you change it, unless you explicitly want to save the adjusted settings as part of the preset.

Clicking the Print button and its settings

After you set up your print (or prints) the way you want them, click Print on the bottom right. Aperture opens the standard system Print dialog, as shown in Figure 7.12. Make sure to click the disclosure triangle, select Color Management from the pop-up menu, and choose the appropriate setting. Remember, if you told Aperture to manage your color (which we recommend), you select No Color Adjustment. If you told Aperture that your printer would manage your colors, choose the appropriate color management settings here.

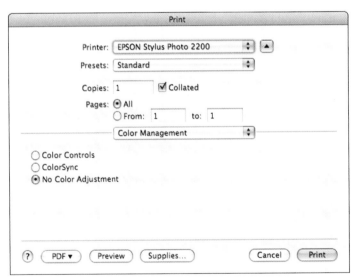

7.12 The system Print dialog and Color Management settings.

Once you finish adjusting your Color Management settings, click Print, and Aperture spools your print job.

Ordering Prints

If you don't own a printer, Aperture provides a tool to order prints via a third-party print service. Unfortunately, you have no control over the paper type or other print settings. To order a print, follow these steps:

1. **Select the images you want to have printed.**

2. **Choose File ⇨ Order Prints.**

3. **Use your Apple ID to sign in.** This is the same ID you use to log in to the iTunes Store. If you don't have an Apple ID, click the Create Account button and follow the steps. The screen changes to display the order form.

4. **As shown in Figure 7.13, use the text fields to select the number of each size of prints that you want to order, and click Continue when done.** The screen changes to display just your order.

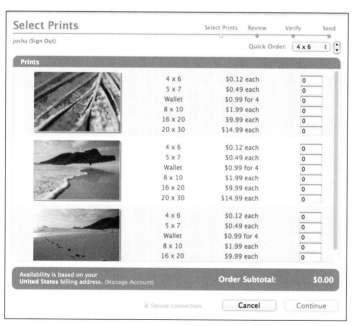

7.13 Use the Select Prints screen to control how many of each type of print for each print you want to order.

5. **Review your order and click either the Back button to make changes or Continue to go forward.** The screen changes again to display shipping and billing information.

6. **Type your shipping and billing addresses as well as your e-mail address for a receipt.** This last Verify screen also includes the estimated tax and shipping charges.

7. **Click Place Order to confirm your order.**

While Aperture's Order Prints tool is quite convenient and priced nicely, for full control over your prints, we recommend using the techniques described in Chapter 8 to create a ready-to-print digital version of your image and send it to a print service that provides more control, such as www. mpix.com.

Genius

For other types of prints, such as a card or calendar, open your Aperture library from iPhoto to access your images. Then order the desired print product from within iPhoto.

Creating a Book

One of Aperture's mature features is the ability to lay out and order a completely custom book of your photos. Creating a book comes down to three main steps: picking the type of book you want to make, laying out the pages in your book, and ordering your book. This section covers how to do each of these tasks and describes in depth how to lay out a page to customize your book.

Creating a new book album and picking themes

To create a new book, follow these steps:

1. **Select the images you want to put into your book.**

2. **Choose File ⇨ New ⇨ Book.** Aperture displays the New Book dialog shown in Figure 7.14. Or click on the New button in the Toolbar at the top of Aperture's screen and select Book from its pop-up menu.

3. **Type your book's title into the Book Name field.**

4. **Select the type of book from the Book Type pop-up menu.** In addition to the standard Apple books, you can also download photo book plug-ins from the Apple website for third-party book printers, such as Graphistudio and Couture Book. Choose Learn More from the Book Type pop-up, and Aperture opens the Photo Book Plug-Ins page in your Browser. Lastly, choose Custom if you want to create a completely custom book that you will print yourself.

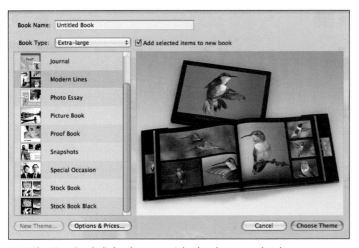

7.14 The New Book dialog lets you pick a book type and style.

5. **Select your book's theme from the list on the left.** As you click on each theme, a theme preview appears on the right side of the dialog. If you're creating a Custom book type, click New Theme to type your book's page size and margin information.

6. **Click Options & Prices to see a list of prices and finishing options for your book.**

7. **Click Choose Theme to confirm these options, create your book album in the Library Inspector, and to open the Book Layout Editor.**

8. **Choose whether you want a Hardcover or Softcover book, if your book type provides the option, by clicking the appropriate button at the top of the Book Layout Editor.** Because this choice affects page layout, changing it later might adversely affect your book's pages.

Note

It's possible to add images from multiple projects and albums to the book by dragging the images onto the book's icon in the Library Inspector.

Genius

Any custom themes you create are saved in /Users/yourUserName/Library/Application Support/Aperture3/Book Themes. To share your theme with another person, copy your custom theme from that folder to the same location on the other person's computer.

Navigating the Book Layout Editor

Whenever you have a book album selected in the Library Inspector, Aperture displays the Book Layout Editor that you see in Figure 7.15 instead of the standard Viewer. This editor lets you control the pages in your book and the layout of those pages including the images, text, and maps placed on the page. There are two main parts to the Book Layout Editor: the Pages pane and the Book Editor Viewer.

- **Pages pane controls.** The Pages pane is on the left side of the Book Layout Editor. It lets you quickly see and navigate between pages in your book, add and remove pages, change page templates, and more. At the top of the Pages pane, there are buttons to switch your book's theme and to switch cover type (if available).

Pages pane Book Editor Viewer

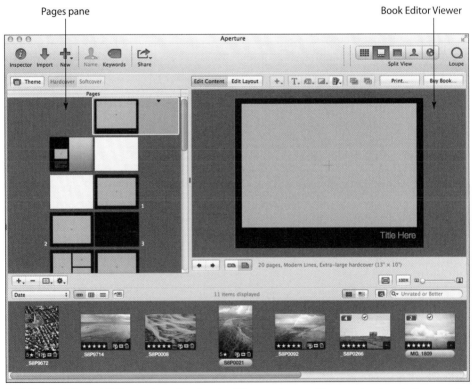

7.15 The Book Layout Editor replaces the standard Viewer when working on a book and allows you to see, navigate between, and edit the pages in your book.

● **Book Editor Viewer.** The Book Editor Viewer is similar to a regular Viewer, but it displays a book page instead of just a photo. Because normal Viewer functions such as View ⇨ Zoom to Actual Size are disabled with the Book Editor Viewer, Aperture provides three controls in the bottom right of the Book Editor to fit the Book Editor Viewer to the available space, zoom it to actual size, and to manually select the zoom scale for the Viewer. There are also buttons at the bottom of this viewer to switch between viewing a single page or a full spread and to go to the previous or next page. At the top of this viewer are buttons to control the contents of the page, and we cover these buttons in more detail in the rest of this chapter. If you are using a Multi-Touch trackpad, swipe here to change pages or pinch to zoom in and out of a page.

Aperture prepopulates the Pages pane with a variety of page types. These prepopulated pages help show what options are available with this theme and provide a nice starting point to create your book.

Note At the bottom-right corner of the Pages pane is the Book Actions pop-up menu. This menu contains many commands we refer to throughout the rest of the chapter.

Placing images and text

As you click on different pages in the Pages pane, Aperture changes the page currently displayed in its Viewer. Notice how many pages have gray areas with a crosshatch in the middle and blocks of *lorem ipsum* text. These are placeholders for images and text, respectively.

Changing the text is fairly straightforward. Double-click on the lorem ipsum text or Section Title text and type the text you want to appear. We cover how to customize your text's appearance shortly.

Placing images is almost as easy. Start by dragging and dropping an image from Browser onto the gray placeholder area (if Browser isn't visible, choose View ⇨ Split View or press V). Double-click on a placed image to open the Image Scale HUD, which lets you zoom your placed image in or out, and click and drag your placed image to move it around within the image box. For example, if you've placed a landscape image onto a portrait placeholder box, you can drag the image around to control how it's being cropped into a portrait image.

Caution

If you're unable to place an image or edit text, make sure the Edit Content button at the top of the Book Editor Viewer is selected and not the Edit Layout button.

Note

When you place an image into a book, Browser displays a small maroon badge with a number indicating how many times this image has been placed into this book.

Genius

The Rebuild Book commands in the Book Actions menu will remove any changes you've made to the book's design, revert to the default series of pages, and automatically fill the image placeholders with either all your images or the selected images, depending on which command, Rebuild Book With All Images or Rebuild Book With Selected Images, you choose.

Rather than placing images manually into each image placeholder, Aperture can automatically place either your selected images or all images that haven't been used yet in the book. To automatically place a specific group of images, select the images in Browser and choose Autoflow Selected Images from the Book Actions pop-up menu. Aperture places the selected images into your book, shown in Figure 7.16, starting with the first empty image placeholder. To have Aperture automatically place any unused images into your book, simply choose Book Actions ➪ Autoflow Unplaced images.

Insert Text

Iceland has a wide variety of landscapes.

7.16 A before and after view of an empty page and a page with text and images filled out.

240

Some layouts will also let you place a photo as the page background. To do so, drag an image from Browser onto the background area of the page, and let go when Aperture highlights the background.

To unplace an image, select the photo box and press Delete. To remove a background image, click the Set Page Background pop-up menu, pointed out in Figure 7.17, and choose either No Background or a background color. Figure 7.17 also points out the other customization menus that we refer to throughout the rest of the chapter.

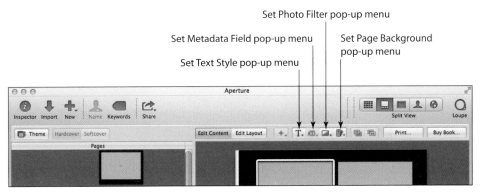

7.17 The text, metadata, photo filter, and page background customization menus provide formatting options for each type of item on the page.

Adjusting metadata boxes

Some themes have special text fields that are linked to a particular image placeholder and display that image's metadata. You cannot directly type new metadata values for the image here (use the Info Inspector if you want to adjust an image's metadata), but you can change what metadata is displayed in the box and link the metadata box to a different image.

To change the metadata box's metadata view, select the metadata box, click the Set Metadata Field pop-up menu, and select the new metadata you want displayed. Note that this menu doesn't provide access to the standard metadata views and isn't customizable. There is only a limited sub-set of metadata that you can have automatically displayed in a metadata box.

To link a metadata box to a different image, follow these steps:

1. **Select the metadata box.**

2. **Choose Book Actions ➪ Unlink Metadata Box.**

3. **Select both the image you want to connect to the metadata box and the metadata box by ⌘+clicking on each.**

4. **Choose Book Actions ⇨ Link Metadata Box.** The metadata box should now be displaying metadata values for the new image.

By default, Aperture doesn't number your images. To turn on automatic numbering, choose Book Actions ⇨ Enable Plate Metadata. Aperture automatically adds the word "Plate" and the image's number to each metadata box.

Configuring item options

Each photo and text box (including metadata boxes) has a number of configuration options related to both style and how the box contents are placed into the box.

To start, the Set Photo Filter pop-up menu provides a number of filters that you can quickly apply to an image, including the page background image. To use them, select a photo and then select a filter from this menu.

There are two ways to apply a different style to a text or metadata box. The first is to select the text box and then click the Set Text Style pop-up menu. This menu, with an example shown in Figure 7.18, lists all the preset styles from this book template. You can choose a different text style by picking one from the menu.

Alternatively, if you highlight the text you want to style and choose Edit ⇨ Show Fonts, Aperture opens the standard System Font dialog. Use this dialog to pick custom fonts, sizes, and colors for your text.

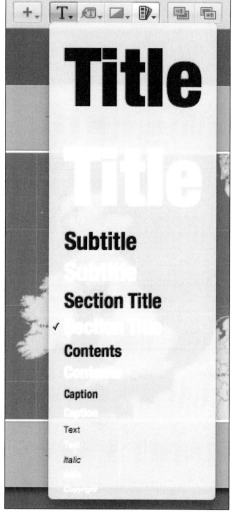

7.18 An example Text Style menu, showing the preset options from the built-in Photo Essay theme.

The next set of configuration settings deals with how each box's contents are placed into its box. If you select a photo box and choose Book Actions ⇨ Photo Box Alignment, you see four options:

- **Scale to Fill.** This option is the default and scales the image up to fill the photo box completely, regardless of aspect ratio.

- **Scale to Fill Centered.** This option scales the photo so that it fits completely into the photo box at the proper aspect ratio. The photo will be centered in the photo box.

- **Scale to Fill Left.** This option scales the photo so that it fits completely into the photo box at the proper aspect ratio. The photo will be placed along the left side of the photo box.

- **Scale to Fill Right.** This option scales the photo so that it fits completely into the photo box at the proper aspect ratio. The photo will be placed along the right side of the photo box.

The Photo Box Alignment options are available both when in Edit Content and Edit Layout mode. However, to make the text box options active, click the Edit Layout tab.

Now, if you select a text box, you'll notice that the Book Actions ⇨ Text Box Alignment menu is active. Use this menu to select whether a text box is left aligned, centered, and so on. We cover the other options available when in Edit Layout mode later in the section on customizing page layout.

Working with Browser's extra book features

In addition to showing you how many times an image is used in a book, as mentioned previously in this chapter, Browser has three extra buttons when attached to the Book Editor, as indicated in Figure 7.19.

Show Viewer for this Browser button Show All Images button Show Unplaced Images button

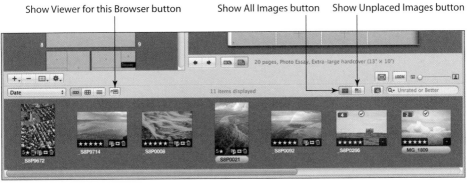

7.19 Browser gains buttons for Show Viewer for this Browser, Show Unplaced Images, and Show All Images when attached to the Book Editor.

On the right, Browser now has buttons to toggle between showing all images in the book album and only showing images that haven't been placed into the book. It's useful to have Browser set to Show All Images while you collect images to put into your book and to switch to Show Unplaced Images mode while placing images.

The other button Browser gains is the Show Viewer for this Browser button. When the Book Editor is open, there's no obvious way to make an adjustment to an image beyond the Book Editor's photo filters, aside from leaving the Book Editor and finding the image in its project. Instead, if you select an image (or images) in Browser and click this button, Aperture temporarily switches the Book Editor out for a normal Viewer so that you can inspect your images and make any adjustments. Click this button again to close Viewer and return to the Book Editor.

Note The Loupe still works even when the Book Editor is open, allowing you to zoom in on your images to check for sharpness. However, it doesn't magnify the entire page contents. It only lets you loupe the images on the page or in Browser.

Using maps

Some themes, such as Photo Essay and Journal, also have map elements on certain pages. These maps integrate with Places, allowing you to flag a specific place or to draw a journey between places. If you haven't yet set a specific place, it's possible to add a new place on the map while creating the book.

To set a map's initial location, either drag a photo with a location set onto the map or follow the following instructions on how to manually add a new place to the map. Double-click on the map to open the Map Options HUD, as shown in Figure 7.20.

7.20 The Map Options HUD lets you control the locations marked on the map, the lines between locations, and other options.

244

There are four main controls in the Map Options HUD:

- **Zoom slider.** This lets you change the map's scale.

- **Title.** This lets you add stylized title text to the map.

- **Places.** This lists the locations flagged on the map. If you're going to set the map to display lines and arrows between locations, drag and drop each location name in the list to rearrange them into the order that you want Aperture to draw the lines.

- **Action pop-up menu.** This contains controls to display how the map's displayed.

To add locations to the map, you can either drag additional photos tagged with a location to the map or follow these steps:

1. **Double-click the map to open the Map Options HUD.**

2. **Click the Add (+) button in the bottom left.** If Aperture doesn't automatically start editing this new item, double-click on it in the Places list.

3. **Start typing the location in Places and Aperture displays a pop-up menu with matching locations.** If you are typing a new address, you might need to wait a second or two for Aperture to give you the option to search the web for this address in its Auto-Complete list.

4. **Pick the correct location from the list.**

5. **The new location now appears in the list in the Map Options HUD and on the map.**

To delete a location, select it in the Map Options HUD and click the Remove (–) button in the bottom left.

The Action pop-up menu in the Map Options HUD has a number of commands to help you configure your map to create a finished map, as shown in Figure 7.21, and they are as follows:

- **Return to Starting Place.** If you have your map set to draw lines between locations, this option closes the loop and draws a line from the last place to the first place.

- **Move Label.** This option causes the label, if visible, for the selected place to move to a different side of the place pin, making it easier to read the label.

- **Show Lines with Arrowheads/Show Straight Lines/Hide Lines.** These options toggle between showing a line between places with arrowheads, without arrowheads, and not drawing any lines.

- Ⓐ **Show Place Marker Text.** Show or hide the place labels.
- Ⓐ **Show Region Text.** Show or hide the larger labels, such as the country name, on the map.
- Ⓐ **Center Map on Places.** Zoom the map automatically to show all places marked on the map.
- Ⓐ **Reset Map.** Reset the map display back to the book's default.

Genius Instead of manually typing a location into the Map Options HUD, double-click on the map and then click and drag the map around to move it. Control+click on a location and choose Add Place to interactively add places to the map.

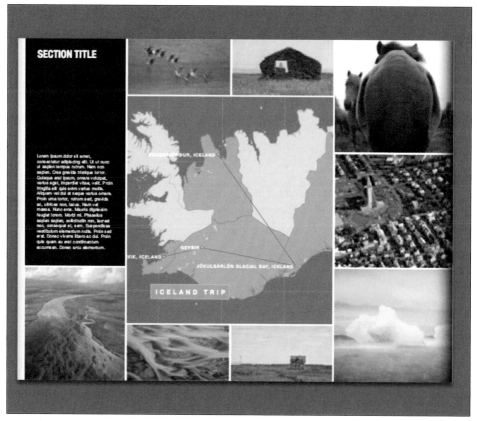

7.21 A finished map, showing different locations, lines with arrows between locations, location names, and a map title.

Switching page styles

To switch page styles between different preset master pages, select the page in the Pages pane and either click the Set Master Page button at the bottom of the Pages pane or click the disclosure triangle that appears next to the selected page. Aperture opens a menu, such as the one in Figure 7.22, with the available page styles. Note that the right and left pages might have different options; for example, the left page has options for styles that span both pages.

7.22 The Master Page pop-up menu, showing a number of different available page styles.

Adding and removing pages

To add a new page, select the previous page in the Pages pane, click the Add Pages button, and choose Add New Page. Aperture creates a blank page with what it determines to be the appropriate master layout, and you can change that layout after the fact. To choose a specific layout and then add a new page using that layout, choose Book Actions ⇨ Show Master Pages, select a master page, and then choose Add Pages ⇨ Add New Page From Master. Choosing Duplicate Page makes a duplicate of the previous page's layout and images, with the layout adjusted to reflect whether the new page is on the left or right side of the book. Note that the default Apple books are limited to 99 pages.

To remove a page, select the page and click the Delete Pages button. Books require an even number of pages and at least 20 pages. If needed, Aperture inserts a blank page later in your book to accommodate these restrictions.

Customizing page layout

While there are plenty of preset page masters to choose from, sometimes you still want to adjust the page layout. To begin, click the Edit Layout button at the top of the Book Editor.

The easiest way to begin customizing a page layout is to drag the different boxes around on the page to rearrange them. As you do so, Aperture displays Smart Guides along the page and snaps the box to them to help you line up your different boxes. Use the Bring Forward and Send Backward buttons at the top of the Book Editor, shown in Figure 7.23, to move items behind and in front of one another. These commands are also in the Book Actions menu under the Arrange submenu.

7.23 The Bring Forward, Send Backward, and Add buttons provide additional commands to modify the page's layout.

Resize a box by selecting it, clicking on one of the handles that appears, and dragging that handle. Hold the Option key while dragging to cause Aperture to scale the box around the middle rather than only the side you're dragging. With a Multi-Touch trackpad, the pinch gesture resizes the object beneath your mouse pointer, and the rotation gesture rotates objects. Hold down the Shift key while rotating to rotate in 15-degree increments.

You can type specific sizes and locations for your boxes by using the Layout Options pane, as shown in Figure 7.24. To open it, choose Book Actions ⇨ Show Layout Options. When you select a box on the page, Aperture fills the Layout Options pane with the box's information. Type new numbers in these fields for precise control over each item's layout.

7.24 The Layout Options pane lets you type exact values for each box's size, position, and rotation.

The Book Actions menu contains a number of other useful layout commands:

- **Photo Box Aspect Ratio submenu.** To quickly apply a specific aspect ratio to a photo box, instead of manually resizing it, select the photo box and choose an aspect ratio from this submenu.

- **Text Box Columns.** To change the number of columns in a text box, select the text box and choose the number of columns from this submenu.

- **Page Numbers.** To force page numbers to be always on or off or to let Aperture automatically determine when to show them, choose the appropriate option from this submenu.

- **Enable/Disable Plate Numbers.** By default, Aperture does not display image numbers in its metadata boxes. Enable Plate Numbers if you want to automatically have plate numbers.

To add a completely new element to the page, whether you want an image, text box, metadata box, or map, either click the Add button at the top of the Book Editor or choose Book Actions ⇨ Add and select the appropriate item. Position, size, and format it using the commands covered in this chapter.

Remove an element by selecting it and pressing Delete.

At any point, if you want to return to the original page master, choose Book Actions ⇨ Reapply Master, and Aperture resets the page to its default.

Editing master pages

Master pages are the default starting layouts for the different pages in your book. Aperture lets you customize these masters, either by editing an existing one or creating a new one.

To see the masters, choose Book Actions ⇨ Show Master Pages. Aperture opens the pane you see in Figure 7.25. As you scroll through this list, you can click on any master page to open it into the Book Editor Viewer. Edit the master's layout as you would any other page to make changes directly to the master. Note that you cannot make changes to the cover page.

To add a new master page, follow these simple steps:

1. **Select an existing master page.**

2. **Click the Add (+) button and select Add New Page.** This adds a new master to the Master Pages pane.

3. **Double-click its name to give it a new, descriptive name.** You can edit its layout as previously described.

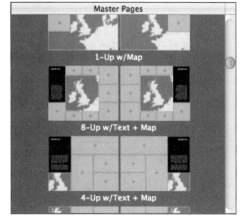

7.25 The Master Pages pane lets you quickly modify and add new master pages to your book.

If, after customizing a normal book page, you decide that you want to add these changes to the master rather than redoing all the changes on the master, simply select the page and choose Book Actions ⇨ Save Page ⇨ To Document Master. If you want to turn your changes into a new master page, rather than modifying the existing master, choose Save Page ⇨ As New Document Master instead. Then show the Master Pages pane, find this new master, and double-click its name to give it a more descriptive name.

By default, when you create a new master, whether by explicitly adding a new master or by saving a page in your book as a new master, Aperture creates versions of this page for both the right- and left-hand sides of your book. You will most likely want to tweak each version of this master. For example, you might have a text field on the left for a page on the left but want the text field to be on the right for a page on the right. To do so, click the left and right sides of your master to make changes to each version.

If you instead want this master to have one layout for both the left and right sides of your book, choose Book Actions ⇨ Unify Master Page. Rather than displaying two thumbnails for each side of the page, your master will now only have one thumbnail representing both sides, as shown in Figure 7.26. To split a master so that the left and right sides have different versions, select the master and choose Book Actions ⇨ Split Master Page.

Unified master pages

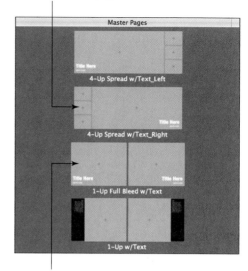

Split master pages

7.26 Unified and split master pages in the Master Pages pane.

Printing or ordering your book

When you finish creating your book, you can either print it yourself, save it as a PDF to send to a third-party print service, or buy it directly through Aperture. To print it or save it as a PDF, click Print in the Book Editor. Aperture opens the standard system Print dialog. Either set your print settings and click Print or choose PDF ⇨ Save as PDF to create a PDF version of your book.

To order a copy of your book directly from within Aperture, do the following:

1. **Click Buy Book in the Book Editor.** Aperture displays a sheet like the one in Figure 7.27.

2. **Log in using your Apple ID or create one if you don't yet have one.**

3. **Adjust the quantity of books you want to order.**

4. **Click Preview Book to see a PDF preview of what your book will look like.**

5. **Click Continue, type your billing and shipping information, and click Place Order to confirm your order.** Aperture uploads your book in the background to the appropriate print service, and your new book arrives in the mail in a few days.

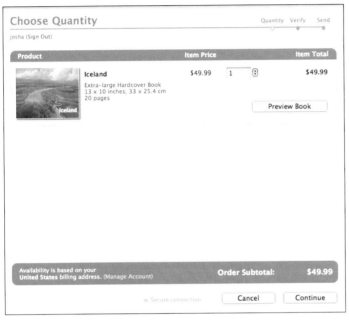

7.27 The very handy book order sheet.

How Can I Share My Images Digitally?

One of the great things about digital photography is that you no longer need to worry about sending original slides through the mail. However, there are many file formats and sizes that you need to decipher to send a digital version of your image. Aperture simplifies your digital sharing workflow, letting you e-mail or post an image to the web with a single click. Furthermore, you can use Aperture to create advanced presentations, such as slide shows and web pages, with just a few clicks. This chapter explores the powerful tools Aperture provides to share your images digitally.

Exporting Originals and Versions of Images 256

E-mailing Images ... 264

Setting Your Desktop Image 265

Creating Slide Shows .. 265

Creating Web Pages .. 275

Facebook .. 282

Flickr ... 285

Using Other Export Plug-ins 287

Exporting Originals and Versions of Images

The most basic forms of image exporting in Aperture are exporting a copy of the original version of your photo (typically the RAW file) or exporting a specific size and resolution of the selected version of your photo, complete with all the adjustments you've made. You might export the original for backup reasons, to provide someone else with your RAW file, or to export the RAW file so that you can open it in a different converter. Typically, though, you export a version of your photo for a specific purpose, whether it's to e-mail to a client or to enter it into a contest.

Fortunately, Aperture is very consistent, and wherever you can export an original or a version of your photos you will see a nearly identical set of options. This section covers the different options available when exporting originals and versions of your photos.

Exporting originals

The basic steps to export an original are quite simple:

1. **Select the images whose originals you want to export.**

2. **Choose File ⇨ Export ⇨ Original.** Aperture opens the dialog in Figure 8.1.

3. **Select the folder to save the originals into.**

4. **Click Export Originals.**

After you click Export Originals, you can check the status of your export by opening the Activity window (Window ⇨ Show Activity). When finished, Aperture will have created copies of the selected original files in the selected folder for you to do with as you please.

At the bottom of the dialog there are two options that you can select. Selecting Include Audio Attachments causes Aperture to export a copy of any audio attachments for the selected images alongside the exported originals. Selecting Show alert when finished causes Aperture to open an alert dialog when it finishes exporting your images.

Aperture also provides options to rename your original files and to control how it exports the original's metadata.

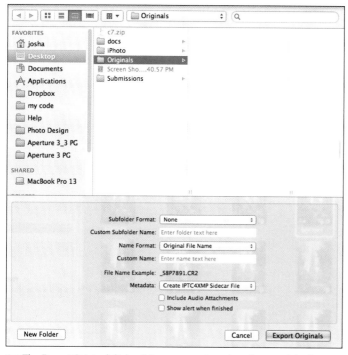

8.1 The Export Original dialog lets you export copies of your original master files out of Aperture.

Folder and filename options

By default, Aperture puts your exported originals into the folder you select. However, you can also set it to create subfolders for your original images automatically and perhaps create an image year/month/day hierarchy for your exported originals.

To pick a different subfolder format, click the Subfolder Format pop-up menu and choose one of the presets. If the preset allows you to set a custom name, make sure to type the custom name into the Custom Subfolder Name text field. To return to the default, no subfolder option, select None.

To create your own subfolder format, follow these steps:

1. **Choose Edit from the Subfolder Format pop-up menu.** Aperture opens the Folder Naming dialog in Figure 8.2.

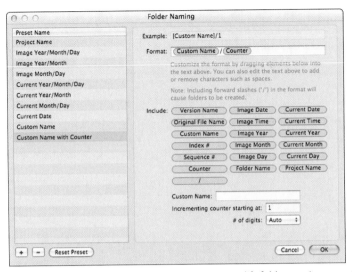

8.2 The Folder Naming dialog lets you create or modify folder naming presets.

2. **Select an existing preset to modify it, or click the Add (+) button to create a new folder naming preset.** Make sure to give your new preset a name.

3. **Drag and drop the tokens on the bottom from the Include area into the Format text field to create your preset.** Table 8.1 describes a select group of tokens that aren't obvious. If you add a Custom Name token, type a default Custom Name in the appropriate field. If you add a Counter token, set its starting number and the number of digits to use (for example, when the counter's value is 5, one digit displays 5 whereas four digits would display *0005*). Note that as you adjust your tokens, the Example field updates to show you a sample filename.

4. **Type any text you want to be part of the preset into the Format text field, such as your initials.**

5. **Select a token in the Format text field and press Delete on your keyboard to remove it.**

6. **Click OK to finish creating your preset.**

Caution

If you use a counter, Aperture continues increasing the counter number for each export unless you manually reset it by typing a zero into the Increment counter starting at field.

Table 8.1 A Few Unintuitive Tokens for Naming Presets Such as Folder Naming Presets

Token Name	Effect
Counter	Adds a counter to the preset that keeps increasing by increments until you reset it.
Index #	Adds an index number that starts at 1 and resets for each export.
Sequence #	Adds text such as "1 of 5" to the preset where the first number is the current item and the second number is the total number of items being exported.
/	Creates a new subfolder. For example, Image Year/Image Month will create a folder for each year (based on your export selection) and subfolders for each month within each year.

In addition to being able to set custom subfolder names, the Export Original panel also lets you control how your exported originals are named. Use the Name Format pop-up menu to control filenames. Choose Original File Name to return to the default (which gives you the original filename) or choose Edit to open the File Naming dialog. This dialog is nearly identical to the Folder Naming dialog covered earlier, and you create and edit file naming presets in the same manner.

Genius Rather than opening an export dialog and choosing Edit from the Subfolder and Name Format pop-up menus, access the File and Folder Naming dialogs directly by choosing Aperture ➪ Presets ➪ Folder Naming and File Naming.

Metadata options

When exporting an original file, there are three metadata options to pick from, with the default being not to export any metadata.

- **Don't Include IPTC.** This option does not export any metadata with the original.
- **Include IPTC.** This causes Aperture to embed the image's IPTC metadata into the original file.
- **Create IPTC4XMP Sidecar File.** This creates an XMP file alongside the original file with the image's IPTC information, without changing the contents of the original file.

Note The Aperture-created XMP file only contains the image's IPTC information and not the full set of metadata on the image.

Exporting versions

Whereas exporting a copy of your original file gives you a duplicate of your initial, unadjusted file in the original format at the original resolution, exporting a version exports an image with the size, format, and quality that you choose containing all your adjustments. You will most likely find yourself exporting versions of your images far more often than the original, whether it's a low-resolution JPEG version to send to a client or a high-quality TIFF version to send to a commercial print house.

The basic steps to export a version are quite similar to exporting an original:

1. **Select the image(s) to export.**

2. **Choose File ⇨ Export ⇨ Version.** Aperture opens the dialog in Figure 8.3.

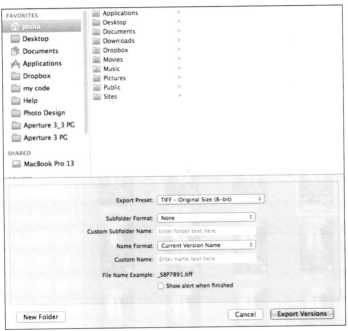

8.3 The Export Version dialog allows you to pick from preset, common formats, and sizes or to create your own.

3. **Set the subfolder and name format, or create a custom format as described in the previous section.**

4. **Choose a preset image format and resolution, or follow the instructions in the next section to create your own Image Export Preset.**

5. **Select whether you want Aperture to display an alert when you finish exporting.**

6. **Click Export Versions.**

Managing Image Export Presets

The Image Export dialog lets you manage your saved Image Export Presets, making it easy to create commonly used image settings to export with. For example, we have an agent who prefers to receive an initial batch of lower-resolution images and then a second set of his selected images at a higher resolution. We have two presets set up, one for the initial submission and one for the final submission. By picking the appropriate preset from the Export Versions sheet, it's easy to guarantee our images are at the right size and format.

To open the Image Export dialog, either choose Edit from the Export Preset pop-up menu or choose Aperture ➪ Presets ➪ Image Exports. There are two main parts in the Image Export dialog, as shown in Figure 8.4. On the left is the list of presets, and on the right are all the available settings for each preset.

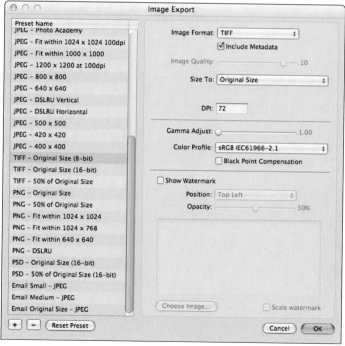

8.4 The Image Export dialog allows you to manage your Export Presets, whether you want to change an existing preset or to create a new one.

To create a new preset, click the Add button (+) in the bottom left. Select a preset to change its options, and if you change a built-in preset, you can click Reset Preset to restore it to its default state.

We cover adding watermarks to a preset in the next section, but here are the different options available for each preset:

- **Image Format.** Use this pop-up menu to select the image's file type, whether it's JPEG, PNG, TIFF, or PSD. TIFF and PSD also have higher-resolution 16-bit options available.

- **Include Metadata.** If you select this check box, Aperture embeds your image's metadata into this exported version. Sometimes, such as when posting an image to the web, you might not want to have your metadata embedded into an image, especially GPS metadata. Note that this option is not available for PNG images.

- **Image Quality.** When you select JPEG for the preset's image format, use this slider to adjust how much compression the image will have. Lower numbers mean a more compressed/smaller but lower-quality file.

- **Size To.** Choose whether this preset exports the image at its original size, scaled to fit within a specific dimension that you type in (specified either in pixels, inches, or centimeters), or scaled to a percentage of the original image size.

- **DPI.** Specify the dots per inch resolution at which to export your images.

- **Gamma Adjust.** This option lets you apply a gamma curve to your image to adjust the midrange brightness. In general, we recommend using a color-calibrated workflow and making adjustments to your image rather than relying on this setting. However, if you're creating an Export Preset for a specific purpose and find that the midrange brightness of your images is consistently off for that purpose, the Gamma Adjust slider lets you add a correction to the preset.

- **Color Profile.** This pop-up menu allows you to select the color profile that Aperture embeds into this version. We typically recommend ProPhoto or Adobe RGB (1998) for most display or print purposes, and sRGB for web or e-mail.

- **Black Point Compensation.** Selecting this check box causes Aperture to scale the black and white values in your image to fit within the export color space. This prevents shadow areas from becoming solid black and highlight areas from becoming solid white, but it might also cause subtle tonal changes throughout your image.

Note You can also control whether Aperture exports Faces and Places metadata with your images, even if you have Include Metadata selected for the selected Export Preset. Unfortunately, these settings are global and apply to all exported files. These options are available by choosing Aperture ⇨ Preferences ⇨ Export.

Note It's always smart to set your on-screen proofing profile to match the color profile your Export Preset uses to double-check your image's color when exporting, making any needed adjustments. We describe how to soft proof your images in Chapter 7.

Adding watermarks

Aperture makes it easy to automatically add a watermark to your exported images. The first step is to prepare an image of your watermark. (You'll need to do this using another program such as Photoshop or Elements.) We recommend creating a PSD, TIFF, or PNG file with a transparent background. We also recommend creating several different-sized watermarks, one for each preset to which you want to add a watermark. That way you're not trying to use the same watermark for a 2048-×-2048-pixel image that you're using for a 640 × 640 image. Note that Aperture scales watermarks down if you choose, but it won't scale them up.

After you create an image file with your mark, follow these steps to add a watermark to an Export Preset:

1. **Choose the Export Preset you want to use.**

2. **Select the Show Watermark check box.**

3. **Use the Position pop-up menu to choose where you want the mark to appear.**

4. **Use the Opacity slider to adjust the mark's opaqueness.**

5. **Click Choose Image and select your watermark image, or drag and drop your watermark image onto the image view.**

6. **Select the Scale watermark check box if you want Aperture to scale the mark proportionately to how it's scaling down your image.**

7. **Click OK to finish editing your preset.**

E-mailing Images

E-mailing an image is one of the most common reasons to export an image, and Aperture has simplified this to a one-button click. Simply select your images, click the Share button in the toolbar, and select Email, as shown in Figure 8.5, or select your images and choose File ➪ Share ➪ Email.

Chances are, though, that you want to select how Aperture exports your images to an e-mail and what mail program it creates a new e-mail within. To access those options, open the Export preferences by choosing Aperture ➪ Preferences and clicking the Export button. Figure 8.6 highlights the options related to e-mailing an image.

The Email using pop-up menu lets you pick what mail program Aperture uses to create a new e-mail for you, be it AOL, Eudora, Mail, Microsoft Entourage, or Microsoft Outlook. The Email Photo Export preset pop-up menu lets you choose what Image Export Preset Aperture uses for your e-mail. Choose the Edit item to open the Image Export dialog to create or modify a preset as discussed previously in this chapter.

8.5 Select your images, click the Share button, and choose Email to quickly export them and attach them to a new e-mail message.

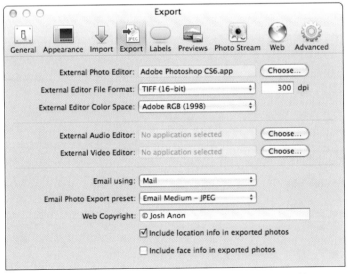

8.6 The Export tab in Aperture preferences has options to control how Aperture e-mails images.

Setting Your Desktop Image

Previously, if you wanted to use a photo in Aperture as your desktop background, you had to maintain a preview for it and then use System Preferences to pick the image. Starting with Aperture 3.3, you can set an image to be your desktop background by selecting it and choosing File ➪ Share ➪ Set Desktop, no preview required.

If you want to have your desktop background randomly select from an album, however, you still need to create previews of the desired images, share the previews with iLife and iWork, and use System Preferences to point the desktop background settings to the desired album.

Creating Slide Shows

While slide shows might initially make you think of the carousels of slides that your Great Aunt Matilda used to show for hours on end (here's Matilda waving to the north, here's Matilda waving to the south, and for variety, here's Matilda waving to the east), digital slide shows are far more engaging than traditional slide shows. Aperture lets you create advanced slide shows with transition effects, custom timing, video, music, and more. Plus, it's easy to export your show to the web or to an iPad.

Creating a new slide show

There are two ways to make a slide show in Aperture. The first is more of an impromptu show, where you just pick images, pick a preset, and give the show. The second involves creating a slide show album, possibly adjusting specific settings on your show, and being able to quickly give this same show again in the future or export a movie of the show.

To create an impromptu slide show, select a group of images and choose File ➪ Play Slideshow. Aperture opens the Play Slideshow dialog, as shown in Figure 8.7.

Choose your preset, described in the following list, from the pop-up menu. If you like how the slide show looks in the preview, click Start to start playing your show.

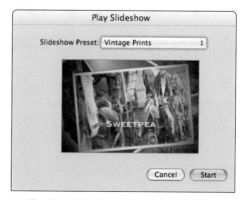

8.7 The Play Slideshow dialog lets you quickly create and play a slide show with little customization.

Creating a custom slide show preset

It's also possible to edit or create your own slide show preset by choosing Edit from the pop-up menu or by choosing Aperture ⇨ Presets ⇨ Slideshow. Figure 8.8 shows Aperture's Slideshow Presets dialog. As usual, there's a table listing your existing presets as well as Add, Remove, and Reset Preset buttons on the left. Select a preset to see its properties on the right.

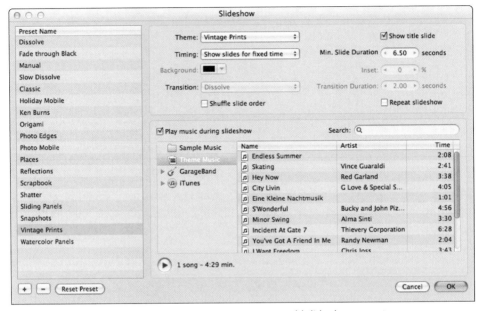

8.8 The Slideshow Presets dialog allows you to customize or add slide show presets.

Your preset options are as follows:

● **Theme.** This sets the general style for the preset, possibly determining what other options are user configurable. For example, choosing a Shatter theme disables the Transition and Transition Duration options.

● **Timing.** Choose from among manually advancing each slide, showing each slide for a fixed period, or adjusting the slide durations so that they all fit within the selected background music's duration.

● **Background.** Select the color that appears in any empty background area.

● **Transition.** Select the visual effect Aperture uses to move from slide to slide.

● **Shuffle slide order.** Will the slides display in a random or sequential order.

● **Show title slide.** Show a slide with text, defaulting to the show's name.

- **Slide Duration.** This determines how long the slide appears on-screen.

- **Inset.** Control the spacing between the edge of the screen and the images.

- **Transition Duration.** Decide how long the transition should last.

- **Repeat slideshow.** Decide whether the slide show start over once it's finished or exit back to Aperture's main interface.

- **Play music during slideshow.** Select this option and then use the audio browser to pick a DRM-free song from your iTunes library or Aperture's built-in music to add background music to your preset. Click the Play button to preview a song.

Caution

Any music you use in an Aperture slide show must be free of any type of digital rights management (DRM).

Using the Slideshow Editor

When you want more control over your slide show and to save it for later, instead of using the Play Slideshow command, you can create a new slide show album and use the Slideshow Editor to configure your show.

To create a new slide show, select some images and choose File ⇨ New ⇨ Slideshow. In the dialog that appears (see Figure 8.9), give your show a name and select what type of transitions you want. Clicking each transition name shows a preview on the right, and most of these are similar to the previously mentioned slide show presets. The Classic and Ken Burns themes provide the most customization options, but the other presets have potentially more appealing visual effects and styles.

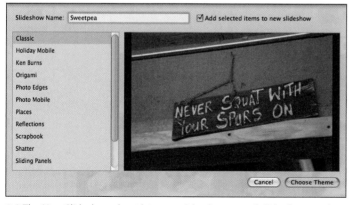

8.9 The New Slideshow sheet lets you pick what type of slide show you're creating.

After you select a theme, Aperture opens the Slideshow Editor, as shown in Figure 8.10. Note how when you move your mouse over the Browser you get a playhead, and Aperture adjusts the Viewer to show what the contents of the slide show are at that point in time. As you move your mouse left or right, you see any animating effects or transitions that happen while this photo is on-screen. This is called *skimming*. There are also a number of buttons in the Slideshow Editor to help you create and play back your show:

- **Theme.** Click this button to switch your slide show's theme.
- **Play Slideshow.** Click to play your slide show in full-screen mode.

Theme button Export button

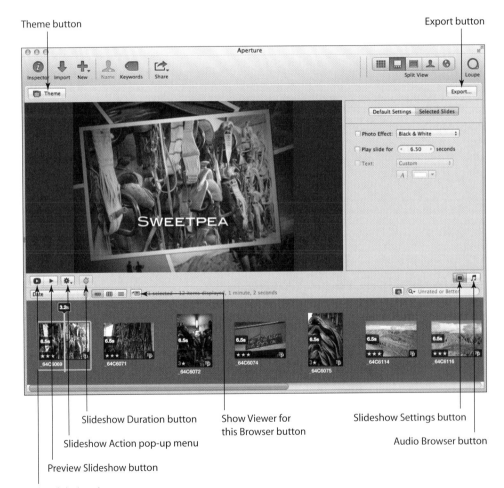

Slideshow Duration button Show Viewer for Slideshow Settings button
 this Browser button
Slideshow Action pop-up menu Audio Browser button
Preview Slideshow button
Play Slideshow button

8.10 The Slideshow Editor lets you create your slide show just the way you want it, and the highlighted buttons provide the tools to do this customization.

- **Preview Slideshow.** Click to play your slide show in your viewer.

- **Slideshow Action pop-up menu.** This menu has useful commands to help set up your show. For example, to turn off the time indicator above the playhead that appears while skimming, click the Action pop-up menu button and toggle View Playhead Info. We refer to this button more throughout this section.

- **Slide Duration.** With Classic or Ken Burns themes, this button lets you record custom per-slide timing.

- **Show Viewer for this Browser.** Temporarily switch out the Slideshow Editor Viewer with a normal Viewer so that you can zoom in and adjust the selected images. Double-clicking an image in the Slideshow Editor's Browser automatically triggers this button.

- **Slideshow Settings.** Click this button to access default settings for the entire show or individual settings for the selected slides.

- **Audio Browser.** Toggle the Aperture Audio Browser to pick background music for your slide show.

- **Export.** Export a movie of your slide show.

Arranging a slide show

The order that your images appear in the Slideshow Editor's Browser is the order in which they will play back. Use the normal Browser sorting techniques to either sort them into some default (such as by date) or drag and drop the images into a manual sort order.

Periodically, you'll want to insert a blank slide, perhaps to separate sections of your slide show. To do so, select the image that you want to insert a blank slide after. Then, from the Slideshow Action pop-up menu, choose Insert Blank Slide or Insert Blank Slide With Text. The only difference between the two is that the With Text version adds a text field with the words "Text Slide" to the blank slide. Select the slide and then click on that text to edit it. Choosing Edit ⇨ Show Fonts allows you to customize the text font and color.

Adjusting the show's settings

The default settings for your slide show affect all slides. To access them, click the Slideshow Settings button and choose Default Settings. You'll see options similar to Figure 8.11 (the defaults vary slightly depending on which theme you selected). Many of these are self-explanatory, such as the Play slide for field that controls the slide's duration. The Aspect Ratio allows you to control the slide show's overall aspect ratio. Devices can have a wide range of aspect ratios, such as 16:10 for an Apple 23-inch cinema display and 3:2 for an iPhone. If you're creating your show for a specific device, start by

setting the Aspect Ratio pop-up menu to match that device. Otherwise, when you need to export to a specific device, we recommend temporarily changing your show's aspect ratio to match that device and then adjusting the border, inset, and text options so that your shows look great when you export them.

If the Crop pop-up menu is set to Fit In Frame and if the show's aspect ratio is different than an individual slide, Aperture adds black bars around the slide to fill out the empty space (instead of cropping or scaling your image). If the Crop pop-up menu is set to Fill Frame, then your image will be scaled up and cropped to avoid black bars. Choosing Ken Burns Effect from the Crop pop-up menu causes Aperture to pan and zoom your image so that you eventually see the whole image, but there's never any black area showing in Viewer.

One slightly unintuitive control is the set of arrows next to the Transition pop-up menu. This control lets you set the direction from which a transition happens (for example, left to right or right to left) by clicking the appropriate arrow if the transition has a direction. Some transitions, such as dissolve, do not have an associated direction.

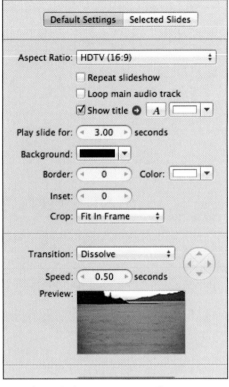

8.11 The Default Settings group allows you to adjust show-wide preferences.

Adjusting individual slide settings

To adjust an individual slide or group of slides, select the appropriate images, click the Slideshow Settings button, and click Selected Slides. This set of options, shown in Figure 8.12, is very similar to the default settings, but it lets you override each setting for a specific slide. There are three main differences: Photo effect, Crop settings, and Text.

● **Photo effect.** Selecting this check box automatically applies an effect that you pick from the pop-up menu (Black & White, Sepia, or Antique) to this slide.

● **Crop settings.** Clicking Edit next to the Crop pop-up menu causes Viewer to change to look like Figure 8.13. In this mode, if you choose Fill Frame, Aperture overlays a green crop rectangle, fixed to the show's aspect ratio, to let you control how your image is cropped. Click and drag this rectangle to move it around or drag the edges to adjust the crop region. Finally, if you choose Ken Burns Effect, you see two crop regions: a green one indicating the starting crop and a red one indicating the ending crop. Adjust these as previously described, and click the Swap button on the starting crop if you want to swap the starting and ending crops.

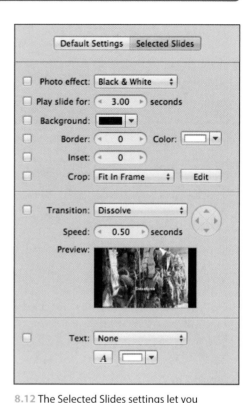

8.12 The Selected Slides settings let you customize settings for a particular slide or group of slides.

● **Text.** Select the Text check box to add text to a slide. Use the pop-up menu to pick between displaying a specific metadata field or custom text. Use the Font button and Color pop-up menu below the Text pop-up menu to set the font style and color. Click and drag the text box that appears on the slide to position the text, and use the handles around the text box to resize it.

Periodically, you'll find yourself wanting to give each slide a custom duration. Rather than clicking on each slide and setting its duration, it's much easier to use the Slide Duration button to record custom timing. Note that this option is only available with the Classic and Ken Burns themes. To use the Slide Duration button, follow these steps:

271

1. **Select the slide where you want to start recording custom timing.**

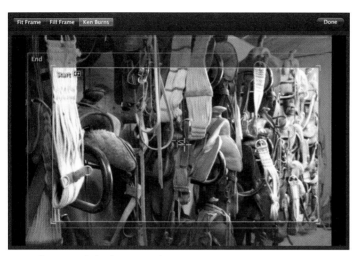

8.13 When you click Edit next to the Crop pop-up menu, Aperture displays the crop options on top of Viewer as well as crop rectangles when you select the Fill Frame or Ken Burns Effect crop.

2. **Click the Slide Duration button.** Aperture adds the overlay to Viewer, as shown in Figure 8.14.

3. **Press the spacebar to start playing the show.** The overlay in Figure 8.14 shows the elapsed time in its timer.

8.14 The Slide Duration overlay provides instructions for how to record custom slide durations as well as displaying the elapsed time for each slide.

4. **Press Return to set the slide's time and to move on to the next slide.**

5. **Press the spacebar when you finish setting slide durations.**

At any point, you can repeat these steps to record new custom timing, and you can use the Slideshow Settings/Selected Slides settings to change a slide's duration without rerecording the timing.

Adding video clips

Adding video to a slide show is quite straightforward because Aperture essentially treats your video clip just like it does your images. Simply drag your video clip onto the Slideshow Album in the Library Inspector to make sure it's in the slide show, use the Slideshow Editor's Browser to position the clip where you want it to be in the show, and you're done.

Just like with an image slide, there are a number of options available for a video slide including photo effects, cropping, transitions, text, and more. There is an extra option for video slides, however, related to the clip's audio track. The Slideshow Settings/Selected Slides settings have four new sliders. The first three, Volume, Fade In, and Fade Out, control the clip audio's volume and how long (if at all) Aperture takes to fade the clip's audio in or out. Set the Volume slider to 0% to not use any of the clip's audio.

There's also a slider and a Reduce volume of main track check box to control any background music in your slide show. Selecting this check box causes Aperture to reduce the background music's volume by the amount specified with the slider so that you can hear the clip's audio instead.

Adding music

To add music to your slide show, start by clicking the Audio Browser button. Aperture opens the audio browser, as shown in Figure 8.15. Use the list at the top to switch between Aperture-provided music, audio files from your camera and movie clips, and your iTunes library and playlists. Drag a song from the audio browser onto the empty area in Browser to add it to your slide show. Aperture displays a green bar behind your images representing the main audio file. If your slide show is longer than the main audio file, the green background ends before the last slide. Either drag an additional audio file onto your show or set the main audio file to loop by going into the show's default settings and selecting Loop main audio track. To delete an audio file, select the green area representing the audio file so that it has a white border around it and press Delete on your keyboard.

8.15 When you add a DRM-free sound file to your slide show from the audio browser, Aperture displays a green area in Browser representing the sound file.

To open the Audio Adjustments heads-up display (HUD), either double-click the main audio clip or select the clip and choose Adjust Audio from the Slideshow Action pop-up menu. The Audio

Adjustments HUD (see Figure 8.16) lets you modify the audio file's volume and fade in and out duration.

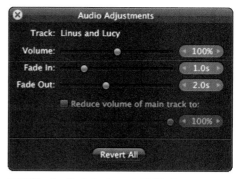

To have Aperture automatically time your slides so that your show lasts exactly as long as your audio, choose Fit Slides to Main Audio Track from the Slideshow Action pop-up menu. Aperture can also automatically analyze your audio file to determine where the beats happen so that your transitions are guaranteed to happen on beats in the music.

8.16 The Audio Adjustments HUD allows you to adjust your audio file's volume.

Simply choose Align Slides to Beats from the Slideshow Action pop-up menu, and Aperture adjusts your timing. To revert your timing, select the slide to revert and choose Reset Selected Slide from the Slideshow Action pop-up menu.

It's also possible to add a second audio track to your show. For example, you might have recorded some narration using Garage Band, and you'd like it to start with a particular slide. To add an audio file as a secondary audio track, select it in the audio browser and drag it onto an image in Browser.

It will appear as a thin, green bar, as shown in Figure 8.17. To adjust the in/out points on the second audio track, move your mouse over its endpoints and your cursor changes to double-arrows. Click and drag to adjust the in/out points. Click and drag the bar to adjust that point in your slide show that the track starts playing; select it and press Delete to remove the track.

8.17 A second audio track lets you add prerecorded narration to your slide show in addition to background music.

Just like with the main audio track, you can double-click to open the Audio Adjustments HUD. When adjusting a secondary audio track, you can set how much the main audio track's volume fades out while the secondary track is playing by selecting Reduce volume of the main track to and adjusting the slider.

Playing and exporting your shows

Once you have your show set up the way you want, click the Preview Slideshow button to watch it play back in Viewer. To play it back full screen, click the Play Slideshow button. If you have multiple monitors, you can choose on which monitor your slide show plays back by choosing Aperture ⇨

Preferences ⇨ Appearance and changing the View slideshows on pop-up menu. To pause your slide show, press the spacebar; to end it early, press Esc.

To export your slide show as a QuickTime movie, click Export. Aperture opens the Export dialog shown in Figure 8.18. Choose where you want to save your movie and what format you want to export it for. If you don't see the right preset, choose Custom and type your desired export settings. To have Aperture add your movie to iTunes so that you can sync it right away to your iPhone, select the Automatically send slideshow to iTunes check box.

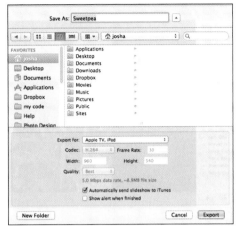

8.18 The Export Slideshow dialog allows you to save your slide show as a QuickTime movie.

Genius

Aperture uses JPEG previews of your photos in its slide shows. If the images in your slide show aren't as sharp or as high quality as you expect, you need to adjust your preview settings. Choose Aperture ⇨ Preferences ⇨ Previews, increase your Photo Preview size to the needed resolution, and increase the Photo Preview quality. Make sure to regenerate your old previews after changing this setting by selecting your old images, Control+clicking them, and choosing Update Previews. Keep in mind that higher-quality previews require more hard drive space.

Creating Web Pages

While slide shows are a great, multimedia-oriented way to present your work, many times it's more effective to create a web page of your images. In addition to letting you easily post images to Facebook and Flickr (which we cover later in this chapter), Aperture makes it easy to create custom web pages of your images that you can upload to your own website.

Comparing web journals, web pages, and Smart Web Pages

A web journal is a website where the main pages have groups of images intermixed with text that you type yourself, as shown in Figure 8.19. A web page (called a web gallery in previous versions of Aperture) displays a contact sheet of thumbnails for images you pick by hand on the main pages

(also shown in Figure 8.19), and a Smart Web Page is just like a web page except Aperture auto-matically populates the web page contents based on a Smart Album's setting. All three types of pages can display image metadata on the main page, and all three types have detail pages with larger versions of each image and optionally more or different metadata.

8.19 Web journals let you mix text and images whereas web pages are focused on just images.

Creating and configuring a new web page

To create a normal web page, select a group of images and choose File ➪ New ➪ web page. Aperture displays a dialog to pick a theme and to give your web page a name. Aperture then adds the web page album to your project, and at any point you can drag more images to this album.

After creating your web page, you see the Webpage Editor in Figure 8.20. You can change themes at any point by clicking the Theme button. There are three key parts to this editor: the Pages pane, the Detail Images pane, and the Preview pane. Use the Pages pane to select the main gallery page that you want to work on or use the Detail Images pane to select an individual image's page. Then use the various options to control how the page looks in the Preview pane. The Preview pane provides a live preview of how your finished site will look.

8.20 The Webpage Editor allows you to create custom web pages, and the Pages and Detail Images panes let you select which page to load into the Preview pane to edit.

Aperture automatically places the images in the web page album onto your site. The images' order in Browser mirrors their order on the site, and the Browser sort-order pop-up menu, which defaults to sorting by date, lets you quickly sort your images by a certain criteria, such as rating. Of course, you can simply drag and drop images into the order you want to create a custom order. At any point, you can choose a different sort order to re-sort your images.

To edit text, such as a copyright notice or site header, double-click the text field on the page, and if it's user-editable, Aperture lets you begin editing the text. Although you can open the System Fonts panel by choosing Edit ⇨ Show Fonts, you cannot change the typography for a web page.

There are also buttons above and below the Preview pane that control your web page's layout. The Theme button lets you switch your site's template. The Metadata Set button changes what metadata set is displayed with your image. Choose Enable Plate Metadata from this pop-up menu to display image numbers. Note that the main thumbnail pages can and typically should have a different metadata set than the individual detail pages.

Below the Preview pane are buttons to go to the previous/next page in the selected group (that is either within the main pages or within the detail pages). Use these instead of scrolling through the Pages and Detail Images panes. The Columns and Rows fields let you control the layout of your thumbnail grid, and the Fit images within pop-up menu and size fields let you control how much space each thumbnail receives. The options for the Fit images within pop-up menu are as follows:

- **Rectangle.** Use the size fields to define a rectangle, and Aperture makes the thumbnails fit within the specified size.

- **Square.** This is similar to Rectangle except the width and height fields are locked together to create a square.

- **Width.** Only the width size is changeable, and Aperture makes all thumbnails have the same width.

Go to a detail page by either selecting it in the Detail Images pane or by selecting the image's thumbnail in the Preview pane and clicking the arrow button that appears. The configuration options for the detail pages are very similar to the main pages. It's important to note that any options you set on a detail page for the metadata set or image size apply to all detail pages. Figure 8.21 shows a sample detail page.

Creating and configuring a Smart Web Page is very similar, except you can't manually pick what images are included in the website, as the smart settings criteria you set do this filtering for you. To create a Smart Web Page, choose File ⇨ New ⇨ Smart Web Page. Rather than displaying the theme dialog as with a regular web page, Aperture instead creates a web page with a default theme and displays the standard Smart Settings dialog, where you set your criteria for what images Aperture automatically adds and places onto the Smart Web Page. Configure a Smart Web Page just as you do a normal web page.

8.21 Detail pages show individual images.

Export your web page by clicking Export Web Pages in the top right of the Webpage Editor. This opens a standard Save dialog, except there are two extra pop-up menus below it. The pop-up menus allow you to choose what Web Export Presets to use for your thumbnails and for the detail images. To create your own Web Export Presets, choose Edit from either pop-up menu. The

options are nearly identical to the Image Export Presets covered earlier in the chapter. When you click Export, Aperture creates a folder in the specified location on your hard drive with your website, which you can then upload to your web server.

Creating and configuring a new web journal

Creating a web journal is very similar to creating a web page, with the only difference being that you choose File ⇨ New ⇨ Web Journal instead of Web Page. Even the Webpage Editor for a web journal (see Figure 8.22) looks very similar to the editor for a web page, although there are a few key new buttons.

8.22 The Webpage Editor for a web journal is quite similar to a web page's editor, although there are a few extra buttons.

- **Add Text Block.** Click this button to add a custom text field to your web journal so that you can type text about the surrounding images.

- **Add Page.** Unlike a web page, where the number of main pages depends on how many images are in the album and the number of rows and columns per page, the layout of each main web journal page is up to you. Click this button to add a new main page.

- **Remove Page.** This button deletes the selected main page and unplaces any images on the page.

- **Page Template.** This button reveals a pop-up menu that lets you adjust the main page template, if your selected theme allows, choosing between a header with text only or a header with text and an image.

- **Webpage Editor Action pop-up menu.** This button's pop-up menu has commands to reorder the main pages and to automatically create new main pages from the selected images based on criteria such as one page per day.

- **Show All Images/Show Unplaced Images.** Because you manually place the images in Browser onto your web journal, this button lets you quickly toggle between seeing all images in the album and seeing unplaced images only.

Placing images onto a web journal is fairly straightforward. Drag them from Browser onto the empty area or next to an existing thumbnail in the Preview pane. Aperture places the image and shows you a badge on the thumbnail indicating how many times (if any) you've placed the image into a web journal. Some themes have an empty, gray rectangle in the header to represent an image placeholder. Drag and drop an image onto this placeholder, and click this placed image in the Preview pane to adjust its scale and crop window.

Add a text block after a group of images by clicking the Add Text Block button. Add new pages as needed or select a group of images and choose a command, such as New Page for Each Day, from the Webpage Editor Action pop-up menu to have Aperture create main pages for you.

When you move your mouse over the Preview pane, group boxes appear, as shown in Figure 8.23. These boxes indicate an image or text block in your web journal. Click and drag the block's header to move the block around the page. Click the Remove button that appears on the block to delete it. Text blocks have an extra button to switch between header and paragraph text.

When you're ready to publish your web journal, follow the same steps described in the section on creating and configuring a new web page.

8.23 As you move your mouse over your web journal, group boxes for each image or text group appear with extra controls.

Facebook

Facebook has exploded from a private social-networking site with its membership limited to select colleges into one of the most trafficked sites on the web. Everyone and his or her Uncle Bob seem to have a profile. Aperture provides direct Facebook integration, which lets you directly publish your images to Facebook either to an album or directly to your wall.

Setting up Facebook access within Aperture

The first time you go to export your images to Facebook, you need to set up access to your Facebook account from within Aperture. Start by selecting a group of images to share.

1. **Choose File ➪ Share ➪ Facebook.**
 Alternatively, click the Share button in the toolbar and select Facebook.

2. **Type your login e-mail and password in the Facebook Login sheet that appears, as shown in Figure 8.24.**
 Make sure to select the I agree to Facebook's terms check box.

3. **Click Login.** Aperture displays a new sheet that lets you actually publish your images to Facebook.

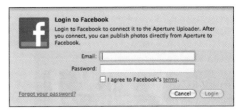

8.24 The Facebook Login sheet is where you log in and set up Aperture's access to your Facebook account.

Publishing images from Aperture to Facebook

The first steps to publishing your images are the same as setting up Facebook access within Aperture — select your images (or an item in the Library Inspector) and choose File ⇨ Share ⇨ Facebook, click the Share button in the toolbar and select Facebook.

In the Facebook sheet that appears, as shown in Figure 8.25, first select if you want to post the image(s) to a New Album, an Existing Album (if you just logged into Facebook to the first time from Aperture, you might need to close and reopen this exporter to see your existing albums), or to your Wall. If you select your Wall, the sheet changes, giving you a field in which to type a comment for the images. If you select New Album, type a name for your album and select whom it should be visible to. We recommend choosing Friends of

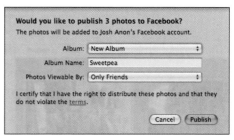

8.25 In the Facebook sheet, you can pick if you want to post your images to your Wall or to a New Album, type a name for your album, and determine your privacy settings.

Friends or Only Friends rather than Everyone to help protect your privacy. Click Publish to send your images to Facebook. Aperture displays a progress wheel next to your album's name under the Facebook group in the Library Inspector.

Once you've shared an image to Facebook (or Flickr), if you open the Info Inspector and switch to the Sharing preset view, Aperture indicates that you've shared the photo online.

After you add your Facebook account to Aperture, a new group appears in the Library Inspector called Web that has your Facebook account listed, as shown in Figure 8.26. Click it to see all of your Facebook albums, and double-click on an album to open it.

When you select your Facebook album in the Library Inspector, its contents look a lot like a normal album except there's a Facebook pop-up menu in the tool strip. This pop-up has commands to adjust your album's settings or to open the album in your web browser. This Settings dialog has options to change the album's name and its privacy settings.

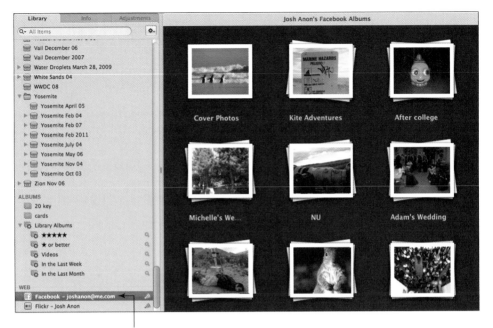

Facebook album in Library Inspector

8.26 Select your Facebook album in the Library Inspector to see its contents.

Managing your Facebook account

From the Library Inspector, Control+click on your Facebook account to find commands to delete or disable your Facebook account. These commands don't affect your actual account, they just affect whether Aperture is connected to your Facebook account. Disabling your account puts it into a state of suspended animation, where it still appears in the Library Inspector, but Aperture won't update the albums to reflect any chances you make to your account elsewhere. Selecting Synchronize Albums forces Aperture to update itself to show the current state of your Facebook albums.

If you choose Aperture ⇨ Preferences ⇨ Web, you see the dialog in Figure 8.27. From here, you can manage both your Facebook and Flickr accounts, either adding new ones or deleting existing ones. It's also possible to set if Aperture automatically updates itself to reflect changes you make to your Facebook (or Flickr) account elsewhere. If you deselect this option, you need to manually synchronize your albums, as we previously described.

When you remove an account, Aperture prompts you if you want to copy the contents of the account to your local library. If you choose to do so, it downloads a copy of every image on your Facebook account before removing it from Aperture. While this can be a convenient way to make sure you don't lose data, if you have a large number of images shared on Facebook, you might end up with unintentional duplicates.

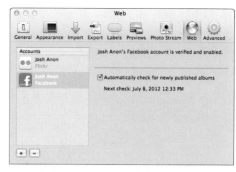

8.27 The Web preferences dialog lets you manage your Facebook and Flickr accounts.

Flickr

Flickr is another very popular way to share photos, and unlike Facebook where photos are a feature and not the primary purpose, Flickr is all about sharing photos. Some art directors even use Flickr to find images that they want to use in their campaigns. From within Aperture, sharing images via Flickr is very similar to sharing via Facebook. In fact, it's possible to set up Flickr's photo stream to display in your Facebook photo stream (you'll need to do this via Facebook's website, not within Aperture) so that any image you upload to Flickr from Aperture also appears on Facebook.

Setting up Flickr access within Aperture

As you might expect, you need to log in to your Flickr account from Aperture to upload images. To do so, follow these steps:

1. **Select the images in Browser or item in the Library Inspector that you want to upload to Flickr.**

2. **Choose File ⇨ Share ⇨ Flickr.**

3. **Click the Set Up button when Aperture asks you if you want to set up Aperture to publish to Flickr.** Aperture opens your web browser and directs it to the Flickr login page.

285

4. **Log in to Flickr.** We recommend selecting the Keep me signed in check box, which keeps you signed in for two weeks.

5. **Click OK, I'll Authorize It when Flickr asks about linking Aperture Uploader to your Flickr account.**

6. **In Aperture, if the New Flickr Set sheet doesn't automatically appear, click the Set Up button again.**

7. **Follow the steps in the next section to publish and modify images on Flickr.**

Caution If you have problems getting Aperture to recognize that you're logged in to Safari, make sure that Private Browsing is not selected in Safari (Safari ⇨ Private Browsing). Private Browsing prevents sites like Flickr from storing cookies, which can make Aperture think you're not logged in to Flickr.

Publishing images to Flickr

Start by selecting images in Browser or the item in the Library Inspector that you want to share, and choose File ⇨ Share ⇨ Flickr. Aperture opens the Flickr sheet, as shown in Figure 8.28. Choose if you're adding these images to an Existing Photo Set, a New Set, or your Photostream (note that the Flickr photostream is different than the iCloud Photo Stream we've

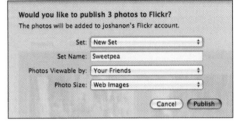

8.28 The New Flickr Set sheet allows you to create a set of photos on Flickr from within Aperture.

covered elsewhere). If it's a new set, type a name for it, adjust your privacy settings using the Photos Viewable by pop-up menu, and use the Photo Size pop-up menu to pick how Aperture should optimize your images. If you don't have a Flickr Pro account, some of the photo size options are disabled. Click Publish to upload your images.

As with Facebook, Aperture creates a collection in the Library Inspector within the web group for your Flickr account. Click on it to see your Flickr photo sets. Drag and drop images onto this collection to add images to a new or existing set.

Within each set, use the Flickr pop-up menu to force Aperture to synchronize the set, or click Visit Set to open Browser to this set.

To delete this set, select it in the Flickr collection view and choose File ⇨ Delete Set.

Just as described for your Facebook account, commands to delete or disable your Flickr account are found by Control+clicking on the Flickr collection within the Library Inspector. You also manage your Flickr account by choosing Aperture ⇨ Preferences ⇨ Web and selecting your Flickr account.

Genius Rather than uploading full-sized images to Flickr directly, if you want to post larger versions, first export optimized versions of your images to your computer and then use Flickr's website to upload these optimized versions.

Using Other Export Plug-ins

As you work with a digital workflow, you'll notice (if you haven't already) that there always seem to be two steps involved with getting an image to someone or some service. First, you prepare a specifically sized and optimized version, and then you send it to that person or service.

Aperture's Image Export Presets make it incredibly easy to prepare images at whatever size, resolution, and format you need, but you still have to upload those exported images somewhere. Fortunately, third-party export plug-ins help Aperture make your workflow even simpler by reducing exporting and uploading (and other tasks) to one step.

For example, if you want more control over how Aperture posts your images to Flickr, including the image title, you can either export optimized versions by hand and then use Flickr's website to upload them or you can purchase Connected Flow's FlickrExport plug-in and use it to upload, optimize, and control your images from within Aperture.

As another example, PhotoShelter, which provides a great online content management system for photographers, has a plug-in for uploading from Aperture to PhotoShelter (see Figure 8.29), so that you can upload either your original images or versions of your files. Josh, for instance, creates a folder on PhotoShelter for each project and uploads high-resolution JPEG versions of each image that PhotoShelter uses for both displaying on the web and enabling a client to purchase an image or print from his site.

8.29 PhotoShelter's Aperture plug-in makes it easy to export images to PhotoShelter at whatever size and format you want.

Because each plug-in is different and there are so many, we can't go into full detail about how to use all of them. Here are a few general tips, however:

- **Plug-in location.** If you have multiple accounts on your computer and want each person to have access to this export plug-in, copy the plug-in to the folder at /Library/ Application Support/Aperture/Plug-Ins/Export. If you're the only person who will use the plug-in, you could also put it at /Users/*YourUsername*/Library/Application Support/ Aperture/Plug-Ins/Export.

- **Opening the plug-in.** Select the images to export and choose File ⇨ Export. A list of all your installed export plug-ins appears. If you don't see your plug-in, make sure it's installed in one of the previously mentioned locations.

- **Using the plug-in.** While each plug-in varies a bit, you will often see radio buttons you can click to switch between exporting a version or original file and then pop-up menus to select the appropriate presets for your export, just like you do when exporting either a version or original file.

To see a full list of the various export plug-ins available for Aperture, go to www.apple.com/aperture/resources and click the Export Plug-ins link.

How Can I Use Aperture with My HDSLR's Video Files?

One of the biggest recent features in dSLRs is the ability to shoot high-definition video. Yet most of the tools designed to work with these video files are geared toward cutting them together into a sequence and not actually managing and organizing the files. Fortunately, Aperture 3 makes it so that you can manage your video files just as easily as you do your images, and it even lets you pull still images out of your video files.

How Does Aperture Handle Video Files?292

Importing Video Files...292

Viewing Video Files..293

Editing a Clip..294

Exporting a Video Clip ...296

Working with Audio Files ...296

How Does Aperture Handle Video Files?

Put simply, video files in Aperture appear just like any other file, except when you have your metadata display set to display badges you see a small movie icon on each video file like in Figure 9.1. It's easy to organize your video files into projects and albums, set ratings, labels, and other metadata on them, and even include them in slide shows. While you can't make adjustments to a video file, aside from basic trims, just being able to manage your video files alongside your images is a huge step forward for anyone shooting video with a dSLR.

9.1 Videos appear just like any other file in Aperture, although they show a movie badge to distinguish them from your still images.

Importing Video Files

As you might expect, video files appear in Aperture's Import panel just like any other file. If for some reason you don't see your movie clips, look in the File Types brick (choose File Types from the Import Settings pop-up menu) and make sure that Exclude videos is not selected. In Grid view, your movie files will again have a small badge indicating that they're movie files (see Figure 9.2), and in List view, their type will be QuickTime movie.

9.2 Movie files in the Import panel appear just like your images.

If you switch to Viewer mode in the Import panel, Aperture displays transport controls over your movie when you move your mouse over it that allow you to play your movie and to step through or scrub through it. Follow the instructions in the next section to learn how to use these controls.

To finish importing your movie files, make sure they're selected and click Import Checked.

Viewing Video Files

Select a video file in Browser just like you would an image, and open Viewer. You will see a still frame (by default the first frame in your video file). When you move your mouse over Viewer, a set of transport controls appears in the HUD, as indicated in Figure 9.3.

9.3 The playback controls for a video file appear in an HUD over Viewer.

There are four key playback controls in this HUD that you can use to view your video files.

- **Play/Pause.** Click this button to play or pause your movie. The spacebar is the keyboard shortcut for this button.

- **Next Frame/Previous Frame.** These buttons let you step to a particular frame in your movie. This is useful if you intend to extract a JPEG still from your movie.

- **Time slider.** This slider indicates where the playhead is in your movie, and you can also click and drag this slider to scrub through your movie.

- **Volume slider.** Use this slider to adjust the playback volume.

Note

When you have a video file selected, the Info Inspector replaces the Camera LCD display with information about your clip's length, size, and frame rate.

Editing a Clip

While Aperture lets you manage your clips quite effectively, its video-editing capabilities are quite limited. They're even more limited than in QuickTime Player X, as you can't perform any adjustments on the image itself, not even a brightness change. However, it is possible to perform two types of adjustments: changing the clip's poster frame and adjusting the clip's in and out points, which define the first and last frames of the movie's playback range and are by default the first frame and last frame in the movie.

Genius

Aperture has settings for separate video and audio external editors so that you can do more sophisticated editing in an external program. Set those editors by choosing Aperture ➪ Preferences ➪ Export, and edit your file by choosing Photos ➪ Edit with External Editor.

Setting the clip's poster frame

A poster frame is simply the frame that Aperture uses as your movie's thumbnail. If you think about a shot, you typically try to record extra frames before and after the main action (the extra frames are referred to as *head* and *tail*) to make it easier to edit the clip into a sequence. However,

to make it easier to tell at a quick glance which clip you're looking at, you will probably want to set the clip's thumbnail to be more representative of the clip's action than the first frame.

Follow these simple steps to set the poster frame:

1. **Select the clip in Browser.**

2. **Use the transport controls in Viewer, and play or scrub to the frame you want to use as the clip's poster frame.**

3. **From the Transport Controls HUD Action pop-up menu, choose Set as poster frame.** Notice that your clip's thumbnail in the Browser updates to display the new frame.

Trimming the clip

Chances are the clip you recorded is longer than you want to actually show people. For example, when you pressed the Stop Recording button on your camera, you probably shook the camera slightly, and it would be nice to edit that bump out of your clip. Aperture 3's main video-editing capability is trimming a clip, where you adjust the in and out points to remove any unwanted head and tail on your video clip. To trim a clip, follow these steps:

1. **Select the clip in Browser.**

2. **From the Transport Controls HUD Action pop-up menu in Viewer, choose Trim.** Aperture changes the HUD to the Trim HUD, as shown in Figure 9.4.

9.4 The Trim HUD allows you to adjust your clip's in and out points.

3. **Click the yellow handles representing the in and out points in your video and drag them to the desired in and out points.** Note that there is no Snap to Playhead feature or way to zoom in for a frame-accurate trim. It can take a couple tries to set the right in and out frames on long clips.

4. **Click Trim to finish trimming your clip.**

To reset your clip's in and out points, choose Reset Trim from the Transport Controls HUD Action pop-up menu.

Exporting a Video Clip

It's possible to export either your original clip or the trimmed version of your clip. Select it and choose either File ⇨ Export ⇨ Original or Version, respectively. Unfortunately these commands don't provide any transcoding options.

If you want to reencode your video or to cut together a sequence of video clips that you export as one movie, you have to repurpose another Aperture feature. Specifically, create a new slide show with your clip (or clips) and use the Classic theme. Assemble it as we describe in Chapter 8, and pay close attention to the aspect ratio setting (make sure it matches your movie files, most likely 16:9). You will probably also want to turn off the show title. Then follow the steps in Chapter 8 to export your clip or sequence in one of the preset formats or to enter your own export settings.

To create a still JPEG image from your movie, scrub to the appropriate frame and choose New JPEG from frame from the Transport Controls HUD Action pop-up menu. Aperture creates a JPEG of the frame at the same resolution of your video, stacked with your video.

Working with Audio Files

In addition to managing video files, Aperture also handles audio files, such as voice memos that some cameras can record and attach to an image.

Importing audio files

By default, Aperture shows any audio files or audio attachments in the Import window. Audio files will have a gray background with a speaker icon, and images with an audio attachment have a speaker badge, as shown in Figure 9.5. If you do not see your audio files or this badge, make sure that Exclude audio files and Exclude audio attachments are not selected in the File Types brick.

9.5 The speaker badge indicates that the image has an audio attachment.

Playing audio

If your audio file is attached to an image, the playback controls are in the Info Inspector (see Figure 9.6). Click the Play button to hear your

audio file, and click and drag the Time slider to scrub through your audio file. When you mouse over the Time slider, Aperture displays handles around the in and out points for your audio attachment. Click and drag these handles to adjust the audio file's in and out points.

If you're working with an audio file that isn't attached to an image, its playback controls will appear in an HUD over the image in Viewer. To change your audio file's in and out

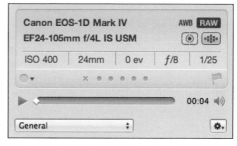

9.6 An audio attachment's playback controls are in the Info Inspector.

points, click Trim, and Aperture displays in and out handles around your audio file that you can click and drag to trim your file. Click Trim again to confirm your changes.

Attaching and detaching audio files

If you use your camera's built-in microphone to record a voice memo, it will most likely be automatically attached to an image, meaning that it moves with the image behind the scenes and is available to play back from the Info inspector. But if you use it to record an audio file or use a separate audio recording device, you will just have an audio file, such as an MP3 or AAC file not automatically associated with any image. It's possible to associate this audio file with a specific image, manually attaching it, or to detach an audio file from an image so that you can leave them as separate files or attach them to a different image.

Attaching audio files

There are two ways to attach an audio file to an image. The first way involves attaching an audio file that you've already imported into Aperture with an image in the same project. Do the following:

1. **Select the image to which you want to attach the audio file.**

2. **Click the Metadata menu and choose Attach Audio File.** Aperture opens the Attach Audio File sheet, as shown in Figure 9.7.

3. **Select the audio file to attach.**

4. **Click Attach.** Your audio file disappears from Browser because it's now attached to the selected image from Step 1.

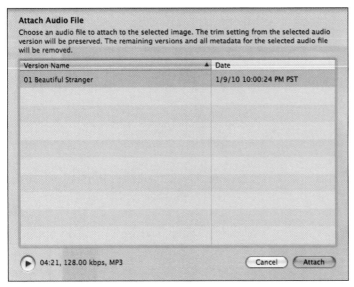

Attach Audio File

Choose an audio file to attach to the selected image. The trim setting from the selected audio version will be preserved. The remaining versions and all metadata for the selected audio file will be removed.

Version Name ▲	Date
01 Beautiful Stranger	1/9/10 10:00:24 PM PST

04:21, 128.00 kbps, MP3 Cancel Attach

9.7 The Attach Audio File sheet lets you pick an audio file to link to the selected image.

Caution

If you're attaching an existing audio file to an image, the two items must be in the same project or the audio file won't appear in the Attach Audio File sheet.

The second way to attach an audio file involves bringing a new audio file from the Finder into Aperture and attaching it to an image. To do so, simply select an image and display it in Viewer. Then drag and drop your audio file from the Finder onto Viewer. Aperture displays a green outline around your image, and when you drop the audio file it attaches it to the selected image.

Detaching audio files

To split an audio attachment out into its own file, select an image with an audio attachment and choose Detach Audio File from the Metadata menu. Aperture creates a new audio file item in your project.

How Can Aperture Make My Workflow Smoother?

Throughout each chapter, we cover the major features that make Aperture the cornerstone of our digital workflows. Yet what really sets Aperture apart is its attention to the small details that help make your workflow more efficient, whether that's working with multiple computers and multiple libraries or running a tethered shooting session. This chapter covers many of the smaller but important workflow-improving features in Aperture 3.

Understanding Badge Meanings 302

Managing Photo Previews .. 304

Working with Multiple Libraries 306

Controlling Tethered Shooting 311

Customizing Keyboard Shortcuts 313

Using Aperture with Automator 315

Using Vaults and Backup .. 319

Using Aperture's Database Repair Tools 326

Understanding Badge Meanings

Throughout this book, we've mentioned some of the various badge overlays that Aperture displays to indicate an image's status, ranging from whether the image has an adjustment to whether it has an audio attachment. Chapter 3 explains how to configure your metadata overlays to see badges if you currently don't see them in Browser or Viewer. However, there are some uncommon badges in Aperture that we haven't covered yet. Table 10.1 provides a quick reference list to those badges so that you don't have to dig through each chapter to figure out what each badge means, and Figure 10.1 helps you identify them.

Table 10.1 Aperture Image Badge Descriptions

Badge	Badge Name	Description
	Referenced	This image has a referenced original.
	Offline original	This image's original is on a drive that's not currently connected, and the original is offline.
	Original not found	This image's original can't be found.
	RAW/JPEG	This image has both a RAW and JPEG original (simultaneously shot), and Aperture displays the first badge when the RAW file is the original and the second when the JPEG is the original.
	Video	This image is a movie file.
	Stack	This is a stack of images, and the badge displays how many images are in the stack.
	Set metadata	This image has user-set metadata.
	Adjusted	This image has one or more adjustments applied.
	Externally edited	This image has been externally edited and has its own original file.
	Audio attachment	This image has an audio attachment.
	Placed	How many times this image has been placed into a book, web gallery/journal, or light table.
	Album pick	Out of the stack of images, this image is the album pick and the top of the stack. Note that an album pick is not necessarily the stack pick displayed at the project's root, and different albums can have different album picks.
	Low quality	This image is a low enough resolution that it might not look good when printed in a book or used in a web gallery.
	MobileMe	This image was downloaded from a MobileMe gallery. Note that as MobileMe has been discontinued, you won't see this badge if you are just starting to use Aperture.

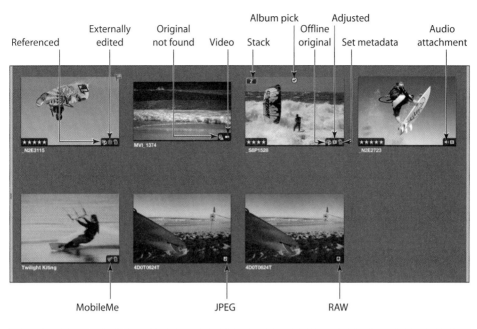

10.1 There are a variety of different badge images that you might see in Aperture.

Managing Photo Previews

One of Aperture's great features is the ability to make multiple adjustments and versions of your images without actually modifying your files on the hard drive. Unfortunately, sometimes you want to quickly access your modified images, such as to sync to your iPhone or to include in an iDVD project, without having to export versions of your images. Aperture can automatically create JPEG previews of your images, with all your adjustments, that you can use whenever you see the media browser, such as in iWork, or even drag right from Aperture and drop onto another application.

However, it's important to pay close attention to how you set your preview preferences so that you don't slow down Aperture or waste tons of hard drive space on unneeded previews. If you're automatically generating previews, Aperture updates your preview every time you make a change to an image, which can slow Aperture down.

We keep our Aperture libraries on external drives but sync our photos to our iPhones. To avoid photos suddenly disappearing if we sync when our drives aren't plugged in, we created an empty iPhoto library that we don't share with Aperture and use iPhoto's Aperture importer to create albums in iPhoto that we then sync to our iPhones. Note that Aperture importer uses Aperture previews and is different from a unified library because you're actually importing image previews from an Aperture library into a different library via iPhoto. Because this small, second library contains all the images we sync to our iPhones and lives on our main hard drives, our images are always available when we sync our devices.

Controlling preview preferences

We recommend setting your preview preferences as soon as possible so that Aperture creates previews the way you want right away. Start by opening the Previews preferences pane (Aperture ⇨ Preferences and click the Previews tab), as shown in Figure 10.2. There are a number of options to set here.

- **New projects automatically generate previews.** If this check box is selected, Aperture starts creating preview JPEGs for your images as soon as you start importing images into a project. We recommend deselecting this so that Aperture doesn't waste time creating previews for images that you throw away. After all, how often do you keep and use every image you import? However, you'll need to remember to have Aperture create previews for some of your images as part of your workflow.

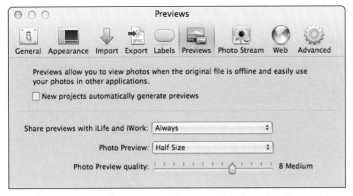

10.2 The Previews preferences pane lets you adjust how Aperture creates its photo previews.

- **Share previews with iLife and iWork.** Use this pop-up menu to choose when Aperture updates its data file that contains information about your previews. Because we leave Aperture running most of the time, we leave this set to Always. Leaving it set to Always (rather than When quitting Aperture or Never) also makes it so we never wonder why other iApps aren't seeing our latest previews.

- **Photo Preview.** This pop-up menu controls the dimensions for your previews. We leave these set to monitor resolution so that full-screen slide shows look good using previews rather than the original files. Preview JPEGs are easier for computers to open and process instead of the full RAW files.

- **Photo Preview quality.** Use this slider to adjust the JPEG compression setting in your previews. A higher quality means less compression. We find a value around 8 to be a good balance between quality and hard drive size.

Genius To turn off automatic preview generation for an existing project, select the project in the Library Inspector and deselect Maintain Previews for Project from the Library Inspector Action pop-up menu.

Generating previews

You're probably asking yourself how and when we create previews for our images, because we turn off automatic preview generation. Our workflow is to only create previews for images once we've done an initial ratings and adjustment pass. Typically we filter a project to show the images we rated as three stars and higher and then create previews for those files.

305

To create previews, select the images in Browser, Control+click them, and choose Update Preview. Aperture shows its progress in the Activity window.

If an image already has a preview, Update Preview won't regenerate the preview. If Aperture thinks your preview is up to date but you're not seeing your latest adjustments, select the image, Option+Control+click it, and select Generate Preview.

To delete an image's preview, select the image, Control+click it, and choose Delete Preview.

Previews and stacks

When you use the media browser in the iApps to browse your Aperture library, you might have noticed that you don't see the full contents of your stacks. Aperture only displays the stack pick. Aperture does respect the album pick (if it's different than the main stack pick) and displays the album pick in that album in the media browser. If you want to see the full contents of the stack, then make a new Smart Album with the image and select the Ignore stack groupings option.

Genius

Once you create a preview for an image, you can drag it from Aperture and drop it onto another program. If you drag an image that isn't a stack pick, Aperture correctly drags that image's preview rather than the stack pick.

Working with Multiple Libraries

At some point, you will end up with a second library. You might create one to separate your work and personal images, or perhaps you'll create one library for each year's worth of wedding shoots that you archive and remove from your main drive at the end of the year. Or perhaps you have more than one computer, such as a laptop and a desktop, and you have a library on each computer. Whatever the reason, it's good to know how to use multiple libraries with Aperture.

In previous versions of Aperture, it was a little clunky to work with multiple libraries and to move images among them. Fortunately, Aperture 3 has simplified this whole process.

Switching libraries

The most basic task when using multiple libraries is to switch to a different or even completely new library. Start by choosing File ⇨ Switch to Library. At the top of this menu is a list of the various libraries that Aperture recognizes on your computer, including any libraries you created with

iPhoto. If you see the library you want to use, select it. To reset this menu, choose Clear Menu. To pick a different library or to create a new library, select Other/New, and Aperture opens the dialog shown in Figure 10.3.

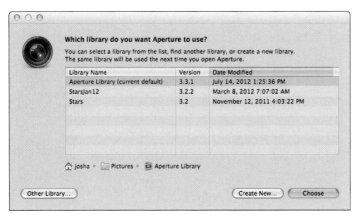

10.3 The Switch to Library dialog lets you pick an existing or new library to load into Aperture.

- **If you see the desired library in the list, select it and click Choose.** Note that when you select the library, Aperture displays information about the library's location, version, and contents.

- **If you don't see your desired library, click Other Library and browse for your library.** Select it and click the Select button to switch to that library.

- **To create a new, empty library, click Create New, select where you want the library to live, give your library a name, and click Create.** Aperture automatically opens this new library.

Genius

To set which library Aperture uses while opening Aperture, hold down the Option key and then open Aperture. Aperture shows you a dialog nearly identical to Figure 10.3. Select the library you want to use and click Choose to continue opening Aperture.

Moving images between libraries

At some point, you will need to move images from one library to another. The simplest way to do so is to export your originals from the first library and to import them into the second. While this

works well if you haven't made any adjustments or set any custom metadata (if you export an XMP file with your original, Aperture exports some of your metadata with the image), it's not adequate for the needs of most users.

Exporting a library

Fortunately, Aperture provides a better way to export images from one library to another. Specifically, it lets you export an album, project, or folder as a library, which contains all your adjustments and metadata that you can then import into the second library. Follow these steps to export your new library:

1. **Select the album, project, or folder in the Library Inspector.**

2. **Choose File ⇨ Export ⇨ Album/Project/Folder as New Library.** Aperture opens the dialog in Figure 10.4.

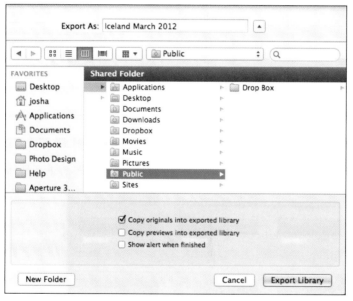

10.4 The Export Library dialog contains controls for exporting your project or album as a library.

3. **Select where you want this new library to live.** If you have referenced originals that you want to keep referenced, make sure the Consolidate originals into exported library option isn't selected. However, if you want to make sure your new library has its own copy of all your original images, select this option. We recommend always selecting this

option if you're transferring your library to another computer. If you don't want Aperture to have to rebuild previews for your images in the new library, select Include Previews in exported library. Note that this makes your exported library larger, sometimes significantly so.

4. **Click Export Library to start exporting.** Use the Activity (Window ⇨ Show Activity) to track your export status.

Genius

A faster way to export albums, projects, and folders is to select them in the Library Inspector and then drag and drop them into the Finder. While Aperture exports them, the new library will have _exporting appended to its name. Aperture removes that extension once it's finished exporting.

Importing a library

After you export your library, the next step is importing it into another Aperture library. To import a library, choose File ⇨ Import ⇨ Library and browse to select the library you exported. (Even though

this command doesn't say "Project," it imports exported projects from previous versions of Aperture.) The dialog in Figure 10.5 appears. If you want to add the contents of this library without modifying your current library, click Add. If you want to merge the two together (this is useful if you're working with one project on multiple computers), click Merge.

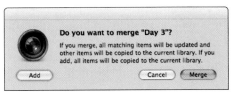

10.5 Aperture prompts to see if you want to add copies of or merge the images in the library you're importing.

When you merge libraries, sometimes there is a conflict. For example, if you export a project from your desktop to your laptop, make similar changes in both places, and then try to merge the library from your laptop with the one on your desktop, a conflict occurs because a file has been changed in both libraries. If Aperture finds a conflict, it prompts you with the dialog shown in Figure 10.6 about how you want to resolve the conflict.

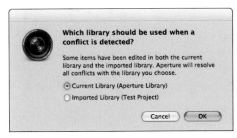

10.6 Aperture lets you pick which library's data it should use to resolve any merge conflicts.

You resolve a conflict by picking which library is accurate. Unfortunately it doesn't provide any information about what the conflict is, and it will apply your pick to all conflicts it finds. If you have merge conflicts, to be safe, we recommend clicking Cancel, reimporting this library, and clicking Add instead of Merge so that Aperture imports its contents as a copy into your library, rather than possibly replacing existing, good data.

Note If you drag and drop a library onto Aperture from the Finder, Aperture prompts you if you want to add or merge this library into the open library.

Genius The Projects View also lets you merge libraries into specific projects. To do so, select the project in the Projects View, Control+click and choose Import ⇨ Library, and select the library to merge.

Working with multiple computers

A very common reason to work with multiple libraries is that you have multiple computers. While you will need to establish a workflow that best fits your setup, here are our recommendations based on our setup. Specifically, we have laptops with limited storage that we take into the field and use on site and desktops with large hard drives in our offices.

- **Create a new library for each shoot on your laptop.** If you have just one Aperture library on your laptop containing multiple shoots, then you need to export a subsection of it to import into the master library on your desktop. If instead you create a new library for each shoot, when you're done you can import it as is to your desktop. Furthermore, if you want to keep a library with shots from multiple recent shoots on your laptop, you can add the single-shoot library into your existing laptop library and then delete the separate one-shot library.

- **Use managed files on the laptop.** When you're tired or working quickly, as often happens in the field, it's easy to lose track of what folders you're putting your images into, how you're renaming your files, and all the other settings. We try to keep Aperture's settings on our laptops as idiot-proof as possible, and managed files give us one less thing to worry about.

- **Connect your laptop to your desktop.** Use either FireWire/Thunderbolt target disk mode or networking, or connect your laptop directly to your desktop's external hard drive with your master Aperture library. We prefer using target disk mode because it's significantly faster than copying large files over a network (especially our wireless ones) and because we don't have to change our external hard drive's connections to hook them up to our laptops.

Note

To enter target disk mode, connect two Macs with a FireWire or Thunderbolt cable, then choose System Preferences ⇨ Startup Disk ⇨ Target Disk Mode on one machine to reboot it into target disk mode, or if one computer is already off, hold down T on that computer while booting it up until you see the screen fill with the FireWire or Thunderbolt icon. That computer appears listed as an external hard drive for your other computer. You can then move or copy files between them.

- **If needed, open your laptop's library from your desktop and export the library to a temporary location.** If you've made one library for each project, skip this step.

- **Switch to your main Aperture library and import the library.** At this point, do any bulk file management, such as switching managed files to referenced files, and if you exported a temporary library, it's now safe to delete it.

- **Alternatively, use a portable external hard drive in the field as a backup and copy the library onto it daily.** Then connect the external drive to your desktop computer at your home/office and import the library from there.

Controlling Tethered Shooting

A useful feature for studio photographers is the ability to shoot tethered. This means that your camera is hooked up to your computer, and as you press the shutter button, Aperture automatically downloads each image and adds it to a project. Then you can quickly check the image's overall exposure or zoom in to check your focus. Clients also like tethered shooting, as they can quickly see what you're shooting on a large display and provide feedback as to what, if any, changes they want.

Configuring a tethering session

To start a tethering session, choose File ▷ Tether ▷ Start Session. This command opens the dialog in Figure 10.7. Notice how these options are very similar to the import options we cover in Chapter 2.

This dialog lets you pick whether your images will be managed or referenced, how they'll be named, what Metadata Preset is applied, whether they're backed up, and what Effect Preset Aperture applies as it imports your images. We recommend selecting the Show HUD check box in the bottom left, as the tethering HUD has useful status information. Click Start Session once you enter your settings.

Running a tethering session

Running a tethering session is quite straight-forward. Press the shutter button on your camera, and Aperture downloads your image and adds it to the selected project. When you're ready to stop the session, choose File ▷ Tether ▷ Stop Session. Note that while the session is running, you see a small camera icon in the Library Inspector next to the project into which you're importing.

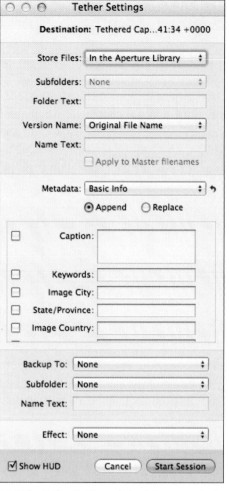

10.7 The Tether Settings dialog lets you control the import options for your tethering session.

Genius

Make sure to check Apple's website to see whether your camera is compatible with Aperture's tethering system. Currently, because of its proprietary nature, some Canon cameras do not work with it. If your camera is listed as compatible but you have a busy message on your camera when connected, make sure your camera's communication method is set correctly (typically to PC Connect and not Print/PTP).

We recommend using the Tether HUD (see Figure 10.8, which is also accessible by choosing File ➪ Tether ➪ Show Tether HUD) because in addition to having a Stop Session button, it shows you what camera it's using, which helps you make sure Aperture recognizes your camera. The Auto Select option controls whether Aperture selects each image as it downloads it. Leaving the Tether HUD up while in a tethering session also provides a helpful hint that you're running a session so that you can stop it when finished.

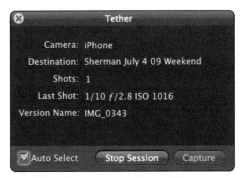

10.8 The Tether HUD provides useful status information about your camera and the last image shot during a tethering session.

Customizing Keyboard Shortcuts

One of Aperture's most underrated features is its ability to customize the keyboard shortcuts for nearly every command, including commands that don't have keyboard shortcuts. Furthermore, Aperture lets you save those command sets and to export them from one machine to another.

Open the Command Editor (see Figure 10.9) by choosing Aperture ➪ Commands ➪ Customize. The Command Editor has three main areas: The keyboard display lets you dynamically inspect what different keys are bound to commands, the Command List allows you to manage every command and its respective shortcuts, and the Key Detail area displays a list of every command associated with a given key and the various modifier keys (such as Shift, Control, and Option).

The simplest way to set a keyboard shortcut is as follows:

1. **Sort through the Command List until you find the command whose shortcut you want to change.**
2. **Select the command.**
3. **Press the shortcut, including the ⌘ key and any modifier keys.** If the shortcut is already bound to another command, Aperture prompts you whether you want to change what the shortcut does. The first time you change a shortcut, Aperture prompts you to make a copy of the default command set, as you can't modify the default set. Click Make Copy and give your command set a new name.
4. **Click Save to save your changes and to close the Command Editor.**

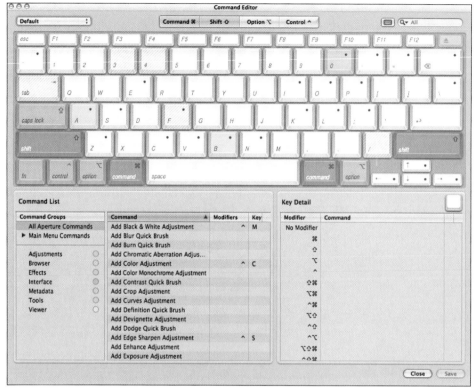

10.9 The Command Editor provides a quick way to customize Aperture's keyboard shortcuts.

There are other ways to use this editor, though. If you click a key in the keyboard display, Aperture updates the Key Detail area to show all the different commands associated with this key and different modifiers. For example, the N key is bound to the Light Table Zoom Navigator, New Project, Add Noise Reduction, and New Folder, depending on the modifier key. To change which modifiers a given key uses (for example, perhaps you want ⌘+Shift+N to be New Project and ⌘+N to be New Folder), drag the command names in the Key Detail's Command column around until they're set up the way you want. You can also drag a command from the Command List to the Key Detail table to set a new hotkey.

Clicking the Keyboard button at the top right shows you what keys have shortcuts attached to them for the selected command group (in the Command List), and Aperture updates the display as you select the different modifiers at the top. You can also drag commands onto the keyboard display or drag them from the keyboard to add and remove commands interactively. Note that as

you drag commands over the keyboard display, Aperture updates the contents of the Key Detail area to reflect the selected key.

To create a new command set, follow these steps:

1. **Open the Command Editor.**

2. **Select the set you want to copy or the Default set from the pop-up menu in the top left.**

3. **Choose Duplicate.**

4. **Give your command set a name and click OK.**

To switch command sets without opening the Command Editor, choose your desired set from the Aperture ⇨ Commands menu. To export a command set, select it from the Aperture ⇨ Commands menu and then choose Aperture ⇨ Commands ⇨ Export. Import that file on another machine by choosing Aperture ⇨ Commands ⇨ Import.

Using Aperture with Automator

Automator is a workflow tool that ships with Mac OS X. It lets you easily assemble workflow actions by dragging and dropping different pieces. For example, you could create a workflow to get the images you have selected in Aperture, export versions of them at a certain size, and load them into Keynote, one image per slide.

We're going to walk through a simple example, exporting images, applying a quartz composition filter, and reimporting them into Aperture. If you've ever used Photo Booth and played with the funky filters, those are all quartz composition filters, and the filters range from simple ones like black and white or sepia tone to funky ones like color pencil and thermal camera. These filters aren't available directly in Aperture, but this workflow makes it easy to apply them anyway. Follow these steps:

1. **Open Automator.** It's in your Applications folder and looks like Figure 10.10 when running.

2. **Go into the Photos group, select Get Selected Images, and drag it onto the area at the right.** Automator now looks like Figure 10.11.

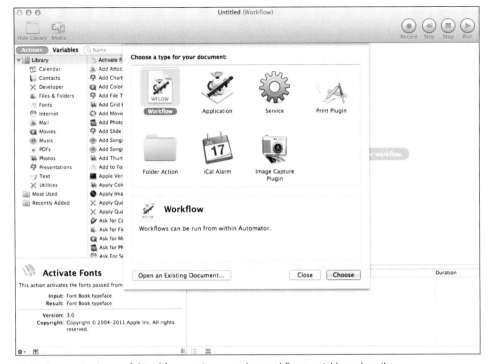

10.10 Automator is a useful tool for creating complex workflows quickly and easily.

3. **Drag the Export Versions action onto the right, after the Get Selected Images task.**
 Set your export options as desired.

4. **Drag Apply Quartz Composer Filter onto the right.** Select what filter you want to
 apply, such as Color Pencil, and set any additional task options for that filter. Automator
 prompts you to add a copy files step because this action modifies your images. Choose
 Don't Add, as a fresh copy of your images was already exported in the previous action
 to modify.

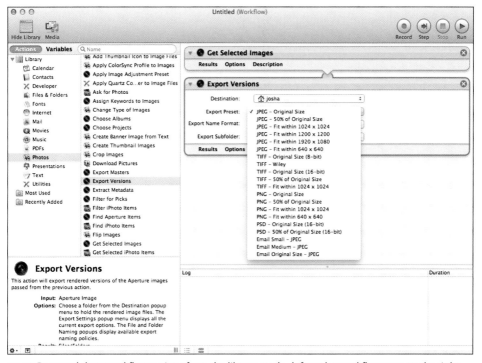

10.11 Drag and drop workflow actions from the library on the left to the workflow area on the right.

5. **Drag Import Photos after Apply Quartz Composer.** Click Options and select the Show this action when the workflow runs check box so that Automator prompts you each time you run this action for where and how Aperture should import your images. Alternatively, if you always want to import your images the same way to the same project, type your settings and leave Show this action when the workflow runs deselected. Your completed workflow will look like Figure 10.12.

6. **Select a few images in Aperture.**

7. **Click the Run button in the top-right corner of Automator.** When it finishes running, look at your newly imported images with the quartz composition filter applied.

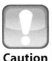

Caution

Sometimes Automator actions have similar names. Make sure the icon for the action matches the icon for the program you want to use (for example, Aperture and not iPhoto) or read the action description in the bottom left that appears once you select the action.

10.12 A completed Automator workflow to apply a quartz composition filter to a group of images.

When your workflow is working, save your Automator action. Automator provides a number of different formats, including workflow, application, and plug-in. Use workflow when you want to open the Automator workflow into Automator and make changes. Use application to create a stand-alone file that you can double-click to run without opening Automator. Use plug-in to create a plug-in for a specific application, such as Finder. For example, if you made a workflow with an Import Photos action, you could save it as a Finder plug-in named Import to Aperture so that you could Control+click any Finder item and choose Automator ⇨ Import to Aperture.

Genius

If your camera doesn't work with Aperture's tethered shooting, you can set up an Automator folder action so that any file placed in the folder is imported into Aperture. Then use your camera's software, such as Canon's EOS Utility, to control the tethering session, setting it to save each image into that special folder.

Using Vaults and Backup

Your digital files are your film negatives, and to a working photographer, they're also your income. Protecting these files is crucial! The first step to protecting your files is to figure out a backup strategy, starting with where you store your photo library.

One of the most common causes of lost data is hard drive failure. Unfortunately, drives don't last forever, and if your library's only on one drive, it's quite possible that you'll lose all your images at some point. Rather than storing our libraries on a single drive, we use redundant arrays of independent disk (RAID) storage devices for our primary photo library. RAID systems let you automatically store your data to multiple hard drives at once, but the combined drives appear as one drive to your computer.

Note

When setting up a RAID system, we recommend buying drives from different manufacturers if possible, so that if a manufacturer has a bad run of drives, your drives don't all fail together.

Currently, we use the Promise Pegasus RAID array with Thunderbolt, shown in Figure 10.13, which is surprisingly quiet and incredibly fast thanks to the Thunderbolt ports. If a drive fails, our data's still intact. Other vendors, such as Data Robotics, also make RAID arrays with Thunderbolt ports. We highly recommend a Thunderbolt drive over a USB drive, though, as USB's sustained data transfer rate is slower than Thunderbolt, which will affect you as you access large images.

While keeping your images on a RAID array helps prevent image loss due to hard drive failure, it won't protect you if there's a fire or some other natural disaster. The simplest way to protect yourself in this case is to keep a second copy of your data at an off-site location. For example, perhaps you buy a second RAID array that you keep in your house rather than your studio. Every so often, take your spare drive to your computer and sync your data either using vaults, as we describe

shortly, or by using a program like SuperDuper that updates your backup drive with any changes that you make on your main drive.

RAID arrays aren't a viable option while shooting in the field because they're too large to be easily portable. When we shoot in the field, we use a two-tiered backup system. The first is that we use field storage devices (specifically Sanho HyperDrive COLORSPACE UDMAs) to back up our memory cards when we download them to our computers. Then we have small, portable hard drives on which we keep an Aperture vault or a copy of our library, so

Courtesy of Promise Technology, Inc.

10.13 The Promise Pegasus Thunderbolt RAID arrays provide high-performing and easy-to-set-up RAID systems for your photo library.

that as we organize our images on our computers, all our changes are synced to our backup drive. Furthermore, should our computer die, Sanho sells an accessory for the HyperDrive so that you can back up to the HyperDrive and an external hard drive at the same time. We feel that this setup gives us the best balance between portability, flexibility, and reliability.

Using vaults to back up your images

A vault is a special backup of your photo library that Aperture incrementally updates when you update the vault. Specifically, each time you update your vault, Aperture's smart enough to only copy over any changes you've made, rather than making a full copy of your library each time. You can create multiple vaults, such as one that you update daily, and another on a hard drive that you keep off-site that you update weekly.

Caution Aperture does not back up referenced files within a vault, only managed files. If you use referenced files in your workflow, see the section on Alternate backup strategies for how to back up your images.

Choose Window ⇨ Show Vaults or switch to the Library Inspector and click Show Vaults to display the Vault pane, as shown in Figure 10.14.

Creating a vault

Creating a new vault is simple. Follow these steps:

1. **Connect your external drive for the vault.**

2. **Open the Vault pane.**

3. **Choose Add Vault from the Vault Action pop-up menu or choose File ⇨ Vault ⇨ Add Vault.** Aperture opens a dialog indicating how many files will be backed up. Click Continue to proceed.

4. **Choose where you want your vault to live and give it a name.**

5. **Click Add, and Aperture creates an empty vault.** Update it right away to create the initial backup.

Vault Status button

MacBookPro Vault 163.1GB of 433.5GB available

Hide Vaults

Update All Vaults button

Vault Action pop-up menu

10.14 Use the Vault pane in the Library Inspector to manage your vaults.

Updating a vault

The Vault Status button, located to the right of each vault's entry in the Vault pane, indicates how up to date the vault is. A black icon means the vault is up to date, a yellow icon means that the vault contains all the original files from your library but not all your adjustments, and a red icon means that there are originals in your library that haven't been backed up.

To update a specific vault, either click the Vault Status button or select the vault and choose Update Vault from the Vault Action pop-up menu.

To update all your vaults, click the Update All Vaults button or choose File ⇨ Vault ⇨ Update All Vaults.

Restoring from a vault

Restoring your library from a vault is straightforward. While hopefully you'll never have to restore a library due to a drive failure, if you purchase a new computer, you can use these easy steps to restore a vault into a fresh Aperture installation rather than manually copying your library.

1. **Connect the hard drive with your vault to your computer.** Wait for it to appear in Finder.

2. **Open Aperture.**

3. **Choose File ⇨ Vault ⇨ Restore Library.** Aperture opens the dialog in Figure 10.15.

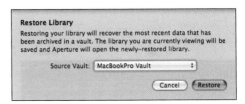

10.15 The Restore Library dialog lets you choose which vault to use to restore your library.

4. **Choose your vault from the Source Vault pop-up menu.** If it's not listed, choose Select Source Vault and navigate to your vault.

5. **Click Restore.** When prompted to confirm, click Restore again.

Deleting a vault

To delete a vault, select it in the Vault Pane and choose Remove Vault from the Vault Action pop-up menu or choose File ⇨ Vault ⇨ Remove Vault. Aperture prompts you to either remove and delete the vault, or to just remove it. If you only remove it, it will still be on your hard drive, and you can still restore from it at a later date. If you choose Remove and Delete, Aperture deletes the vault from your drive.

Alternate backup strategies

While vaults are quite convenient, they don't back up referenced images and therefore aren't the ideal backup solution for every photographer. Fortunately, there are plenty of other backup tools out there.

Time Machine

The simplest backup tool, Time Machine, comes standard with every Mac that has OS X 10.5 or later installed. Time Machine is sort of like a vault, but it operates on your entire hard drive and not just your Aperture library. It's like a vault in that it's an incremental backup — it only backs up files that have changed since the last backup. But it goes far beyond an Aperture vault, too. It keeps hourly backups for the past day, daily backups for the past month, and weekly backups until its area of the hard drive is full. Should you need to restore a file, Time Machine's interface lets you go back in time to find and restore the files you want.

To use Time Machine, choose System Preferences ➪ Time Machine, and you'll see the pane in Figure 10.16. Make sure the big switch is set to On. Click Options to select any folders you don't want to back up. Then connect an external hard drive, and when prompted, if you want to use that drive for Time Machine, click Yes. Note that the initial backup takes a while, but subsequent backups will be significantly faster.

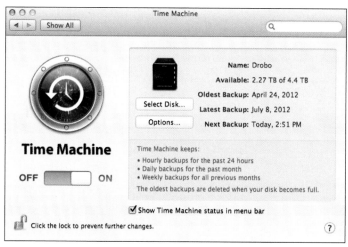

10.16 The Time Machine System Preferences pane lets you control what Time Machine backs up and to turn it off and on.

Note

Because hard drives can always fail, we recommend either using a RAID system for your Time Machine backups or having two different external hard drives that you use for backup. Should you use a Drobo RAID, the Drobo FS supports Time Machine natively, but using Time Machine with other Drobo products has a number of issues due to how the Drobo works, and we don't recommend it.

Other physical storage

An alternative to using hard drives to back up your data is to use another type of physical storage such as a DVD or a tape drive. Tape drives, while once popular backup solutions, aren't common on the desktop now, and we don't recommend them for the typical user.

Using DVDs is sort of a middle ground. While it seems like a great idea (hey, my data's being laser-etched into a disc — isn't that better than a hard drive?), DVDs can also go bad, and sometimes they don't even last a year. At the very least, make sure to use archival gold DVDs, which last longer, and look for DVD-R and not DVD-RW discs. The DVD-RWs, or rewritable variety, don't last as long as the write-once type. DVDs are also convenient for keeping a copy of your data off-site, as they take far less space than a hard drive.

Unfortunately, because DVDs typically only hold about 4GB (a bit more if you use a dual-layer disc), you'll probably need a lot of discs to back up your images. If you choose to use DVDs to back up your work, we recommend that you use referenced files. That way, you can point third-party programs that automatically distribute large chunks of data among a number of DVDs at your image folders. Plus, you can periodically also burn your Aperture library to a disc to back up your project structure and metadata.

Online backup

A different alternative is to use an online backup service. There are a number of services that photographers would be interested in, but they primarily fall into two camps. The first camp is a photography-oriented backup service, designed to both archive your photos and to provide gallery and sales features, and the second camp is a general-purpose backup solution, designed to back up your entire hard drive.

Some of the photography services include PhotoShelter (www.photoshelter.com) and SmugMug (www.smugmug.com). PhotoShelter and SmugMug (as of this writing) charge either a monthly or

yearly fee, and they have different rates depending on what features you need, ranging from basic gallery services to terabytes of storage with online sales and custom website templates. Josh currently uses PhotoShelter to drive his website. He uses its Aperture export plug-in to upload his original files to a RAW folder within his PhotoShelter archive, and he uploads JPEG versions of his images, with all his adjustments burned in, to another folder that he then posts publicly.

Unfortunately with these services, you have to manually select what images you want to upload to the sites and upload them yourself. But that's a small price to pay to be able to access your images anywhere and for some of the other features these sites provide.

The more general services, like CrashPlan (www.crashplan.com), Mozy (www.mozy.com), and Carbonite (www.carbonite.com) provide programs that monitor the data on your computer and upload any new or changed files whenever you make a change. These services cost less (each is roughly $60 per year for unlimited backup, compared to the $60 per month you might pay PhotoShelter for storage), but they don't provide any gallery or photo sales features.

Should you choose to use an online backup service, remember that the initial backup can take a significant amount of time depending on how much data you have to back up and your network connection, possibly even weeks. A big reason we chose to use CrashPlan as our online backup service is that for a small fee it sends you a large hard drive that you can seed with your initial backup so that you don't have to wait months (depending on your connection speed) for your initial backup to finish. Furthermore, if you need to restore your data, again for a small fee, CrashPlan sends you a hard drive with a copy of your backup so that you don't have to download gigabytes of data from its site, which can also take a long time.

With all of these services, there's always the risk that the company goes out of business, leaving your data stranded. For example, the previous version of this book mentioned Swiss Picture Bank because of its lifetime guarantee with the Foundation for Data Permanence, but just two years later Swiss Picture Bank is out of business. Don't let that possibility stop you from using an online backup service, but we highly recommend that you have more than just an online backup of your data.

Caution

When choosing an online backup service, read its privacy policies carefully to make sure your data is only accessible by you, even if the company goes out of business.

Using Aperture's Database Repair Tools

At its core, Aperture uses a database to contain and organize information about your images, ranging from where the files are on the hard drive to where each thumbnail is stored to what faces are tagged in each image. Unfortunately, once in a while, it's possible for something bad to happen, such as the power going out while Aperture is using its database, which causes the database to become corrupt.

Aperture 3 includes a first-aid tool that you should use as the first problem-solving step when you encounter problems with Aperture. It can fix everything from images showing the wrong thumbnails to Aperture not being able to open the library file and can be faster than restoring your library from a backup.

To access the Library First Aid tools, follow these steps:

1. **Quit Aperture if it's running.**

2. **Find the problematic Aperture library in the Finder.**

3. **Hold down the ⌘ and Option keys and then double-click the library file.** Aperture displays the Photo Library First Aid dialog, as shown in Figure 10.17.

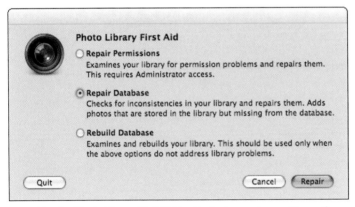

Photo Library First Aid

○ **Repair Permissions**
Examines your library for permission problems and repairs them. This requires Administrator access.

⊙ **Repair Database**
Checks for inconsistencies in your library and repairs them. Adds photos that are stored in the library but missing from the database.

○ **Rebuild Database**
Examines and rebuilds your library. This should be used only when the above options do not address library problems.

Quit Cancel Repair

10.17 Use the Photo Library First Aid tool to try to repair your library if you have problems.

4. **Select the appropriate option (described in the following list) and click Repair/ Rebuild.**

Within the Library First Aid dialog, there are three repair options:

- **Repair Permissions.** Select this option if Aperture can't open or display either the library or some of the images within the library. Note that this option requires an administrator password for your computer. Also note that if Aperture can't open your images because they're referenced and have missing originals, this option will not reconnect your images for you.

- **Repair Database.** If Aperture is displaying the wrong metadata for various images (or not displaying any metadata) or having trouble with something other than accessing your image files, select this option.

- **Rebuild Database.** This option uses the different data files within your Aperture library to rebuild the library's database. Use this option as a last resort if Repair Database fails, as it can be quite slow.

If you still have problems with your library after using the Library First Aid tool, we recommend simply restoring your library from your most recent backup.

Genius

Because of how Aperture stores some of its internal files, your library can become fragmented across your hard drive. If you notice Aperture's performance slowly degrading over time, try using a defragmentation program on the drive that you use to store your Aperture library.

Index

A

access, setting up
 for Facebook, 282
 for Flickr, 285–286
accounts
 Facebook, 284–285
 Flickr, 285–286
actions, running automatically after
 importing, 53
Add button (+), 262
Add Page button (Webpage Editor), 281
Add Text Block button (Webpage Editor), 281
Add to Favorites command (Inspector), 15
Adjusted badge, 302, 303
adjustments
 Auto Enhance, 167–168, 212
 bricks, 169–200
 brushing out, 200–202
 commonalities of all bricks, 162–163
 creating and using effects, 211–214
 cropping images, 166–167
 external editors, 214
 Highlights & Shadows, 181–182
 histogram, 163–164
 making, 162–202
 Quick Brushes, 202–210
 reprocessing originals, 156–158
 setting preferences for making, 158–162
 straightening images, 164–166
 third-party editing plug-ins, 215–216
Adjustments Inspector, 92
Adobe RGB, 220
Album pick badge, 302, 303
albums
 about, 11, 56
 creating, 236–237
 deleting, 23
 managing files with, 21–23
 removing images from, 23
All Projects view, 23–24
Anon, Ellen & Josh (author)
 See It: Photographic Composition Using Visual
 Intensity, 169
Aperture. *See also specific topics*
 about, 4
 compared with
 iPhoto, 4–5, 56–57
 Lightroom, 5–6
 customization options, 26–29
 file structure, 6–12
 interface, 13–26
 library, 7–8, 26–27, 54–58
Aperture Trash, 25
appearance preferences, 27–28
attaching audio files, 297–298
Audio attachment badge, 302, 303
Audio Browser button (Slideshow Editor), 268, 269

audio files. *See also* video files
 attaching, 297–298
 detaching, 298
 importing, 296
 playing, 296–297
Auto Enhance, 167–168, 212
AutoFill feature, 111–112
automatic backup, setting on import, 53–54
Automator, 315–319

B

background brightness, 74
Background preset option, 266
backups
 about, 319–320
 DVDs, 324
 online, 324–325
 Time Machine, 323–324
 vaults, 320–322
badges, 302–303
Batch Change tool, 118–119
batch changes, 117–119
Black & White Effects, 212
black and white, converting images to, 194–195
Black Point Compensation option, 262
Blur Quick brush, 210
Book Actions menu, 249–250
Book Editor Viewer, 239
Book Layout Editor, 238–239
books
 about, 236
 adding pages to, 248
 Book Layout Editor, 238–239
 choosing themes, 236–237
 creating albums, 236–237
 customizing page layout, 248–250
 editing master pages, 250–251
 ordering, 251–252
 placing images/text, 239–246
 printing, 251–252
 removing pages from, 248
 switching page styles, 247
Boost slider, 188

bricks, 169–200
brightness, changing for background, 74
Browser
 about, 13–14, 17–20
 book features, 243–244
 flagging and unflagging images in, 99
 multiple, 66–67
 searching within, 120–122
 using in Full-Screen mode, 73–74
Browser Filter, 137
Brush Size slider, 205
built-in custom presets, 232–234
built-in views, 23–25
Burn Quick Brush, 207
buttons
 Add (+), 262
 Add Page (Webpage Editor), 281
 Add Text Block (Webpage Editor), 281
 Audio Browser (Slideshow Editor), 268, 269
 customizing sets, 115–116
 editing, 113
 Export (Slideshow Editor), 268, 269
 Filter HUD, 121–122
 Name, 133–134
 Page Template (Webpage Editor), 281
 Play Slideshow (Slideshow Editor), 268
 Preview Slideshow (Slideshow Editor), 268, 269
 Print, 234
 Remove Page (Webpage Editor), 281
 Show All Images/Show Unplaced Images (Webpage Editor), 281
 Show Original, 79
 Show Viewer for this Browser (Slideshow Editor), 268, 269
 Slide Duration (Slideshow Editor), 268, 269
 Slideshow settings (slideshow Editor), 268, 269
 Theme (Slideshow Editor), 268

C

calibrating
 monitors, 221–222
 printers, 222

cameras, importing from, 32–37

categorizing images. *See* Faces; Places

chromatic aberration, removing, 197–198

clipping, 68

color

 converting images to monochrome, 195–196

 managing for hard copies, 220–224

Color controls, 184–186

Color Efex Pro, 215

Color Effects, 212

Color Profile option, 262

Compare mode (Viewer), 64–65

configuring

 destination projects, 38–40

 file types to import, 50–51

 item options, 242–243

 standard print hard copies, 225–230

 tethered shooting, 312

 web pages, 277–280

Connected Flow, 287

contact sheets, 231–232

Contrast slider, 176

CrashPlan, 9, 325

creating

 albums, 236–237

 contact sheets, 231–232

 effects, 211–214

 hard copies, 236–252

 locations, 143–144

 slide shows, 266–275

 vaults, 321

 web pages, 275–282

cropping images, 166–167

Curves, 190–194

customizing

 about, 26

 button sets, 115–116

 changing

 appearance preferences, 27–28

 default import behavior, 28–29

 interface, 62–68

 modifying preview preferences, 29

 setting library location and General

 preferences, 26–27

D

database repair tools, 326–327

Datacolor Spyder 4, 221

date, adjusting after import, 109–110

De-noise slider, 189

Definition Quick Brush, 210

Definition slider, 176

deleting

 albums, 23

 folders, 23

 projects, 23

 vaults, 322–323

desktops, setting image for, 265

destination projects, configuring, 38–40

detaching audio files, 298

Detect Edges slider, 206

devignetting, 197

Dfine, 215

displaying hot and cold areas, 67–68

Dodge Quick Brush, 207

DPI option, 262

dragging and dropping files, 58

DVDs, 324

E

e-mailing images, 264

Edges slider, 188

editing

 buttons, 113

 keywords, 113

 master pages for books, 250–251

 third-party plug-ins, 215–216

 video clips, 294–295

editors, external, 214

Effect Presets, 48–50

effects

 creating and using, 211–214

 removing, 212

efficiency

 Automator, 315–319

 backup, 319–326

 badges, 302–303

 database repair tools, 326–327

keyboard shortcuts, 313–315
libraries, 306–311
photo previews, 304–306
tethered shooting, 311–313
vaults, 320–322
enabling
Faces, 128
Places, 137
Enhance tools, 176–181
EXIF (Exchangeable Image File) data, 102
Export button (Slideshow Editor), 268, 269
Export Project/Folder/Album as New Library
command (Inspector), 16
exporting
about, 256
libraries, 308–309
originals, 256–259
slideshows, 274–275
versions, 260–263
video clips, 296
exposure controls, 172–175
external editors, 214
Externally edited badge, 302, 303

F

Facebook
about, 282
managing account, 284–285
publishing images in, 283–284
setting up access, 282
Faces
about, 128
assigning names using, 130–133
enabling, 128
finding people using, 135–137
interface, 129–135
view, 24
filename export options, 257–259
files
audio
attaching, 297–298
detaching, 298
importing, 296
playing, 296–297

configuring types to import, 50–51
dragging and dropping, 58
managed, 8–9, 40–42
managing with Projects and Albums, 21–23
referenced, 8–9, 40–42, 87, 107
renaming on import, 42–44
structure of, 6–12
video
about, 292
adding to slide shows, 273
editing, 294–295
exporting, 296
importing, 292–293
viewing, 293–294
filmstrip, 74–76
Filmstrip view, 19
Filter HUD button, 121–122
finding images. *See* metadata
flags, 99–102
Flickr
about, 285
publishing images in, 286–287
setting up access, 285–286
FlickrExport plug-in, 287
folders
about, 11–12
deleting, 23
export options, 257–259
Full-Screen mode, 72–77

G

Gamma Adjust option, 262
General preferences, 26–27
gestures, 25–26
GPS receivers, assigning locations using,
146–147
Grid view, 19

H

Halo Reduction Quick Brush, 210
hard copies
adding pages, 248
Book Layout Editor, 238–239
built-in custom presets, 232–234

hard copies *(continued)*
 calibrating
 monitors, 221–222
 printers, 222
 choosing book themes, 236–237
 color management, 220–224
 configuring standard print, 225–230
 creating
 books, 236–252
 contact sheets, 231–232
 customizing page layout, 248–250
 editing master pages, 250–251
 ordering
 books, 251–252
 prints, 235–236
 placing images and text, 239–246
 Print button, 234
 Print dialog, 224–235
 printing books, 251–252
 removing pages, 248
 soft proofing, 222–224
 switching page styles, 247
hard drives, importing from, 32–37
HDR Efex Pro, 215
HDR Soft, 215
heads-up displays, 76–77
Highlights & Shadows adjustments, 181–182
Highlights & Shadows tool, 214
histogram, 163–164
hot and cold areas, displaying, 67–68
HUD (Metadata heads-up display), 103
Hue Boost slider, 188, 189

I

iLife, 305
Image Adjustments group, 229
Image Export dialog, 261
Image Export Presets, 287
Image Format option, 262
Image Options group, 230
Image Quality option, 262

images
 assigning locations to, 137–148
 converting
 to black and white, 194–195
 to color monochrome or sepia, 195–196
 cropping, 166–167
 defined, 7
 dragging
 between Projects and Albums, 22
 onto maps using Places, 139–141
 e-mailing, 264
 Export Presets, 261–263
 finding using Places, 149–152
 flagging in Browser, 99
 for desktop, 265
 importing
 Aperture library, 7–8, 26–27, 54–58
 changing default behavior, 28–29
 choosing settings, 37–54
 configuring file types, 50–51
 dragging and dropping files, 58
 from memory cards, cameras, and hard
 drives, 32–37
 Import panel, 32–37
 iPhoto library, 54–58
 Photo Stream, 24–25, 59
 offline, 9
 organizing, 9–12
 original, 9, 82–85, 156–158, 256–259
 placing in books, 239–246
 previews, 304–306
 publishing
 in Facebook, 283–284
 in Flickr, 286–287
 references, 83–87
 rejected, 98–99
 removing
 from albums, 23
 location information from, 148–149
 searching for. *See* searching
 sharpening, 186–187, 229
 straightening, 164–166
 unflagging in Browser, 99

Import panel, 32–37
importing
audio files, 296
images
Aperture library, 7–8, 26–27, 54–58
changing default behavior, 28–29
choosing settings, 37–54
configuring file types, 50–51
dragging and dropping files, 58
from memory cards, cameras, and hard drives, 32–37
Import panel, 32–37
iPhoto library, 54–58
Photo Stream, 24–25, 59
libraries, 309–310
video files, 292–293
Include Metadata option, 262
Info Inspector
about, 102–104
assigning locations with, 141–142
switching and customizing metadata views, 104–106
Inset preset option, 267
Inspector, 13–16
Intensify Contrast Quick Brush, 208–209
interface
about, 13
albums, 11, 21–23, 56, 236–237
Browser, 13–14, 17–20, 66–67, 73–74, 99, 120–122, 243–244
built-in views, 23–25
customizing, 62–68
Faces, 24, 129–137
gestures, 25–26
Inspector, 13–16
Projects, 21–23
Viewer, 13–14, 20–21
International Press Telecommunications Council (IPTC) metadata, 102, 125
iPhone GPS information, 144–145
iPhoto
compared with Aperture, 4–5, 56–57
Effects, 199–200
library, 54–58

IPTC (International Press Telecommunications Council) metadata, 102, 125
IPTC Core, 105, 107
item options, configuring, 242–243
iWork, 305

J
JPEG badge, 302, 303
JPEG previews, 275

K
Keep Albums & Projects Arranged By command (Inspector), 15–16
keyboard shortcuts, 20, 130, 313–315
keywords
about, 110–112
control bar, 112–116
editing, 113
heads-up display, 116–117
Keywords library, 113–115

L
labels, 99–102
Large Caption view, 105
layout options, 226–227
Levels, 182–184
libraries
about, 306
Aperture, 7–8, 26–27, 54–58
exporting, 308–309
importing, 309–310
iPhoto, 54–58
Keywords, 113–115
moving images between, 307–310
multiple computers, 310–311
switching, 306–307
Library First Aid tools, 326–327
library items, rearranging and grouping, 62–63
Lift and Stamp tool, 119
Light Table, 90–92
Lightroom, compared with Aperture, 5–6
List view, 19

locations
 adding to maps, 245
 assigning
 to photos, 137–148
 using GPS receivers, 146–147
 using iPhone GPS information, 144–145
 using Projects view, 147
 with Info Inspector, 141–142
 with search option, 142
 creating and assigning custom, 143–144
 deleting from maps, 245
 removing from images, 148–149
Loupe tool, 70–71
Low quality badge, 302, 303

M

Maintain Previews for Project command
 (Inspector), 16
managed files, 8–9, 40–42
managed originals, converting from referenced
 originals, 87
Map Options HUD, 245–246
maps, in books, 244–246
margin options, 226–227
master pages, editing, 250–251
Matching RAW files, 52–53
memory cards, importing from, 32–37
merging projects, 24
metadata
 adding, 117
 adjusting
 boxes, 241–242
 time/date, 109–110
 applying batch changes, 117–119
 flags, 99–102
 Info Inspector, 102–109
 keywords, 110–117
 labels, 99–102
 options, 259
 ratings, 96–99
 searching for images, 120–124
 setting, 107
 writing IPTC information to originals, 125
Metadata heads-up display (HUD), 103

Metadata Options group, 230
Metadata Overlays, 80–82
Metadata Presets, 45–48
Mid Contrast slider, 182
MobileMe badge, 302, 303
Moire slider, 188
monitors, calibrating, 221–222
Mozy, 9, 325
music, adding to slide shows, 273–274

N

Name button, assigning names using, 133–134
names
 assigning using Names button, 133–134
 correcting, 134–135
Natural Gray method, 170, 171
Next Frame control, 294
Nik Software, 215
noise, removing, 198–199
Noise Reduction Quick Brush, 210

O

offline images, 9
Offline original badge, 302, 303
online backups, 324–325
ordering
 books, 251–252
 prints, 235–236
organizing images, 9–12. See also metadata
original images
 about, 9
 exporting, 256–259
 reconnecting, 84–85
 reprocessing, 156–158
Original not found badge, 302, 303

P

Page Options group, 230
Page Template button (Webpage Editor), 281
pages
 adding in books, 248
 customizing layout in books, 248–250
 editing master pages in books, 250–251

removing from books, 248

switching styles in books, 247

web

 about, 275–276

 configuring, 277–280

 creating, 275–282

 Smart Web Pages, 275–276

 web journals, 275–276, 280–282

Pages pane (Book Layout Editor), 238

people, finding using Faces, 135–137

Perceptual method, 228

Photo Stream, 24–25, 59

Photomatix, 215

photos. See images

PhotoShelter, 287–289, 324–325

pins, moving, 148

Placed badge, 302, 303

Places

 about, 137

 assigning locations to photos, 137–148

 dragging images onto maps using, 139–141

 enabling, 137

 finding images using, 149–152

 Search option, 142

Places view, 24

Play music during slideshow preset option, 267

Play Slideshow button (Slideshow Editor), 268

Play/Pause control, 294

playing audio files, 296–297

plug-ins

 for exporting, 287–289

 third-party editing, 215–216

Polarize Quick Brush, 208

poster frame, of video clips, 294–295

preferences

 appearance, 27–28

 General, 26–27

 preview, 304–305

 setting for making adjustments, 158–162

presets

 about, 45

 built-in custom, 232–234

 custom slide show, 266–267

Effect, 48–50

image export, 261–263

managing and applying, 107–109

Metadata, 45–48

Preview Slideshow button (Slideshow Editor), 268, 269

previews

 about, 304

 controlling preferences, 304–305

 generating, 305–306

 JPEG, 275

 modifying preferences, 29

 preferences, 304–305

 stacks and, 306

Previous Frame control, 294

Primary Only, 77–78

Print button, 234

Print dialog

 about, 224–225

 built-in custom presets, 232–234

 configuring standard prints, 225–230

 creating contact sheets, 231–232

 Print button, 234

printers, calibrating, 222

printing books, 251–252

prints, ordering, 235–236

projects

 about, 11

 deleting, 23

 managing files with, 21–23

 merging, 24

 view, 147

Promise Pegasus RAID array, 319–320

publishing

 images in Facebook, 283–284

 images in Flickr, 286–287

Q

quarter tone controls, 184

Quick Brushes, 202–210

Quick Fixes, 212

Quick Preview, 78–79

QuickTime, 275

R

Radius slider, 188
ratings
 about, 96
 rejected images, 98–99
 setting, 96–97
RAW badge, 302, 303
Raw Fine Tuning, 187–190
RAW+JPEG pairs, 51–53, 82–83
reconnecting original images, 84–85
Referenced badge, 302, 303
referenced files, 8–9, 40–42, 87, 107
referenced images, 83–87
referenced originals
 converting to managed originals, 87
 relocating, 85–87
rejected images, 98–99
Relative Colorimetric method, 228
Remove from Favorites (Inspector), 15
Remove Page button (Webpage Editor), 281
removing
 chromatic aberration, 197–198
 effects, 212
 noise, 198–199
renaming files, 42–44
Rendering options, 227–229
Repeat slideshow preset option, 267
restoring from vaults, 322
Retouch brushes, 202–204

S

Saturation Quick brush, 210
Saturation slider, 178–179
searching
 about, 120
 with stacks, 124
 within Browser, 120–122
See It: Photographic Composition Using Visual
 Intensity (Anon & Anon), 169
sepia, converting images to, 195–196
Set metadata badge, 302, 303
Set Photo Filter pop-up menu, 242

settings
 images for desktops, 265
 import, 37–54
 ratings, 96–97
 time zone, 44
sharing images
 creating
 slide shows, 266–275
 web pages, 275–282
 e-mailing, 265
 exporting, 256–264
 Facebook, 282–285
 Flickr, 285–287
 plug-ins, 287–289
 setting desktop images, 266
Sharpen Quick brush, 210
sharpening, 186–187, 229
Sharpening slider, 188
shortcuts (keyboard), 20, 130, 313–315
Show All Images/Show Unplaced Images button
 (Webpage Editor), 281
Show Original button, 79
Show title slide preset option, 266
Show Viewer for this Browser button (Slideshow
 Editor), 268, 269
Shuffle slide order preset option, 266
Silver Efex Pro, 215
Size To option, 262
Skin Smoothing effect, 206–207
Skin Tone method, 170
Slide Duration button (Slideshow
 Editor), 268, 269
Slide duration preset option, 267
Slideshow Action pop-up menu (Slideshow
 Editor), 268, 269
Slideshow Editor
 about, 267–269
 adding
 music, 273–274
 video clips, 273
 adjusting
 show settings, 269–270
 slide settings, 270–272
 arranging slide shows, 269

exporting shows, 274–275
 playing shows, 274–275
Slideshow Settings button (Slideshow
 Editor), 268, 269
slideshows, 265–275
Smart Albums, 11, 56, 97, 122–123
Smart Settings HUD, 123
Smart Web Pages, 275–276
SmugMug, 324–325
soft proofing, 222–224
Softness slider, 205
Split view, 18–19
sRGB, 220
Stack badge, 302, 303
stacks, 12, 88–90, 124
straightening images, 164–166
Strength slider, 205–206
Swiss Picture Bank, 325
switching libraries, 306–307

T

Temperature & Tint method, 170
tethered shooting
 about, 311
 configuring, 312
 running, 312–313
text, placing in books, 239–246
Theme button (Slideshow Editor), 268
Theme preset option, 266
themes, book, 236–237
third-party editing plug-ins, 215–216
Thunderbolt, 319–320
Time Machine, 323–324
Time slider, 294
time zone settings, 44, 109–110
Timing preset option, 266
tokens, 259
toolbar, 74–76
tools
 Batch Change, 118–119
 database repair, 326–327
 Enhance, 176–181
 Highlights & Shadows, 214

Library First Aid, 326–327
Lift and Stamp, 119
Loupe, 70–71
Zoom, 68–70
Zoom Scroll, 69–70
Topaz plug-ins, 215
Transition Duration preset option, 267
Transition preset option, 266
Trash, 25
trimming video clips, 295

U

updating vaults, 321–322

V

vaults
 about, 320–321
 creating, 321
 deleting, 322–323
 restoring from, 322
 updating, 321–322
versions, 9–11, 260–263
Vibrancy Quick Brush, 210
Vibrancy slider, 178, 180
Video badge, 302, 303
video files. See also audio files
 about, 292
 adding to slide shows, 273
 editing, 294–295
 exporting, 296
 importing, 292–293
 viewing, 293–294
Viewer
 about, 13–14, 20–21
 modes, 64–65
 using in Full-Screen mode, 73–74
 using with multiple monitors, 65–66
viewing
 images
 customizing interface, 62–68
 displaying hot/cold areas of images,
 67–68
 in Full-Screen mode, 72–77

viewing, images *(continued)*
 library items, 62–63
 Light Table, 90–92
 Loupe tool, 70–71
 Metadata Overlays, 80–82
 multiple Browsers, 66–67
 multiple monitors, 65–66
 original images, 82–83
 Primary Only, 77–78
 Quick Preview, 78–79
 RAW+JPEG pairs, 82–83
 referenced images, 83–87
 scrolling, 68–70
 Show Original button, 79
 stacks, 88–90
 Viewer modes, 64–65
 zooming, 68–70
 video files, 293–294
views
 All Projects, 23–24
 built-in, 23–25
 Faces, 24
 Filmstrip, 19
 grid, 19
 Import panel, 34–37
 metadata, 104–106
 Places, 24
 project, 147
 Split, 18–19
vignette, adding/removing, 196–197
Volume slider, 294

W

Wacom Cintiq, 16
watermarks, adding, 263
web journals, 275–276, 280–282
web pages
 about, 275–276
 configuring, 277–280
 creating, 275–282
 Smart Web Pages, 275–276
 web journals, 275–276, 280–282
Webpage Editor Action pop-up menu (Webpage
 Editor), 281
websites
 CrashPlan, 325
 Mozy, 325
 PhotoShelter, 324
 SmugMug, 324
What-You-See-Is-What-You-Get (WYSIWYG), 220
white balance, 169–172
White Balance Effects, 212
WYSIWYG (What-You-See-Is-What-You-Get), 220

X

X-Rite ColorMunki, 221–222
X-Rite Pantone Huey, 221

Z

Zoom Scroll tool, 69–70
Zoom tool, 68–70